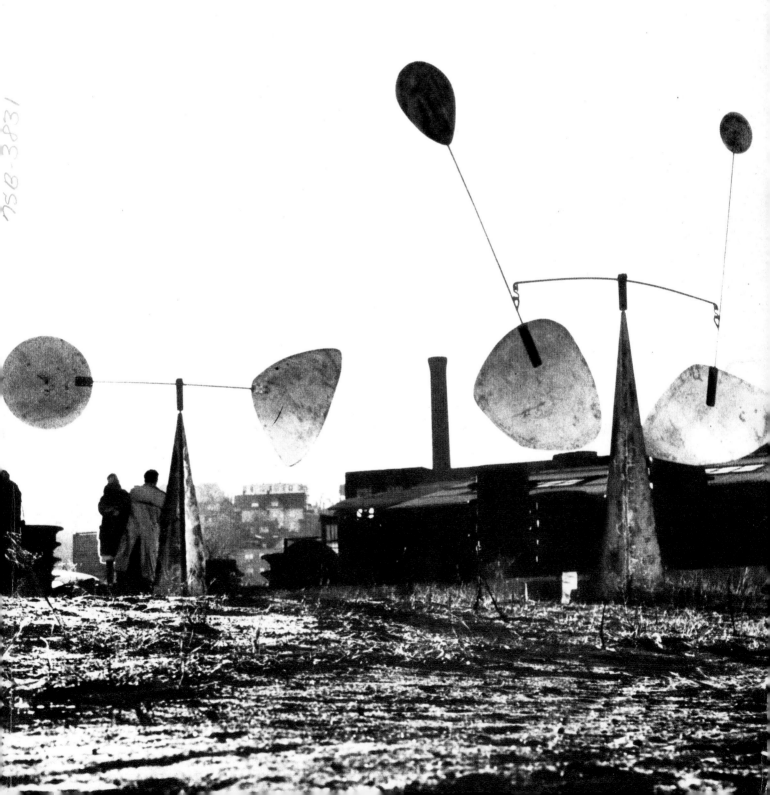

*(End papers)*
*Alexander Calder: 'Views of the mobile I made for the Los Angeles County Museum which I called "Hello Girls!" The title was the result of a little difficulty in placing the piece. It was originally designed to be in a little pond among several buildings, but oil was discovered there so they moved it and put up a derrick instead. In its new location there was some question of its general visibility, so I added a couple of elements to increase the height and since that gave the effect of a gay salute, hence the title "Hello Girls!"*

# CALDER

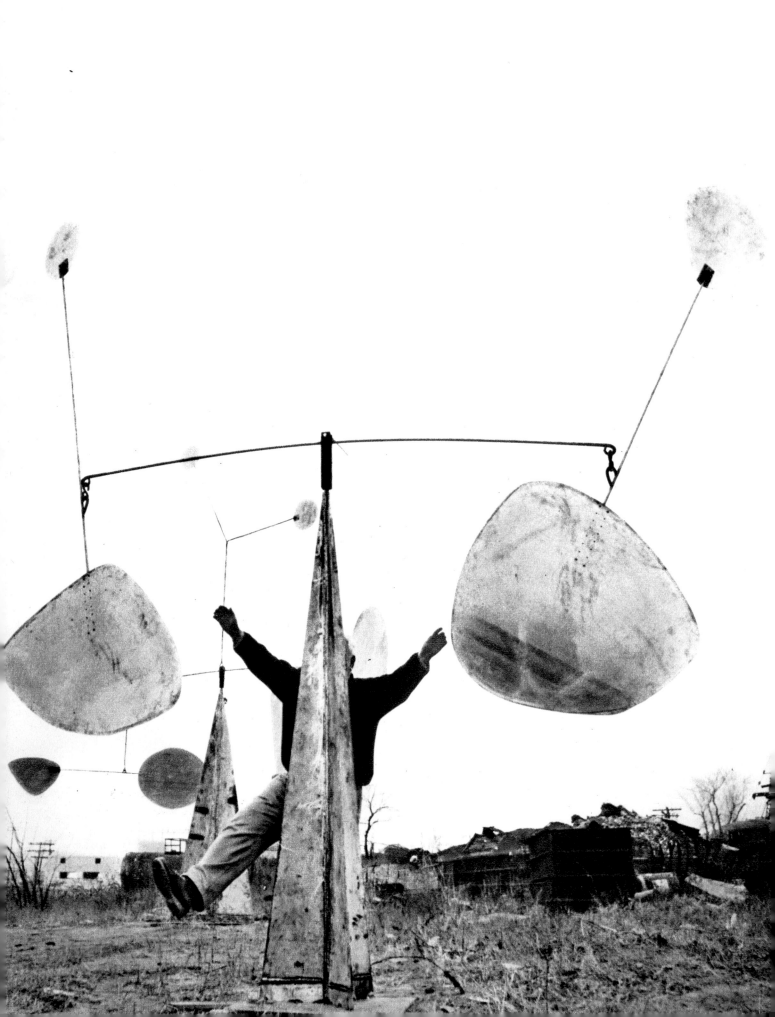

# CALDER

PHOTOGRAPHS AND DESIGN BY UGO MULAS

INTRODUCTION BY H. HARVARD ARNASON

WITH COMMENTS BY ALEXANDER CALDER

A STUDIO BOOK
THE VIKING PRESS · NEW YORK

# CONTENTS

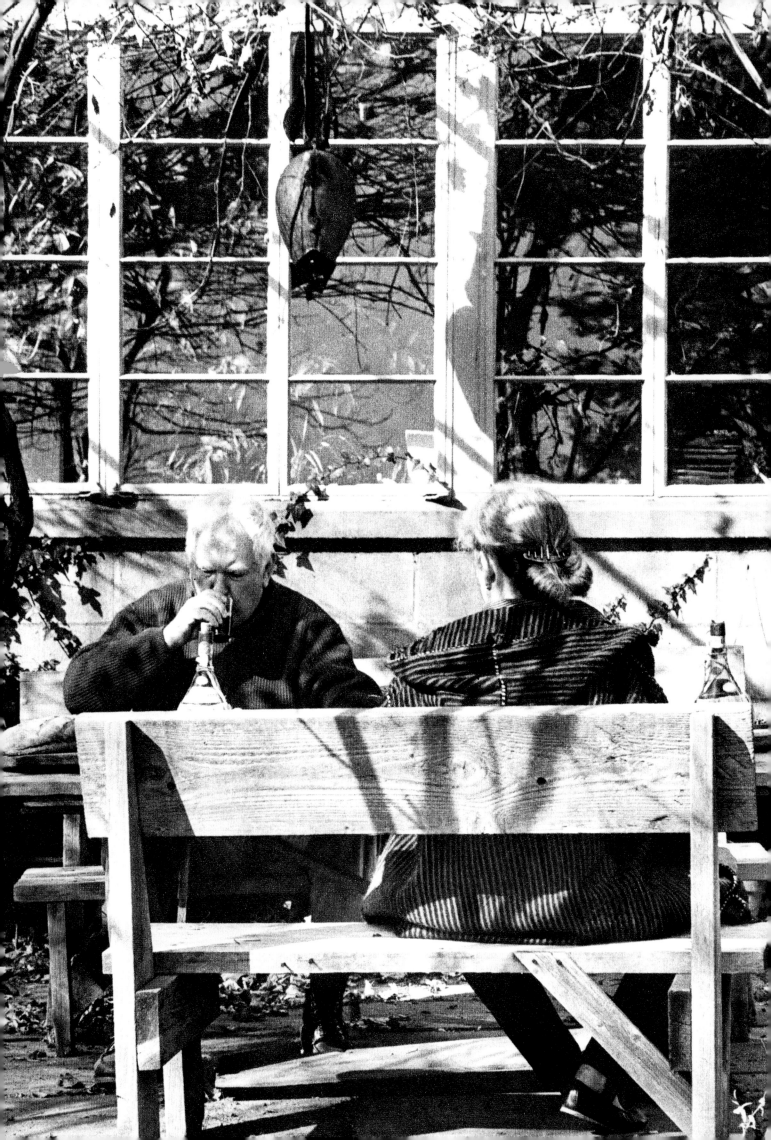

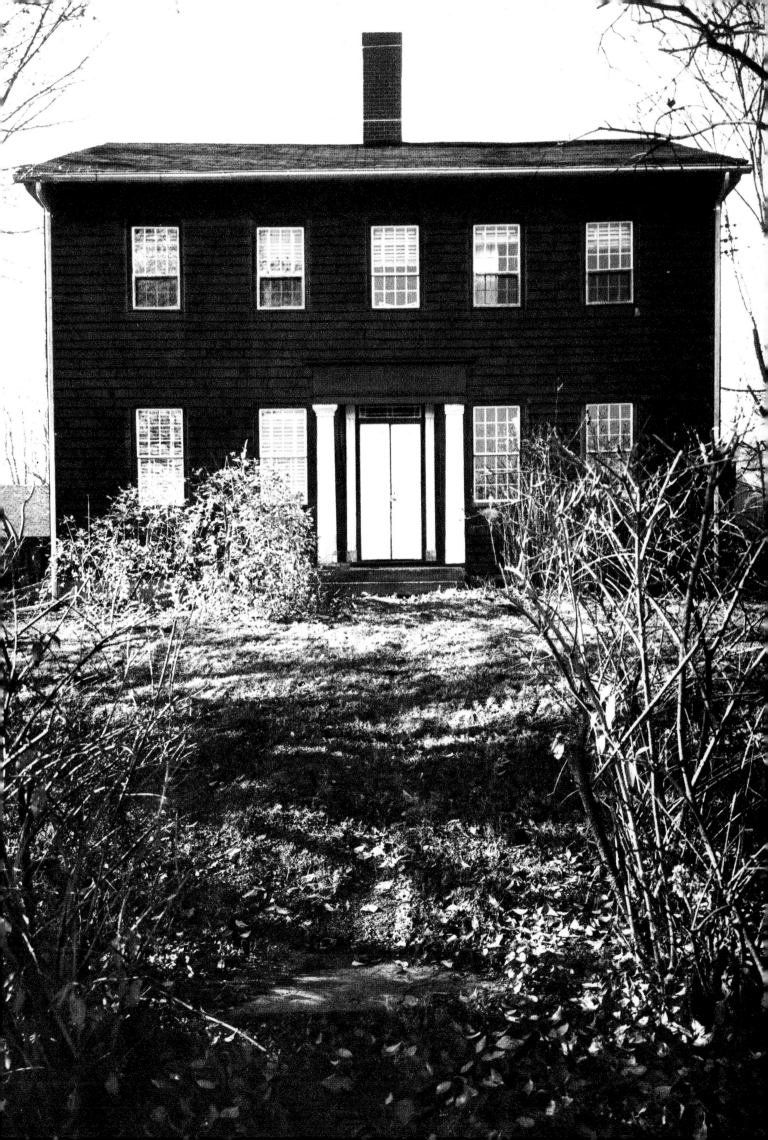

# FOREWORD AND ACKNOWLEDGMENTS

This book is a photographic interpretation of Alexander Calder and his sculpture, accompanied by a text that includes a chronology of the artist's career, interpolated with quotations from Calder himself, and from artists and critics who have known the man and his work since he first appeared on the scene in the 1920s. In preparing the text I have leaned heavily on Calder's informal autobiography; on James Johnson Sweeney's pioneer catalogue for the Museum of Modern Art, New York; on the catalogue of the Guggenheim Museum exhibition; on that of the Musée National de l'Art Moderne, Paris; and on the book by Arnason and Guerrero (see bibliography). For the bibliographical and research material I am deeply indebted to the research facilities of the Museum of Modern Art and the Guggenheim Museum, New York; and above all to the efforts of my assistant, Anna Golfinopoulos.

H.H.A.

April 1970

## QUOTATIONS IN THE TEXT

Atlantic-Little, Brown and Co.: 'Alexander Calder' from *Garland for the Winter Solstice* by Ruthven Todd. Reprinted by permission of Atlantic-Little, Brown and Co.

The Bodley Head, London and Arno Press, New York: From *The Painter's Object* by Myfanwy (Evans) Piper.

Harper & Row, Publishers, Inc.: 'Alexander Calder' from *The Artist's Voice* by Katharine Kuh. Copyright © 1960, 1961, 1962, by Katharine Kuh. Reprinted by permission of Harper & Row, Publishers, Inc.

*Mouvement*: From 'Mobile Sculpture' by Recht, June 1933. Reprinted by permission of R. Gerder.

*The New York Times*: 'Calder Oversees Creation of "Man"' by Jay Walz. Copyright © 1967 by The New York Times Company. Reprinted by permission.

*Newsweek*: 'Calder On-Stage' March 25, 1968. Copyright Newsweek, Inc. 1968.

Oxford University Press: From *Mechanization Takes Command* by Siegfried Giedion. Copyright 1948 by Oxford University Press, Inc. Reprinted by permission.

Random House, Inc., and Penguin Books Ltd.: From *Calder: An Autobiography With Pictures*, by Alexander Calder and Jean Davidson. Copyright © 1966 by Alexander Calder and Jean Davidson. Reprinted by permission of Pantheon Books, a Division of Random House, Inc.

*XXᵉ Siècle*: From 'Calder: *Personne ne pense à moi quant on a un cheval à faire*' by Yvon Taillandier. Published in French in *La Revue XXème Siècle*, March 1959.

The comments by Alexander Calder that appear in the captions (as below) and in the List of Plates (pp. 201–206) were made in conversation with H. H. Arnason.

◀ *Alexander and Louisa Calder at Roxbury. AC.: 'We manage to get back to Roxbury for a brief period each year.'*

# ALEXANDER CALDER

Alexander Calder was born in 1898 in Lawton, Pennsylvania, now a part of the city of Philadelphia. He was the son and grandson of sculptors, and his mother was an accomplished painter; he grew up in the atmosphere of American academic art of the early twentieth century. Despite this environment he seems to have had little inclination to become an artist himself until 1922, when he began taking drawing lessons at a night school in New York. Aside from an unusual amount of traveling and moving around, necessitated in part by his father's health, Calder's youth and interests were typical of middle-class American boys growing up in the early years of the century. His reminiscences of his early activities—which are remarkable for their completeness—have to do largely with family affairs, sports, and relations with his classmates. Perhaps the only indication of his subsequent career lay in a facility for making things and an enjoyment of various kinds of gadgetry.

When the time came to choose a college and, presumably, a career, his family was living in San Francisco. Calder's selection was impressively casual:

> My sister joined a sorority (at the University of California) and became very fond of a noisy athlete named Hayes, whom she eventually married and who belonged to a fraternity. Between the fraternity and the sorority, they all seemed to have a very gay time. This led me to the belief that I must too go to college. But my father said:
> 'What do you want to study?'
> And here I was a bit nonplussed. But a fellow at Lowell High School, Hyde Lewis, told me he was going to be a mechanical engineer. I was not sure what this term meant, but I thought I'd better adopt it.*

*Direct quotations, through kind permission of the artist and his publisher, are taken from Calder's autobiography, except where noted otherwise. It should be emphasized that quotations from Calder can be extremely deceptive. Although he has almost total recall of his entire life and career—including the present location of even minor works—he has an aversion to discussing art in any form, whether in general, in terms of other artists or of his own ideas about his works. Thus he tends to turn off direct questions about specific works or his relations with other artists with an anecdote, a joke, or a purely technical explanation. There are exceptions to this attitude. Early in his career he did make a number of statements on sculpture and the art of the mobile. He has long acknowledged a debt to Mondrian and an even greater one to Joan Miró. In his early years in Paris in the 1920s he was very much involved in the art scene—although from his accounts of it we learn little except about the friendships he formed and the parties he gave or attended. But as he has matured and become a world figure, he has increasingly dissociated himself from the 'world of art' in order to concentrate on his own production.

*A.C.: 'A picture of me thin*

AUTO BIOGRAPHY
TRY TO FIND.
MAY BE IN.
BOSTON
LIBRARY

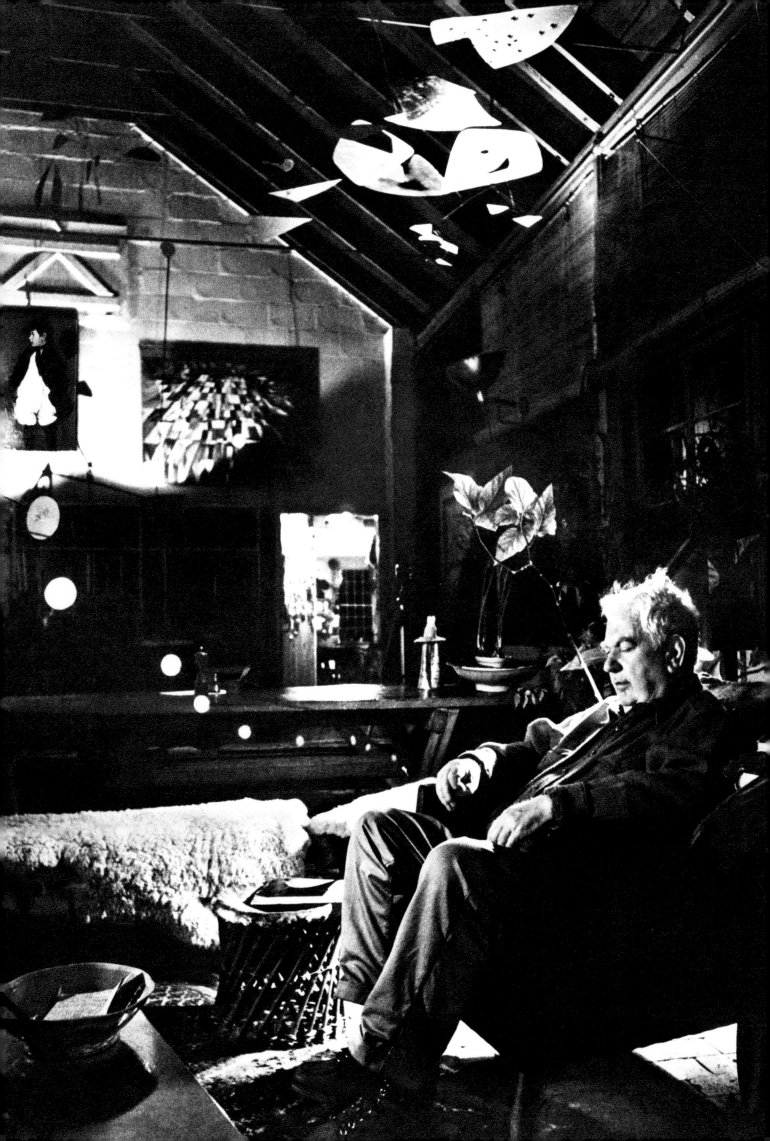

The Calder family moved back to New York from California in 1915; Calder's sister, Peggy, transferred to Barnard College as a Junior, and Calder himself enrolled at the Stevens Institute of Technology in Hoboken, New Jersey. After four years at Stevens, briefly interrupted by student military training during the First World War, Calder graduated and set about finding work. In later years, his only comment on his academic career is that he 'had some facility in mathematics — won a hundred once or twice in exams.' The rest has to do with accounts of his friends and his athletic and fraternity activities.

It may have been the utter boredom of the various jobs he took after graduation which in 1922 inspired him briefly to take an evening class in drawing from a friend of his father's. The restlessness and lack of direction which had already driven him from job to job continued, and later that year he signed on as a fireman with a ship bound for the Pacific. Leaving the ship in San Francisco, Calder continued by various means to Aberdeen, Washington, where he was met by his sister and her husband. For a time he worked as a timekeeper in a logging camp, where, for some reason, the urge to draw and paint emerged again. After a disagreement with the logging boss, 'Cranky Jack Moore', Calder moved on to another logging camp where he took a drafting job, 'more satisfactory to me than all those I had held so far, because I was at least using some of my engineering knowledge.' After various other odd jobs, he tired of drifting, and on the advice of a Canadian engineer, a friend of his father's, he finally decided to do what he actually wanted to do — become a painter.

Returning to New York, he entered the Art Students League in the autumn of 1923, where he worked first with Kenneth Hayes Miller and then with George Luks and John Sloan. At this point Calder was influenced by the painters of the New York scene, the so-called Ash-Can School, of which Sloan and Luks were among the leaders. He says:

My chief delight was probably hanging up the canvas with a few nails and string. Thus I could attach it to a fence, a post, or anything. I guess the center of my composition was usually a derrick or some such device, and I tried to carve out its most potent features from the surrounding atmosphere. Later we used to go out painting in the evening, and I thought I was getting pretty good at painting artificial lights.

His aspirations, true of many American artists of the time, did not extend far beyond securing a well-paying job in illustration or commercial art. He describes his first successful venture in these fields:

They used to sell wrapping paper at the League and we found out that it was pretty good for drawing. You folded a sheet into eight rectangles and it would fit in your pocket. With this we used to pass our time drawing people in the subway on our way to and fro.

I seemed to have a knack for doing it with a single line. And once, in one of my job-hunting moments, I tried the *Police Gazette*. The editor . . . was interested in this single-line drawing and gave me a modest job, doing half-pages of boxers training, which developed into covering other sports as well.

◀ *Portrait of Calder by his mother; below it, a standing mobile called 'Valentine'. Roxbury.*

At the Art Students League, he also began working with Guy Pène du Bois, whose manikin-like figures particularly appealed to him. But perhaps the major single influence was Boardman Robinson, an accomplished draftsman and experienced journalistic illustrator, whose teaching helped Calder to get his first illustrating job on the *National Police Gazette*. At intervals during this period he continued to live with his parents. About 1925, in need of a clock, he made from wire a 'rooster on a vertical rod with radiating lines at the foot indicating the hours. I'd made things out of wire before—jewelry, toys—but this was my first effort to represent an animal in wire...'

The *Police Gazette* assignments led to the exploration of athletic events and, most significant for Calder's future career, the discovery of the circus:

I went to the circus, Ringling Brothers and Barnum and Bailey. I spent two full weeks there practically every day and night. I could tell by the music what act was coming on and used to rush to some vantage point. Some acts were better seen from above and others from below. At the end of these two weeks I took a half-page layout to the *Police Gazette* and Robinson [a *Police Gazette* editor] said, 'We can't do anything with these people, the bastards never send us any tickets.'

After several other routine commercial illustrating jobs, Calder finally decided, in 1926 at the age of twenty-eight, that he would go to Paris, the world center for modern art. Sailing as a deck hand on a British freighter, he arrived in Paris in June. At first somewhat lost and ill at ease, Calder gradually met some old American acquaintances and made new friends, including the painter and printmaker, Stanley William Hayter. Eventually he acquired his own studio at 22 Rue Daguerre and started working in earnest. It was here that he began concentrating on toy-like animals made of wood and wire. These he showed to an American painter, Clay Spohn:

When he visited my studio and saw the objects I made out of wood and wire—I had a cow, a four-horse chariot which was quite wonderful but some damn fool lost it—he said, 'Why don't you make them completely out of wire?'

I accepted the suggestion, out of which was born the first Josephine Baker and a boxing Negro in a top hat.

In the meantime through Hayter I got to know José de Creeft, a Spanish sculptor living in the Rue Broca, near the Santé, eight or ten blocks from the Rue Daguerre. He induced me to make some things for the Salon des Humoristes.

In his efforts to supplement a meagre income of seventy-five dollars a month, Calder made articulated toys for toy companies and undertook advertising and illustrating jobs for agencies and journals. In the meantime his famous circus was gradually developing out of the wire animals and acrobats with which he was constantly experimenting. It was already operative by the end of 1926 and beginning to attract spectators.

Calder relates that through a friend from California, Lloyd Sloane, he

met a fellow who ran a weekly called *Le Boulevardier*, somewhat similar to *The New Yorker*. He gave me some things to do and their artistic adviser, Marc Réal, became quite a friend because when I said I had a small circus, his face brightened up and he said, 'let's see it'.

*A.C.: 'Photographs of family and friends.... They are tacked up on the walls in the* ▶ *downstairs toilet and elsewhere. There are a couple of pictures of my father. I must admit that he couldn't get my early wire sculptures and mobiles .... However, some of the pieces amused him and he was never actually hostile.'*

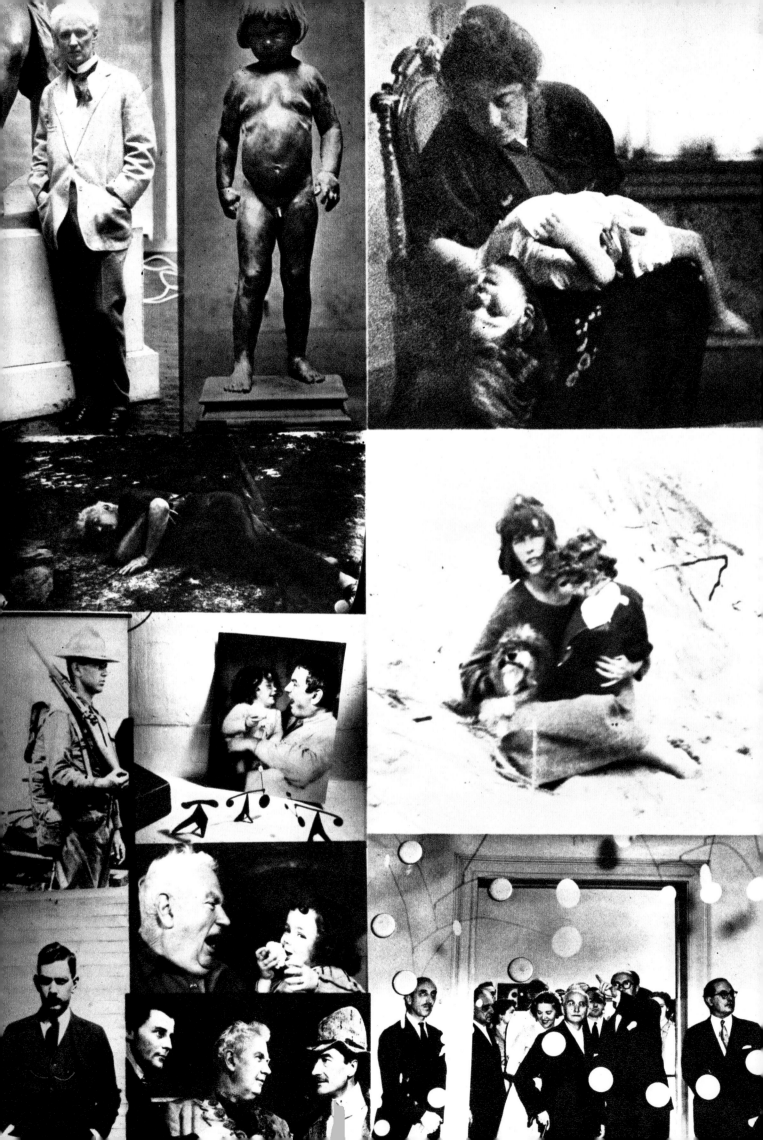

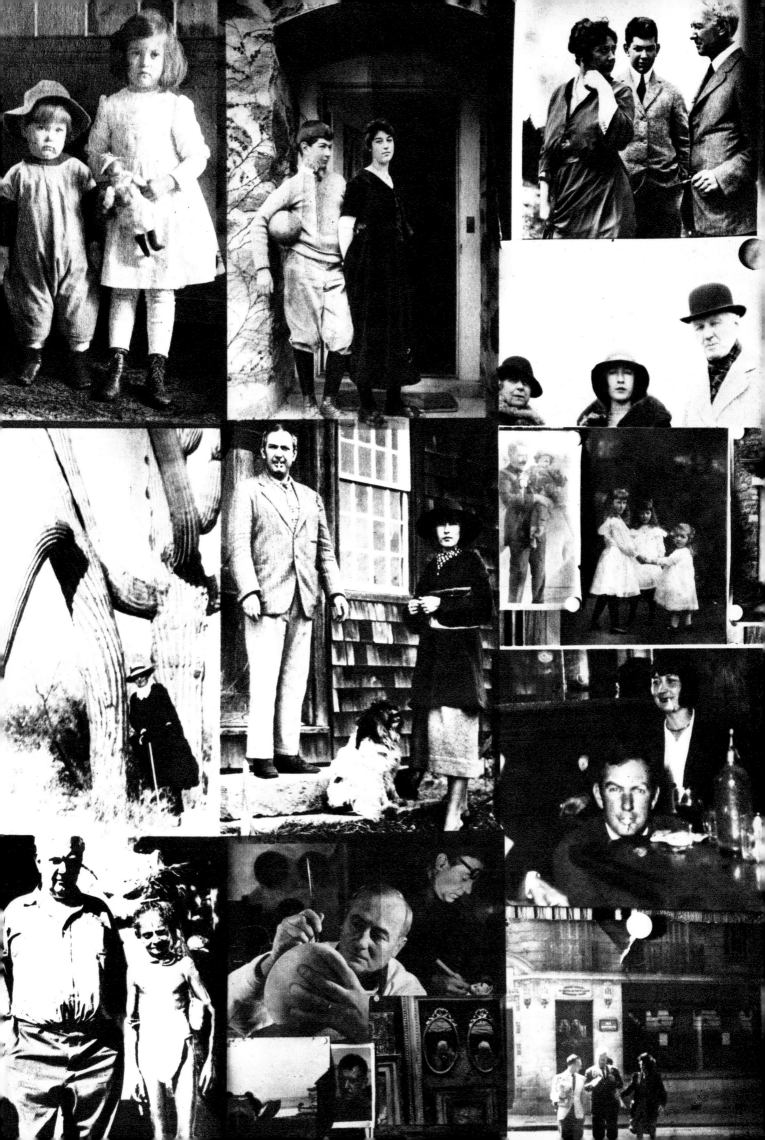

So, he used to come with a gang and we'd play 'Ramona' (*Belle brune de Barcelonne, tes baisers me donnent des frissons d'amour*) over and over again on the gramophone. He brought several friends, among them Guy Selz and Legrand-Chabrier, who was a circus critic and who insisted I have a net under my trapeze act. I promptly devised one.

One time Réal brought Paul Fratellini [the great circus clown] and he took a fancy to the dog in my circus show. It was made of rubber tubing and he got me to enlarge it for his brother Albert, who always dragged a dog around with him. Before that he had had a stuffed dog. Mine trotted and its tail wagged around . . . .

In 1927, Calder returned to the United States, taking his circus with him. Here he received some commissions to make articulated animal toys, and

In New York in February of 1928, I showed wire animals and people to Carl Zigrosser of the Weyhe Gallery and Bookshop and he decided forthwith to give me a show. My first show. There were about fifteen objects and we priced these things at ten and twenty dollars. Two or three were sold. Among those sold was the first Josephine Baker which I had made in Paris. I think it is about then that some lady critic said:
'Convoluting spirals and concentric entrails; the kid is clever, but what does papa think?'

Despite the vast differences between their sculptures, the elder Calder seems always to have been tolerant, even sympathetic to his son's experiments, and their relationship remained close and affectionate. Calder rented a 'gold-leafed triangular room' as a studio:

I gave a few modest presentations of the circus that winter. And after the wire show at the Weyhe Gallery, I resumed carving wood in the triangular room . . . .

In the triangular gold-leafed room, I also remember making a seven-foot-tall lady, holding a green flower, whom I called 'Spring' — it was in the spring of 1928. I also made, during the same period, an eleven-foot she-wolf, complete with Romulus and Remus. To embellish either sex, I used doorstops I had bought at the five-and-ten — wood and rubber. These two wire sculptures I exhibited in the New York Salon des Independants, at the old Waldorf Hotel on Thirty-fourth Street.

'Spring' was held upright by a box pedestal with a counter-weight in it. But the she-wolf necessitated two tables arranged end to end. I went home and got a piece of blue denim to put under Romulus and Remus and the she-wolf, in order to unify the tables . . . .

After the show, I doubled these objects into a bale and, in the fall of 1928, took them to Paris, where I showed them in the French Salon des Indépendants the following spring. A friend who'd been to see the show on a Sunday told me they were pulling 'Spring' to the side and letting her sway back and forth. . . .

When the show was over, I rolled them up again, all four of them, in the same bale and left them in the warehouse of my friend Maurice Lefebvre-Foinet. Thus 'Spring' and 'Romulus and Remus' stayed there from 1929 to 1965 — for thirty-five years!

When we undid them the next time, they had all the freshness of youth — of my youth. They were sent in private cases to New York to be exhibited at the Guggenheim for my November 1964 show, and have been acquired by the Guggenheim since.

During 1928 Calder made many wooden and wire sculptures besides 'Romulus and Remus' and 'Spring' and had some financial success with commercial applications of the wire pieces. By this time, however, he was thirty years old, and although gaining a modest recognition and obviously having a good time, he cannot be said to have had any startling success either artistically or commercially.

When he returned to Paris in the middle of April, a short film of his studio on the Rue Cels was made by the Keystone Movie Company. 'I got Kiki de Montparnasse to come and pose for me. She had a wonderful nose that seemed to jut out into space, and she eventually found a place at the Guggenheim Museum, 35 years later, along side of *Spring* and *Romulus and Remus*.'

In June 1929, Calder returned to New York on the *De Grasse*, and it was on this trip that he met Louisa James (a grandniece of William and Henry James), who later became his wife. In New York, Calder continued to expand his circus (which now required not two but five suitcases for transport) and to make animal figures as well as portraits from wire. In December he had an exhibition at the Fifth-Sixth Street Gallery, and staged several performances of the circus. At this point he seems to have been primarily concerned with making a living as best he could (he even designed some textiles) and having a good time. He was still earning a modest income from the Oshkosh Toy Company, and had enough money to return to Paris in March 1930 on a freighter. He rented a studio and began looking up his old friends — Pascin, Foujita, Man Ray, Kiki, Desnos, and many others.

Through Edgar Varèse, the composer, he met the architect Frederick Kiesler. Kiesler, who was fascinated with the circus, introduced Calder to Fernand Léger (who became a close friend), Le Corbusier, Mondrian, Theo Doesburg, and the critic Carl Einstein. It was through a friend from St. Louis, an artist who was also named Einstein, that Calder came to visit Mondrian's studio at 26 Rue de Départ:

It was a very exciting room. Light came in from the left and from the right, and on the solid wall between the windows there were experimental stunts with colored rectangles of cardboard tacked on. Even the victrola, which had been some muddy color, was painted red.

I suggested to Mondrian that perhaps it would be fun to make these rectangles oscillate. And he, with a very serious countenance, said:

'No, it is not necessary, my painting is already very fast.'

This visit gave me a shock. A bigger shock, even, than eight years earlier, when off Guatemala I saw the beginning of a fiery red sunrise on one side and the moon looking like a silver coin on the other.

This one visit gave me a shock that started things.

Though I had heard the word 'modern' before, I did not consciously know or feel the term 'abstract'. So now, at thirty-two, I wanted to paint and work in the abstract. And for two weeks or so, I painted very modest abstractions. At the end of this, I reverted to plastic work which was still abstract.

This was perhaps the crucial moment in Calder's life when he decided to stop being an illustrator and entertainer and to try to become an artist.

The St. Louis Einstein had just somehow joined the group of artists called "Abstraction-Création", which included Arp, Mondrian, Robert Delaunay, Pevsner, and Jean Hélion, among about thirty in all. The invitation to join was extended to me after an investigation by several members. They came to the studio at Villa Brune and saw what I was doing. So, I became a member too.

*The kitchen at Roxbury.* ▶

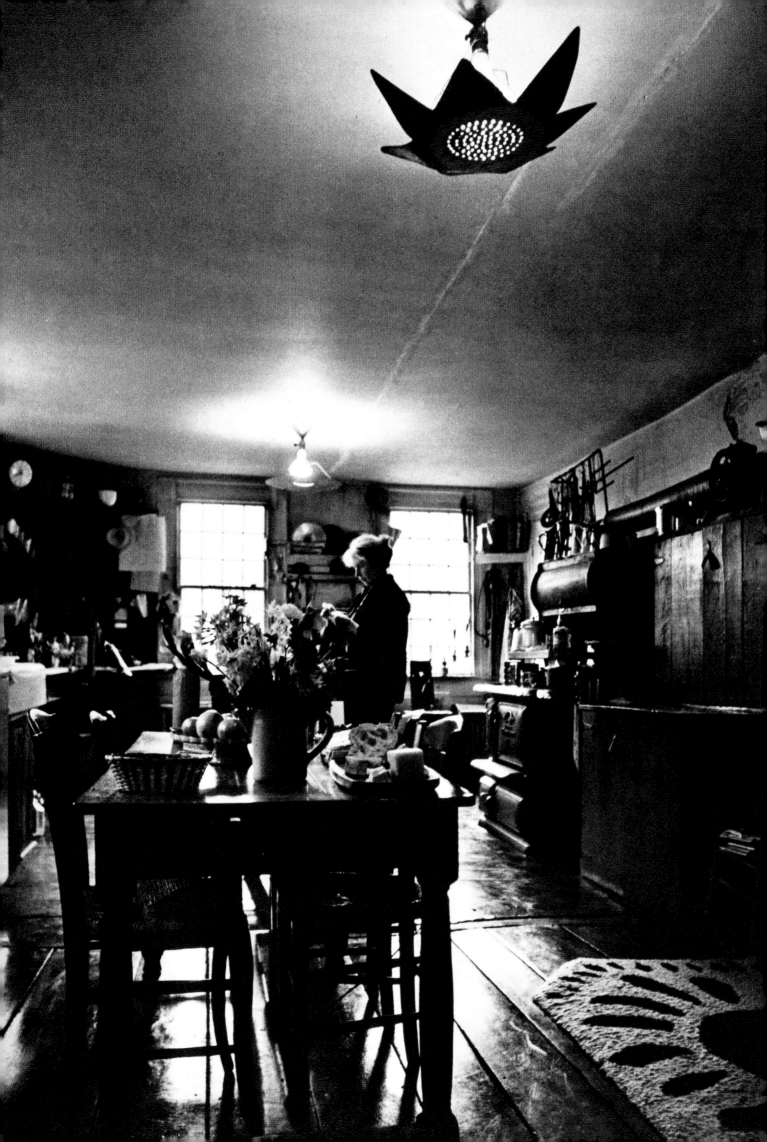

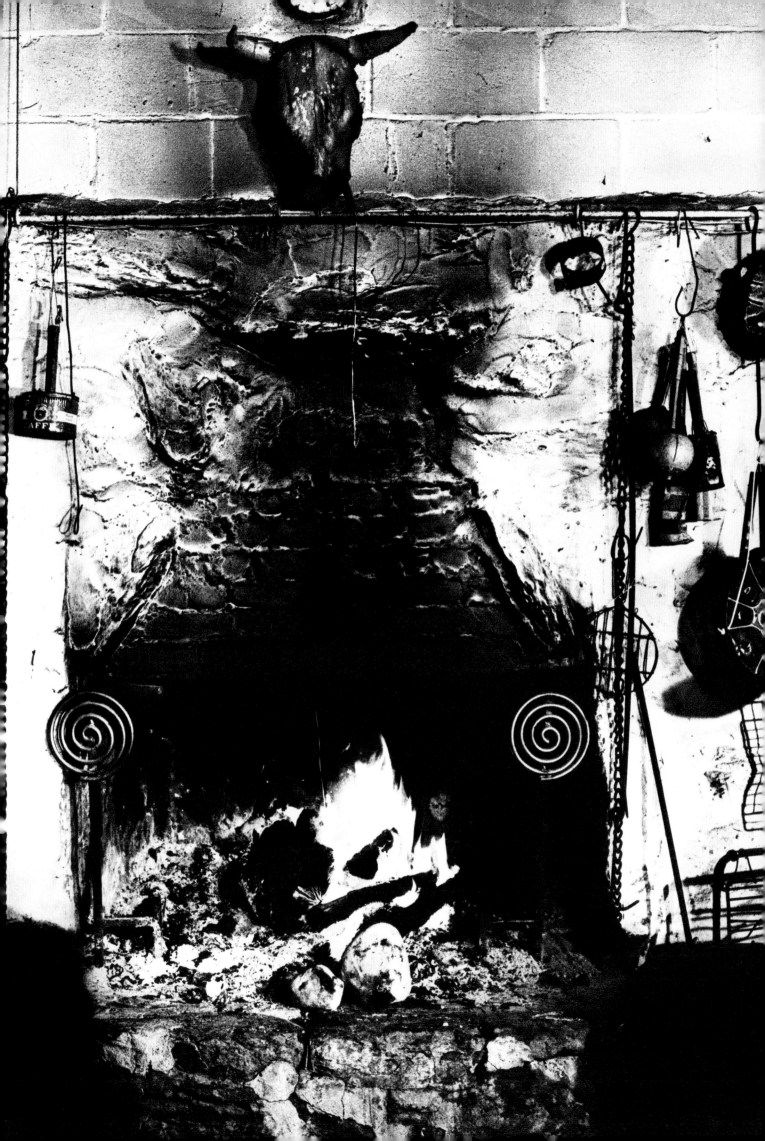

During the "Abstraction-Création" days, I also came forth with this statement:
'Disparity in form, color, size, weight, motion, is what makes a composition.... It is the apparent accident to regularity which the artist actually controls by which he makes or mars a work.'

In the middle of December 1930, Calder returned to the United States where he continued to hold performances of his circus. In January 1931, he and Louisa James were married. It was his effort to fashion a wedding ring for Louisa that really started Calder's long involvement in making highly individual jewelry. Returning to Paris shortly after his wedding, he began to work seriously in an abstract vein.

Due to the efforts of some friends in Abstraction-Création, I arranged for a show in the Galerie Percier and Léger wrote the preface. I still had some planks from Villa Brune; we put these on champagne boxes and painted everything white. The objects all ranged around the gallery, one or two were located in the middle, and on the walls overhead were wire portraits. In the window, we had two drawings of the circus.
I remember Mr. Level, the owner of the gallery, objecting to the size of the breasts of one trapezist and Mendes-France, the painter, who had introduced me to him, saying,
'Mais dans l'autre vous voyez le trou du cul du cheval....' (But in the other, you notice the asshole of the horse.)
These were things I had been making the previous fall and currently. I continued sawing off some circus bleachers, making square bases for my abstract objects.
There were two slightly articulated objects that swayed in the breeze. One was a more or less horizontal rod with a square sheet of tin on one end and an ebony counterweight on the other. The second object was an almost vertical rod, slightly inclined, about a yard long with at the top a little wire loop with a counterweight at its far end, and another little piece, with another counterweight — there were three elements. I rather liked it.

As the preface to the catalogue of this exhibition, called 'Volumes, Vecteurs, Densités, Dessins, Portraits', Léger wrote:

Why not? 'It's serious without seeming to be!'
A *neo-plasticien* at the beginning, he believed in the perfection [l'absolu] of 2 colored rectangles....
His need for fantasy broke the tie [with neo-plasticism]; he began to 'play' with materials: wood, plaster, wire, above all wire ... a colorful and witty period [in his work]....
... Reaction; the wire becomes taut, rigid, geometrical — pure form — this is his current style — an anti-Romantic tendency dominated by a need for equilibrium.

Confronting these transparent, objective, precise new works, I think of Satie, Mondrian, Marcel Duchamp, Brancusi, Arp, those uncontested masters of inexpressible, quiet beauty. Calder is of that line.
He is 100% American.
Satie and Duchamp are 100% French.
And so we have a resemblance?

F. Léger, 'Eric Satie illustrated by CALDER', *Galerie Percier*, 1931.

At this time, Calder also exhibited with Abstraction-Création in the Porte de Versailles and gave a performance of his circus. For a catalogue of the Abstraction-

◀ *The fireplace at Roxbury. A.C.: 'The andirons are somewhat related to the jewelry that I used to make in the 1930s and still do occasionally.'*

Création group he made the following statement:

How does art come into being?
Out of volumes, motion, spaces carved out within the surrounding space, the universe.
Out of different masses, tight, heavy, middling — achieved by variations of size or color.
Out of directional line — vectors representing motion, velocity, acceleration, energy, etc. — lines which form significant angles and directions, making up one, or several, totalities.
Spaces and volumes, created by the slightest opposition to their mass, or penetrated by vectors, traversed by momentum.
None of this is fixed. Each element can move, shift, or sway back and forth in a changing relation to each of the other elements in this universe.
Thus they reveal not only isolated moments, but a physical law of variation among the events of life.
Not extractions, but abstractions:
Abstractions which resemble no living thing, except by their manner of reacting.

Alexander Calder, Abstraction-Création, Art Non-Figuratif, 1932

Although he took many trips with Louisa and seemed to be enjoying life more than ever, he continued to work seriously on his wire sculptures. With the exception of those at the Galerie Percier, which oscillated slightly, he had not yet experimented with actual motion. However, in the winter of 1931–32,

I had met Mary Reynolds when I went to pick up some photographs, rue de Montessuy, and again in Villefranche when I came off Fordham's boat. We had gotten to be very good friends — as a matter of fact, she got one of the best stars off Marc-Antoine's Christmas tree. One evening, she brought Marcel Duchamp to the rue de la Colonie, to see us and my work.
There was one motor-driven thing, with three elements. The thing had just been painted and was not quite dry yet. Marcel said:
'Do you mind?'
When he put his hands on it, the object seemed to please him, so he arranged for me to show in Marie Cuttoli's Galerie Vignon, close to the Madeleine.
I asked him what sort of a name I could give these things and he at once produced "Mobile." In addition to something that moves, in French it also means motive.
Duchamp also suggested that on my invitation card I make a drawing of the motor-driven object and print:

CALDER
SES MOBILES

The show opened around April and there were fifteen objects with motors and some fifteen others, all of which had moving elements. As I used to run a string as a belt around numerous corners — nostalgia for the whistle-punk days — these strings had to be tightened up every so often. And as I made most of the reduction gears myself, there was a good deal of greasing necessary. I spent most of the day of the opening leaning over my gearing, greasing and adjusting my babies. Louisa went home and got a clean shirt for me, but I had quite a beard by the end of the afternoon....
I guess all the members of Abstraction-Création came to see my show. Moreover, their publication came out about this time. They kept it going for several years — one issue a year. At the end, they were hard up for funds and it was suggested they invite some successful artists to have their pictures printed alongside our own — they'd pay a bit more than we to carry the publication along. Somebody suggested inviting Picasso, and Delaunay became furious.
They did invite Brancusi. He sent a photograph, but no funds.

*The house at Saché. A.C. 'When I saw this place all the windows and doors were closed ▶ up with rocks, but I thought it was wonderful. And we've been moving in ever since.'*

25

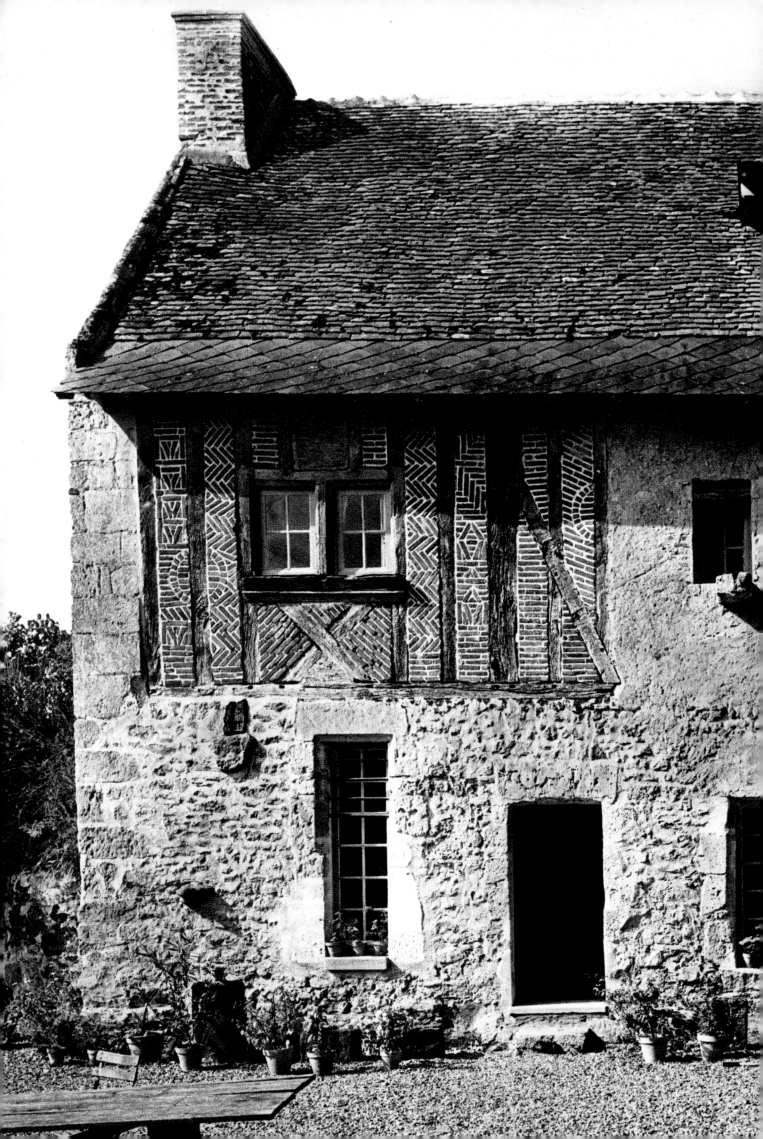

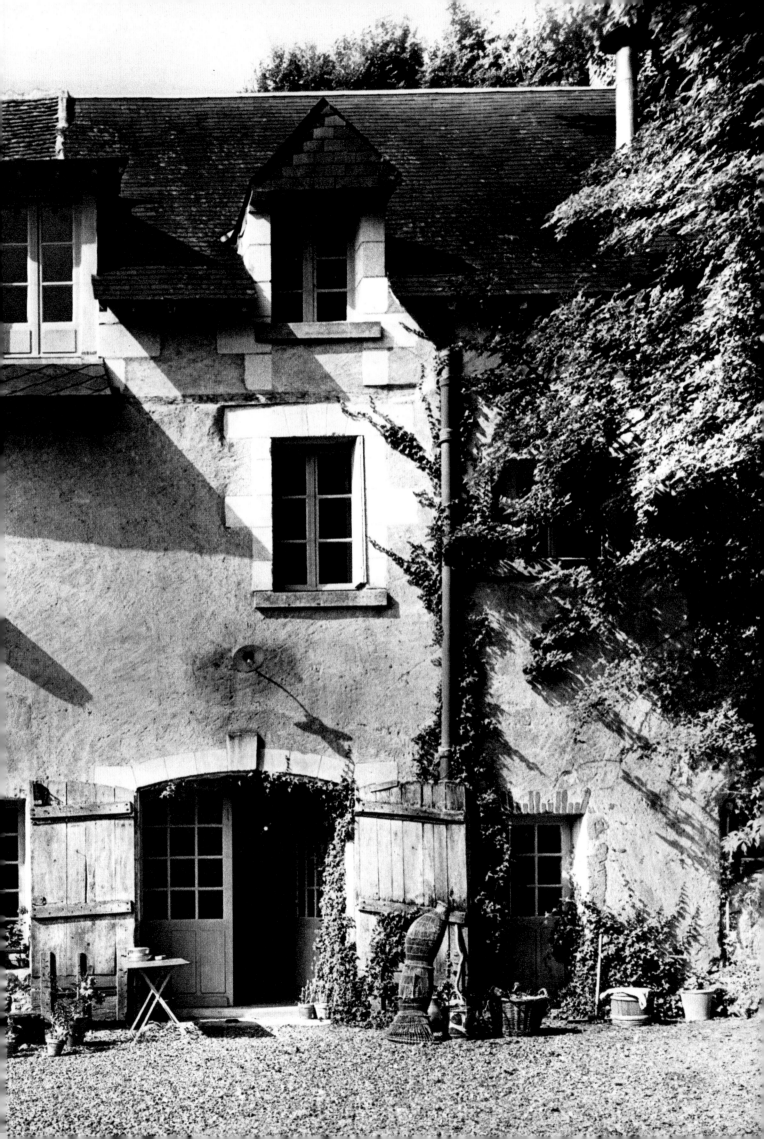

It was about this time that Jean Arp said to me, 'Well, what were those things you did last year (for Percier's) — stabiles?'

Whereupon, I seized the term and applied it first of all to the things previously shown at Percier's and later to the large steel objects I am involved in now — such as "The Guillotine for Eight", shown at the Guggenheim in 1964.

The journalists did not seem to understand anything I was driving at. There were notes about "l'art automobile", and a photograph of one object, likening it to a gear shift. They just did not, or would not, understand.

My fellow members seemed to understand. However, some of the lesser lights asked me, 'What formula do you use?'

All this while, Louisa and I were enjoying the house at the rue de la Colonie very much. We saw Campigli, whom we had met at Villa Brune. Campigli was a very good cook. When buying a chicken, he would sniff it — you know where.

Sometimes, we almost had a full reunion of Abstraction-Création at the house. Mondrian used to listen to records and say very seriously, with a shake of the head:

'Ça, c'est bon.

'Ça, c'est pas bon'.

One day, I had gone to see him and he surprised me greatly by saying, 'At Le Boeuf sur le Toit, they painted the walls blue — like Miró'.

I was amazed to hear that he frequented such cabarets or acknowledged Miró.

About May 1932, Calder and Louisa returned by freighter to New York. An exhibition was arranged at the Julien Levy Gallery, including several of the motor-driven mobiles. Back in Europe some five months later, the Calders stopped to visit Miró in Montroig, staging a performance of the circus for the Mirós and their friends.

In Paris the following spring,

Jean Hélion, who was quite a friend of Pierre Loeb of the Galerie Pierre, arranged with him to have a group show of six artists: himself, Arp, Miró, Pevsner, Seligmann, myself.

There was a Bessarabian critic who wrote something on each of us. His name was Anatole Jakovski. The text was not too interesting; he was trying to be poetic, and all I can remember is the following sentence:

'Pas besoin de boussole dans le pays de Seligmann'. (You don't need a compass in Seligmann's land.)

I can't even remember more than one of my objects: a cone, two feet long, of ebony and an ebony sphere six inches in diameter and a sort of a helmet shape made of two pieces of ebony. These were hung at the far end of two bars as eveners, and they rotated and floated up and down.

I went to the gallery once and was alarmed to discover that Pierre and some of his friends were amusing themselves by throwing all the elements of this particular object up in the air at the same time, thus succeeding in bending the bars and spoiling its motion.

For some reason, I did not repeat the show of the previous year at Marie Cuttoli's, but had one at Pierre Colle's, on the rue Cambaceres. I ran into Dali during one of the visits to the gallery before my show. As he lived not far away from the rue de la Colonie, I decided to call on him. He was busy sorting dirty postcards, but took time out to give me a little green book, Babauo, which was a scenario for a movie. He had written it and had it printed.

A few days later, I returned it with a remark that there were in it 'too many restless inner tubes, pumping up and down'. He immediately took offense, and this coolness has existed between us ever since.

28

The exhibition at the Pierre Colle Gallery resulted in one of the closest analyses of the mobile principle to appear to date:

American influence on modern civilization is remarkable for having given back to the old world its symbols and customs, after having concretized them as fully as modern science permits. The meaning of certain animated landscapes by Léger or de Chirico is clear enough at first glance. Critics have nonetheless been unable to resist these mirages; they have invented portions of these enchanted universes out of whole cloth. The Pierre Colle Gallery has just presented an exhibition of the works of the American sculptor Calder. These structures are articulated so that, at the slightest touch, they open up like flowers . . . .

Some of the structures are disconcerting in their freedom; you see two balls, one large and one small, attached respectively to wires of unequal lengths, which are in turn attached to the extreme ends of an arm—like the arm of a scale—which hangs from the ceiling. Animated by a pendular and a rotary movement, the large ball drives the small ball, which describes the most unexpected scrolls in the air as it strikes the surrounding objects. Using means like gravity and centrifugal force, Calder has produced the most extraordinary visual variations on the theme of fatality.

Some of Calder's compositions are filled with celestial conjunctions, and other coincidences, which can be observed as the eye becomes aware of the recurrent cycles of movement. In one case there are two simple sticks, one white and one black, which are driven by a hidden motor that buzzes like a hive; all of which recalls the approach of the Maenads. The sticks vibrate, rise up, almost meet, then fall away from each other, with the grace, uncertainty and timidity of rudimentary, schematic beings. The observer is mesmerized by them.

Paul Recht, 'Mobile Sculpture', *Mouvement*, June 1933.

Somewhat concerned by the political situation in Europe, the Calders returned to the United States in June–July 1933 with Jean Hélion, and began looking for a house. It was then they acquired their home on Painters Hill Road, Roxbury, Connecticut. Here Calder constructed the first studio he had ever owned and gradually got down to work again.

An exhibition was held in August 1933 at the Berkshire Museum, for which Calder wrote the following:

The sense of motion in painting and sculpture has long been considered one of the primary elements of the composition.

The Futurists prescribed for its rendition.

Marcel Duchamp's "Nude descending the stairs" is the result of the desire for motion. Here he has also eliminated representative form. This avoids the connotation of ideas which would interfere with the success of the main issue—the sense of movement.

Fernand Léger's film, "Ballet Mécanique", is the result of the desire for picture in motion.

Therefore, why not plastic forms in motion? Not a simple translatory or rotary motion, but several motions of different types, speeds and amplitudes composing to make a resultant whole. Just as one can compose colors, or forms, so one can compose motions.

The two motor driven "mobiles" which I am exhibiting are from among the most successful of my earliest attempts at plastic objects in motion. The orbits are all circular arcs or circles. The supports have been painted to disappear against a white background to leave nothing but the moving elements, their forms and colors, and their orbits, speeds and accelerations.

Wherever there is a main issue, the elimination of other things which are not essential will make for a stronger result. In the earlier static abstract sculptures I was most interested in space, vectoral quantities, and centers of differing densities.

*Two views of the kitchen at Saché.* ▶

29

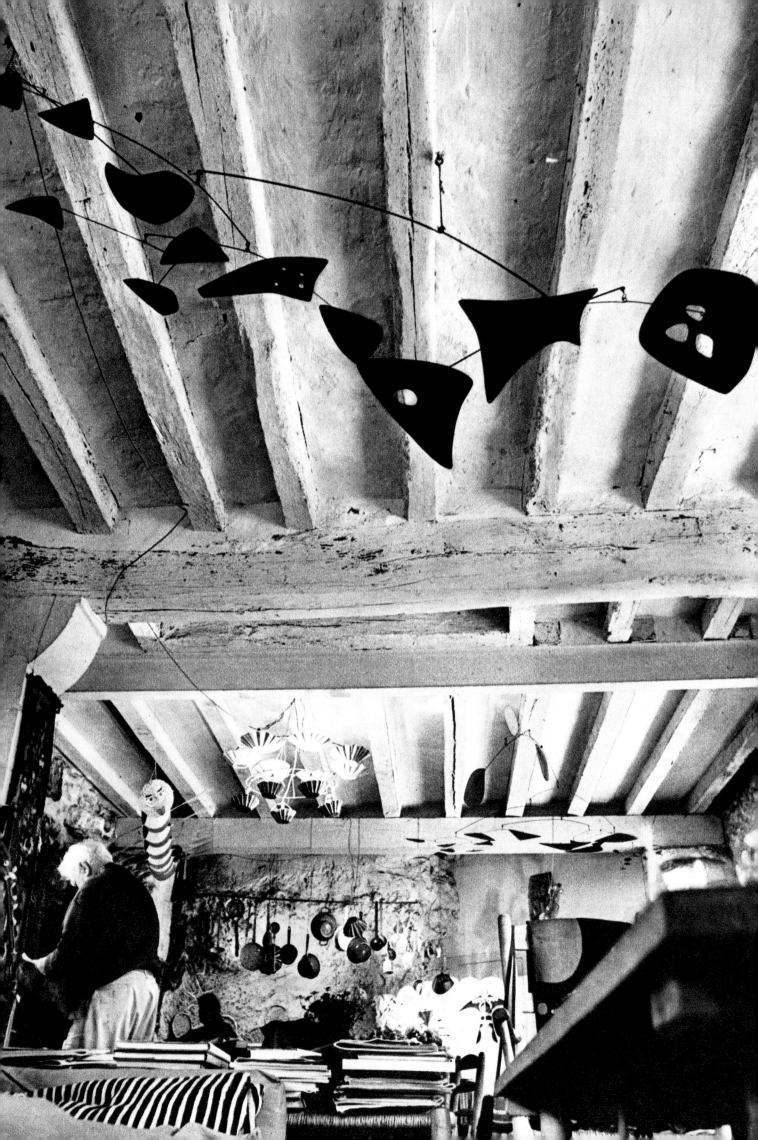

The esthetic value of these objects cannot be arrived at by reasoning. Familiarization is necessary.

Alexander Calder, *Berkshire Museum*, Pittsfield, Mass.,
12 to 25 August 1933.

In terms of contacts with the Museum of Modern Art, New York, and the Pierre Matisse Gallery, 1934 was an important year:

In the spring of 1934, Mayor La Guardia decided to have an exposition of art in some New York public building and I sent two things, one of which was objects suspended in a vertical circle of wire — this was bought by Alfred Barr for the Museum of Modern Art. (He later exchanged it for a motorized "universe.") This, after my selling two small objects to the Pittsfield Museum and another object to a lady in Rochester, was my first break since our return from France and the rue de la Colonie.

In Paris, I had met Pierre Matisse and he had come to the rue de la Colonie once. So I asked him for a show in his New York gallery, and had one in the spring of 1934.

For about eight or nine years thereafter, I had shows with him almost every year. When we had the group show at Pierre Loeb's in Paris, I had met James Johnson Sweeney, of whom Léger had spoken several times. He wrote a preface for my first Matisse show and I gave him an object — but he insisted on giving me a modest payment.

Most of the objects in my first Matisse show I had made during the winter of 1933, in Roxbury, but the object Sweeney chose I had made in Paris. The Calderberry-bush: a two-meter rod with one heavy sphere suspended from the apex of a wire. This gives quite a cantilever effect. Five thin aluminum discs project at right angles from five wires, held in position by a wooden sphere counterweight. The discs are red and the supporting members, including the heavy sphere, are black, while the wooden sphere is white.

The exhibition at Pierre Matisse's New York gallery was held in April 1934. Sweeney's preface to the catalogue is a brief note relating Calder's work to the modern development of sculpture as line, space, and motion rather than as static mass. It was to be the first of many essays Sweeney wrote on Calder's sculpture, essays climaxed by the extended account in the catalogue of the 1943 retrospective exhibition which Sweeney organized for the Museum of Modern Art, New York.

In February–March 1935, Calder had an exhibition at the Arts Club in Chicago which was also shown at the Renaissance Society of the University of Chicago. Once again James Johnson Sweeney wrote the catalogue introduction. He emphasized still further the sheer gaiety and delight of the mobiles, their sense of vitality, and the introduction of time as an element of sculpture. He suggested an analogy with Renaissance and Baroque fountain sculpture, in which the play of water in motion is the principal sculptural medium. A somewhat more extended statement in *Axis*, July 1935, developed Sweeney's original reactions, emphasizing the 'lyric quality', the 'respect for sensibility' that emerges from — and despite — Calder's training as an engineer.

During 1935, Calder designed his first outdoor mobile, for the garden in Rochester, New York, of Mrs. Charlotte Allen, whom he had met through

Fletcher Steel, the landscape architect. He also undertook his first theatrical work, mobiles for the set of Martha Graham's *Panorama* for the First Workshop production at the Bennington School of the Dance in Vermont. His shows at the Pierre Matisse Gallery continued and his work began gradually to be acquired by institutions such as the Smith College and Vassar College Museums, as well as by individuals. In 1936 he did the mobile settings for a production of Erik Satie's *Socrate* at the First Hartford Festival, Connecticut.

Returning to Paris in May 1937 with their daughter Sandra, then 2, the Calders soon became involved in the Paris World's Fair and particularly with the Spanish Pavilion. They were living temporarily in a large, almost empty house, designed by Paul Nelson:

Here we entertained all sorts of people: Alvar Aalto, the Finnish architect, and his wife Aino; Alberto, the Spanish sculptor, who had done a large thing at the Spanish pavilion of the Paris World's Fair of 1937 and who sang to us beautifully in Spanish; and many other people.

It had been four years since we had left Paris, and we saw many old friends and I gave my circus. Possibly due to the Paris 1937 World's Fair, one day I went with my friend Miró to see the proposed Spanish pavilion where he was to do a large painting. I met José Luis Sert, the architect of the pavilion.

When I saw what was going on in general in this pavilion, which included "Guernica" by Picasso, I promptly volunteered my services to do something or other for it.

Sert was against this, for obviously I was no Spaniard, but later on, when he had received a fountain displaying mercury from Almaden, which looked like a plain drinking fountain, he called me in to get him out of the dilemma.

I was told that mercury was chemically very active and that the only things it would not corrode were glass and pitch. Whereupon I decided to make my object of iron covered with pitch. I had been to Lalique's to see what was available in the way of glass, and decided that 'glass is not for me' — that is, the glass of Lalique. (I have made things, such as mobiles and several fish, with pendent pieces of broken glass selected by me — some eroded by sea and sand, which I picked up on beaches.)

Finally the Spanish pavilion was ready and it was opened with special ceremonies. The part I liked best was a little old man who beat a tattoo with a mortar and pestle.

Léger was there and said to me:

'Dans le temps tu étais le Roi du Fil de Fer, mais maintenant tu es le Père Mercure.' (In the old days you were Wire King, now you are Father Mercury.)

To make the mercury circulate it was necessary to put a little water in with it so that it would wet the pipes and the pump; it would not work otherwise. The pump and a reservoir four feet across were located in a closet under a stairway. The reservoir was eighteen inches deep and full of mercury to maintain a steady pressure. The mercury was led to my fountain, underground, through a half-inch tube and then up thirty inches where it spewed onto an irregularly shaped dish of iron, lined with pitch. This dish was very nearly horizontal; otherwise the mercury would have rushed off. It trickled in turn onto another plate, differently shaped, and then from that onto a chute which delivered it rather rapidly against a sort of bat, attached to the lower end of a rod, which held at the upper end another rod — with a red disc at the bottom and in hammered brass wire the word ALMADEN on top.

The impact of mercury against the bat made the combination of the two rods, the red disc, and the word 'Almaden' weave in the air in a sort of figure eight.

The basin was seven feet and three inches across, but nonetheless we soon discovered that there were little particles of mercury being splattered on the cement floor all around. As the mercury was very expensive, we tried to conserve it by making slowing-up dams in the chute. This

*A piece of Calder's jewelry and Louisa Calder wearing another piece.* ▶

33

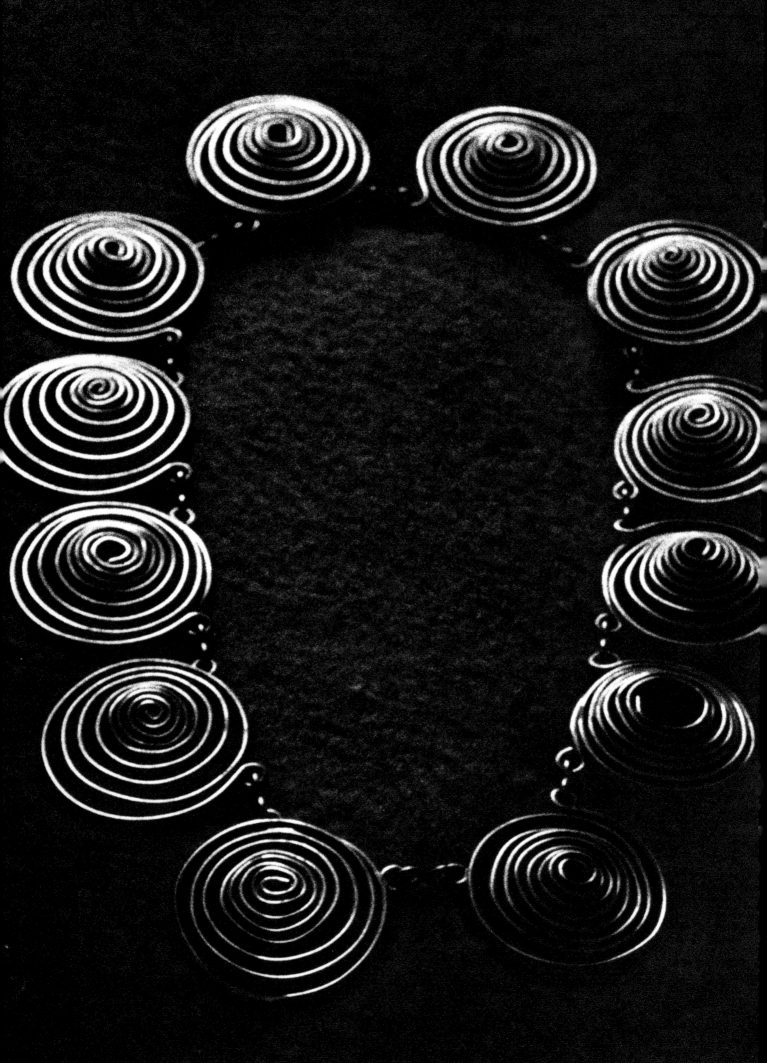

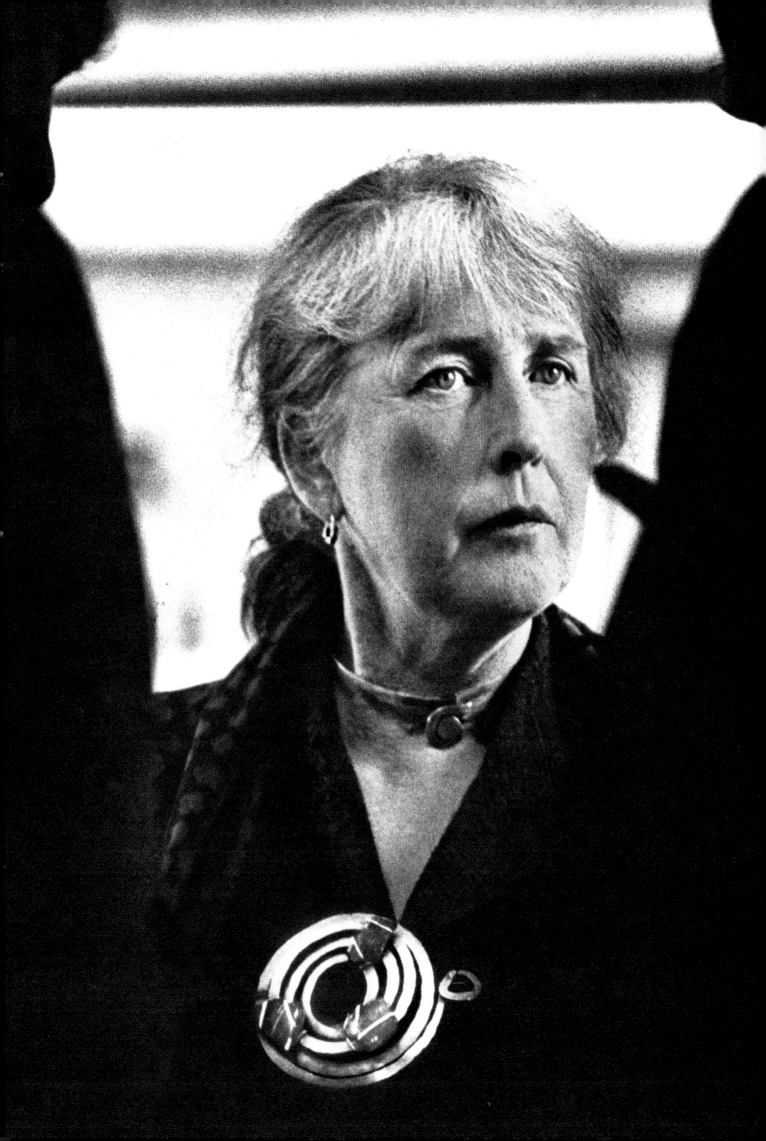

was easy because all we had to do was to warm the pitch and stick in a piece of iron. I also made a labyrinthine spiral for the end of the bat to avoid lateral splatter.

But the most astute conservation stunt was not mine. Somebody took a folded-up fly screen and placed it just where the mercury dripped from one plate to another and this incarcerated the dripping mercury. Finally all worked beautifully, and there was no need to add any mercury to the fountain during the whole show.

It became the favorite pastime of onlookers to throw coins at the surface of the mercury and see them float. This did not gum up the functioning, as the mercury was drawn off from the bottom of the basin.

Some American journalist came through and dubbed me: 'Calderon de la Fuente'. But Lacasa, an architect and public relations man for the pavilion, claimed it was I who had thought it up.

Although Calder characteristically discusses only the mechanics of the Fountain, it was a masterpiece of design and conception. André Beucler, not aware that Calder had created it, or even that he was not a Spaniard, wrote:

In this field of plastic expression, Spain has realized a masterpiece: the mercury fountain. The exploitation of the mercury of Almaden is an important industry for Spain. There would have been many ways to make this theme tedious. They could have explained the nature of this metal, its properties, they could have exhibited it with all the trappings apparently due to precious things (as was done for the Belgian diamonds) but, true artists, the Spaniards concentrated on one thing only: on the beauty of the mercury in its mysterious fluidity. The architects of the Spanish Pavilion, L. Lacasa and José Luis Sert therefore designed a fountain, a simple basin, in the center of which a strange construction of black iron, graceful and precise like a great insect, allowed the mercury to flow slowly, to collect itself into a mass, to scatter, to roll from time to time in melting pearls, to play perpetually by itself, to the delight of the public which was present for the first time at the delicate spectacle of mercury moving in a fountain . . . .

André Beucler, 'Les moyens d'expression', *Arts et Métiers Graphiques*, 62: 15–36 March 1938.

Five years later, James Johnson Sweeney quoted Beucler's remarks in the catalogue of his Museum of Modern Art show, and went on to call the *Mercury Fountain* 'a key point in the evolution of Calder's art. Here all the important threads of his work up to this point were drawn together . . .. With it Calder achieved the first full mastery of his new idiom. He now had the assurance to speak out boldly in the future.'

Through Jean Hélion the Calders met John and Myfanwy (Evans) Piper, Ben Nicholson, and Barbara Hepworth. This resulted in the publication of the first extensive interview with the artist.

When an artist explains what he is doing he usually has to do one of two things: either scrap what he has explained, or make his subsequent work fit in with the explanation. Theories may be all very well for the artist himself, but they shouldn't be broadcast to other people. All that I shall say here will be about what I have already done, not about what I am going to do . . ..

I did a setting for Satie's *Socrate* in Hartford, U.S.A., which I will describe, as it serves as an indication of a good deal of my subsequent work.

There is no dancing in it. It is sung by two people — a man and a woman. The singing is the main thing in it. The proscenium opening was 12 feet by 30 feet. There were three elements in the setting. As seen from the audience, there was a red disc about 30 inches across, left centre. Near

the left edge there was a vertical rectangle, 3 feet by 10 feet, standing on the floor. Towards the right, there were two 7 foot steel hoops at right angles on a horizontal spindle, with a hook one end and a pulley the other, so that it could be rotated in either direction, and raised and lowered. The whole dialogue was divided into three parts: 9, 9, and 18 minutes long. During the first part the red disc moved continuously to the extreme right, then to the extreme left (on cords) and then returned to its original position, the whole operation taking 9 minutes. In the second section there was a minute at the beginning with no movement at all, then the steel hoops started to rotate toward the audience, and after about three more minutes they were lowered towards the floor. Then they stopped, and started to rotate again in the opposite direction. Then in the original direction. Then they moved upwards again. That completed the second section. In the third, the vertical white rectangle tilted gently over to the right until it rested on the ground, on its long edge. Then there was a pause. Then it fell over slowly away from the audience, face on the floor. Then it came up again with the other face towards the audience; and that face was black. Then it rose into a vertical position again, still black, and moved away towards the right. Then, just at the end, the red disc moved off to the left. The whole thing was very gentle, and subservient to the music and the words.

For a couple of years in Paris I had a small ballet-object, built on a table with pulleys at the top of a frame. It was possible to move coloured discs across the rectangle, or fluttering pennants, or cones; to make them dance, or even have battles between them. Some of them had large, simple, majestic movements; others were small and agitated. I tried it also in the open air, swung between trees on ropes, and later Martha Graham and I projected a ballet on these lines. For me, increase in size — working full-scale in this way — is very interesting. I once saw a movie made in a marble quarry, and the delicacy of movement of the great masses of marble, imposed of necessity by their great weight, was very handsome. My idea with the mechanical ballet was to do it independently of dancers, or without them altogether, and I devised a graphic method of registering the ballet movements, with the trajectories marked with different coloured chalks or crayons.

I have made a number of things for the open air: all of them react to the wind, and are like a sailing vessel in that they react best to one kind of breeze. It is impossible to make a thing work with every kind of wind. I also used to drive some of my mobiles with small electric motors, and though I have abandoned this to some extent now, I still like the idea, because you can produce a *positive* instead of a fitful movement — though on occasions I like that too. With a mechanical drive, you can control the thing like the choreography in a ballet and superimpose various movements: a great number, even, by means of cams and other mechanical devices. To combine one or two simple movements with different periods, however, really gives the finest effect, because while simple, they are capable of infinite combinations.

Evans, Myfanwy, ed., 'Alexander Calder Mobiles',
*The Painter's Object*, 1937.

The summer of 1937 was spent at Varengeville in company with Georges Braque, the Paul Nelsons, Herbert Read, George and Marguerite Duthuit, Miró, and the dealer Pierre Loeb.

One morning Calder had a visit from Braque:

We had quite a long and pleasant talk, he and I, and he came out with a statement that when there are people around and you are working, and you prefer to stop working for a moment and think of something by yourself, then the people who surround you wonder what in the world you are doing and why the hell you don't get busy.

In February 1938, Calder exhibited in the Mayor Gallery, Cork Street, London, and in the spring of that year the Calders returned to the United States

*A.C.: 'One of the series of flat cats I made in the 1950s and 1960s.'* ►

where, in the autumn, he had a retrospective exhibition at Springfield, Massachusetts, the opening of which was attended by Alvar Aalto, Léger, and Siegfried Giedion, the architectural historian. Meanwhile, he was building a new studio at Roxbury, complete with pulleys on which he could hoist his mobiles.

In February 1939, another important essay by Sweeney appeared in *Architectural Forum*, in which he placed the concept of motion in historical perspective. He traced changes in spatial concepts for painting and architecture between the Renaissance and modern art, and pointed out how Calder's introduction of actual movement was a logical consequence of forces long at work in the history of sculpture. It was not only in the introduction of movement that Calder's achievement lay – in this he had, of course, been anticipated by Gabo and others. It was rather in the particular and personal use to which movement was put, the creation of free, natural, unpredictable rhythms in a romantic statement involving humour as well as sentiment.

During 1939 and the years immediately following, there were several important events in Calder's career:

1939 was the year of the New York World's Fair and I had been commissioned by [Wallace] Harrison to do a water ballet for the New York Edison Company. They were all ready to light the ballet before I had made it. And I even had to give an interview to two boobs – where the light would come from, etc. – before I'd made it. They also had me give a sort of lecture to a batch of young students, boys and girls, who were to be guides in their Fair building. I made a couple of wisecracks and began to consider myself a lecturer.

The engineer in charge of the nozzles for the ballet wasn't interested in the project, so nothing at all came out of it, then. At any rate, they installed a row of jets of their own around the building – they were forty feet high – and these were put into action.

They had a bridge over the pool – where my ballet was supposed to be – and this bridge led into their building. To avoid any recriminations from ladies whose silk gowns might receive a drop of water, they built a cellophane tunnel over the bridge. I doubt whether this cellophane tunnel would have suited my ballet, anyhow!

Several years later, I proposed this same ballet to Eero Saarinen for the General Motors Technical Center, near Detroit. This turned out to be the most expensive fountain in captivity, but it really works, I believe, and I have received two or three compliments on it . . ..

And now, it was 1940. I had continued to have shows at Pierre Matisse's since 1934, with one or two years out. I'd done such things as "The Whale" (Museum of Modern Art, New York), "The Black Beast", of which I made a copy for Eliot Noyes in New Canaan (*Life* made a lot of photographs of it in the snow), and "The Spherical Triangle", now in Rio. These were fairly large outdoor objects: "The Black Beast" is eleven feet long and almost nine feet high. They were the forerunners of the big stabiles to come.

In the fall of 1940, I had a show of jewelry at Marian Willard's gallery on Fifty-seventh Street. The show was relatively successful and I sold a few things.

The next year, I tried to repeat my success at Marian's with another jewelry show – we set it up on a Sunday. Louisa was supposed to come down from Roxbury the next day for the opening. But she called to say she had had a little accident with the car. So I went back to bring her to New York the next morning. When I arrived, she said the Japs had bombed Pearl Harbor. It was December 7, 1941.

For the next two years Calder continued working on his mobiles and stabiles, but under difficulties resulting from the war.

◄ *Calder's grand-daughter Andrea.*

40

In 1943, aluminum was being all used up in airplanes and becoming scarce. I cut up my aluminum boat, which I had made for the Roxbury pond, and I used it for several objects. I also devised a new form of art consisting of small bits of hardwood carved into shapes and sometimes painted, between which a definite relation was established and maintained by fixing them on the ends of steel wires. After some consultation with Sweeney and Duchamp, who were living in New York, I decided these objects were to be called 'constellations'.

Pierre Matisse must have thought Yves Tanguy and I were not doing so well, because he showed us together. I was mostly in the first room and Tanguy in the second room. In the constellations nothing moved, and it was a very weird sensation I experienced, looking at a show of mine where nothing moved.

The first constellation I had made was a small thing to stand on a table, with at one end a small carved thing looking like a bone and painted red. At the Matisse Gallery, this was standing on the floor and Jacqueline Breton, who was separated from André and affected an enormous Great Dane, came to the show with her mutt, and when he saw this bone-shaped object he menaced it and made as though to take a snap at it....

During the fall of 1943, I had a jewelry show in Chicago. Rue Shaw was now president of the Arts Club and she invited me to show my jewelry there. I had been invited a year or two before, when I made "Red Petals" for the Arts Club, but I had not gone.

"Red Petals", by the way, was made during the war for a little octagonal room lined with rosewood. As I become professionally enraged when I see dinky surroundings, I did my best to make this object big and bold—to dwarf these surroundings. As it was during the war, I went to a junkyard and bought a big chunk of an old boiler. It had a pebble grain due to the action of the water in the boiler, which gave it a very fancy surface. I cut out a big somewhat-leaf-shape, which standing on end came to seven feet high, with an arm standing out at the top. This was held vertical by two leaf-shape legs behind it. From the arm overhead, I hung some red aluminum leaves—they might well have been remnants of the boat of the Roxbury pond.

So, this time, I arrived in Chicago with my jewelry and tacked it on the walls of the self-same room—the rosewood octagonal room.

During the war years the Calders saw a great deal of Yves Tanguy and his wife, Kay Sage, who lived near them in Woodbury, Connecticut. They also saw much of the André Massons as well as many of the other European artists who had migrated to the United States as a result of the war. Then, in 1943, James Johnson Sweeney organized the Calder retrospective at the Museum of Modern Art, with the assistance of the photographer-designer, Herbert Matter. Sweeney's catalogue has remained a primary source for the study of Calder, and he followed it in May 1944 with an article in the *Magazine of Art* that placed Calder as the most significant *international* American artist.

That same year, at the suggestion of Madame Ivy Litvinoff, Calder presented a large sculpture, *The Black Lily*, to the Museum of Western Art in Moscow. It was officially accepted and even loaned back for an exhibition of Paul Nelson's at the Museum of Modern Art. Since its subsequent delivery to Moscow, however, Calder has never been able to trace it.

At the end of 1944 Calder's father died, an event to which he refers with a restraint that gives little indication of the deep affection which existed between them. About the same time,

*Calder at work in the small studio at Saché.* ▶

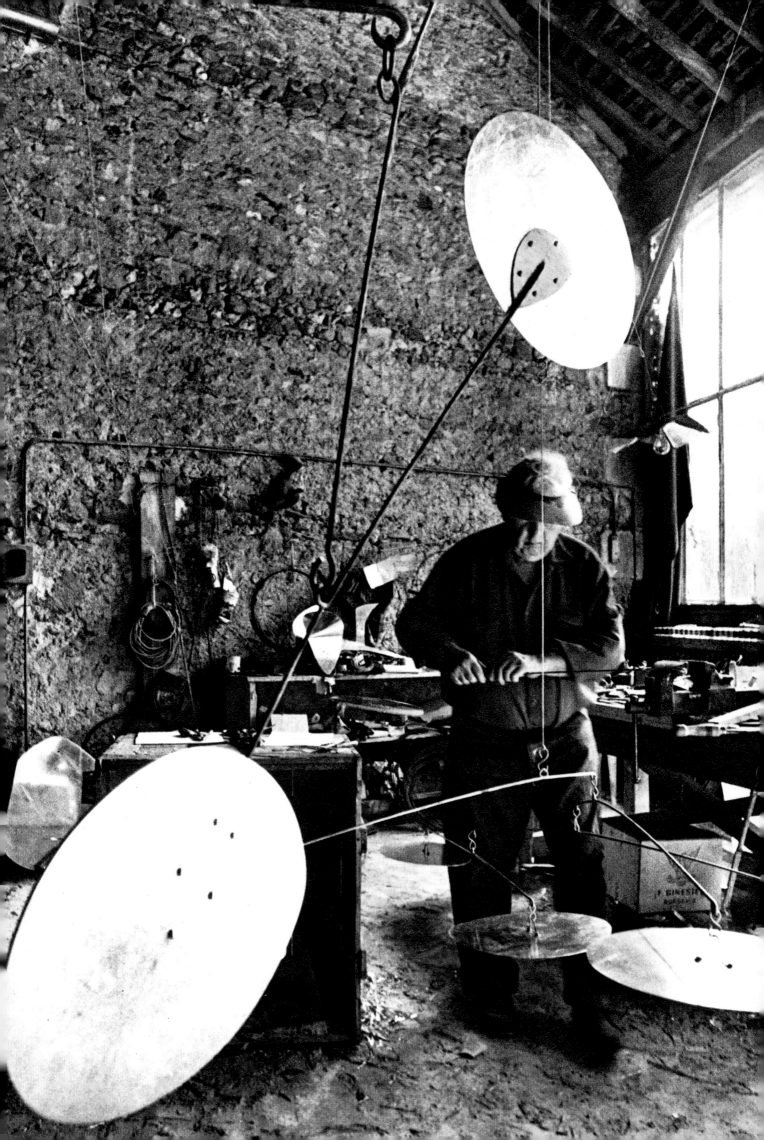

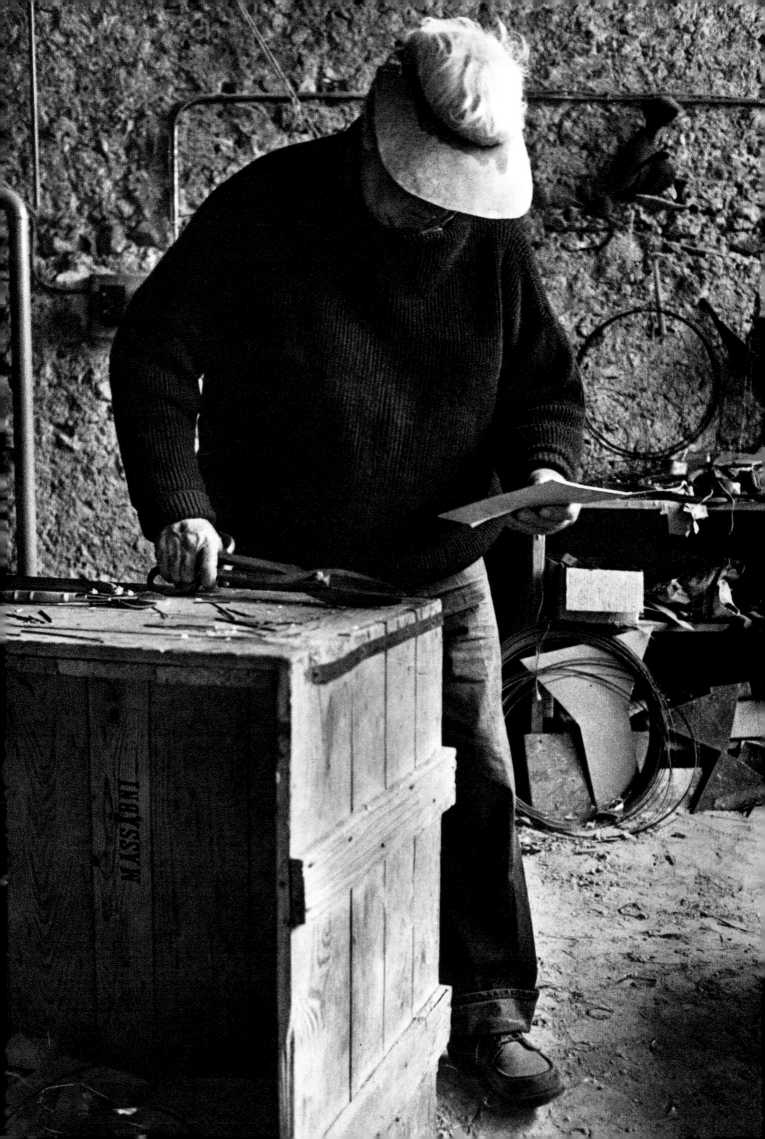

Some architect appealed to me to make one or two very small mobiles to go with the model of a proposed building. I made these, took them to New York, and stopped at the Sweeneys' where I met the Serts. Everybody shouted:

'He's not such a good architect!'

And Laura Sweeney grabbed one little object and Moncha Sert grabbed another one. The architect never saw any of them.

These two little objects are the forebears of a line of very small mobiles I occasionally make. I got rather excited making them as small as my so-called clumsy fingers could do them.

Then in the fall of 1945, Marcel Duchamp said, 'Yes, let's mail these little objects to Carré, in Paris, and have a show.'

So a whole race of objects that were collapsible and could be taken to pieces was born.

I discovered at that time that a package eighteen inches long and twenty-four inches in circumference was [the maximum size] permissible [for mailing]. Well, I could squeeze an object into a package two inches thick, ten inches wide, and eighteen inches long. Using the diagonal, I could even squeeze in a nineteen-inch element. Some of my plates bolted together and the rods unhooked and collapsed, and I kept mailing these to Carré, who had replied in the affirmative to a cable of Marcel Duchamp. So by June 1946, I had quite a stock of objects in Carré's larder and I took a plane over. There were even some quite large objects, such as the 'Lily of Force'. We set about photographing these things with Carré's photographer. The photographic material was very poor that year.

It was in the middle of the summer and I still don't understand why the show was put off — probably because the middle of the summer is a dead season in Paris. So I decided to go home again, via England where I got a plane.

I came back to Paris in October 1946. Jean-Paul Sartre had been in Mexico the previous year and on his way back, during a stay in New York, he had visited a few French artists. André Masson brought him to see us in Roxbury and I saw him again in New York, where he came to my little shop. I gave him a mobile bird made out of Connecticut license plates — there is nothing tougher than these; they look like aluminum, but they hang on forever.

During my first visit to Carré, we decided to ask Sartre for a preface, and he agreed. When I came back to Paris the second time, the catalogue was about ready.

One day, Carré said, 'You go to Mourlot, the lithographer, and see what I have been doing for you.' I went, and discovered a beautiful catalogue, in which the indifferent photography was replaced by a sort of line drawing — the contour of my objects — with color fillings.

Unfortunately, I found the thing a bit monotonous, as all the backgrounds were gray, and I suggested a few blue and yellow backgrounds as well.

However, the lithographic printing process is quite inexorable; you can't go back on what you did yesterday.

The following day, I got a *petit bleu* — telegram — from Louis-Gabriel Clayeux, the right hand of Carré at the gallery then, saying, "*Catastrophe*!"

Carré was furious with me and threw out the yellow backgrounds.

Finally Sartre's preface arrived and it all made a fine little book, with some of Herbert Matter's photographs, as well, of objects in motion.

In the show, there were several objects composed of a heavy metal plate, hanging horizontally close to the floor from a davit that came up from the floor through a hole in the plate; above this were some foliage and berries.

Carré wanted to put these on some pedestals and I said, 'No, my wife insists these must be right on the floor'.

And Carré said, 'Ce n'est pas noble'. (It is not dignified.)

There were two mobiles of the epoch of the constellations — the war period — made of bits of hardwood, carved, painted, and hanging on strings at the end of dowel sticks. Carré had previously deleted these from what he wanted to show, so I gave them to Mary Reynolds, who was back in Paris. And she always refers to them, ever since, as the 'Pas Nobles Mobiles' (the undignified mobiles.)

These now belong to the Guggenheim Museum.

The show at Carré's opened on October 25, 1946; there were a lot of visitors and even Henri Matisse. The gallery was in the *huitième arrondissement* — there are a lot of electric-power users in this section, and from five to six in the afternoon they would turn off the electricity to save coal, as a postwar economy measure.

So, we put a candle on the floor under an object with a multitude of small leaves and made it rotate. It was very fine with the shadow going around the candle on the ceiling. This object is now in the Basel Museum . . . .

## The Sartre introduction was translated for an exhibition at Curt Valentin's Buchholz Gallery, New York:

If sculpture is the art of carving movement in a motionless mass, it would be wrong to call Calder's art sculpture. He does not aim to suggest movement by imprisoning it in noble but inert substances like bronze or gold, where it would be doomed forever to immobility; he lures it into being, by the use of unstable and base materials, building strange constructions of bits of bone, tin or zinc, of stems and palm-leaves, of disks, feathers and petals. They are sometimes resonators, often booby-traps; they hang on the end of a thread like spiders, or perhaps squat stolidly on a pedestal, crumpled up and seemingly asleep. But let a passing draft of cool air strike them, they absorb it, give it form, spring to life: a "mobile" is born!

A "mobile", one might say, is a little private celebration, an object defined by its movement and having no other existence. It is a flower that fades when it ceases to move, a "pure play of movement" in the sense that we speak of a pure play of light. I possess a bird of paradise with iron wings. It needs only to be touched by a breath of warm air: the bird ruffles up with a jingling sound, rises, spreads its tail, shakes its crested head, executes a dance step, and then, as if obeying a command, makes a complete about-turn with wings outspread.

But most of Calder's constructions are not imitative of nature; I know no less deceptive art than his. Sculpture suggests movement, painting suggests depth or light. A "mobile" does not "suggest" anything: it captures genuine living movements and shapes them. "Mobiles" have no meaning, make you think of nothing but themselves. They *are*, that is all; they are absolutes. There is more of the unpredictable about them than in any other human creation. No human brain, not even their creator's, could possibly foresee all the complex combinations of which they are capable. A general destiny of movement is sketched for them, and then they are left to work it out for themselves. What they may do at a given moment will be determined by the time of day, the sun, the temperature or the wind . . . .

I was talking with Calder one day in his studio when suddenly a "mobile" beside me, which until then had been quiet, became violently agitated. I stepped quickly back; thinking to be out of its reach. But then, when the agitation had ceased and it appeared to have relapsed into quiescence, its long, majestic tail, which until then had not budged, began mournfully to wave and, sweeping through the air, brushed across my face. These hesitations, resumptions, gropings, clumsinesses, the sudden decisions and above all that swan-like grace make of certain "mobiles" very strange creatures indeed, something midway between matter and life. At moments they seem endowed with an intention; a moment later they appear to have forgotten what they intended to do, and finish by merely swaying inanely. My bird, for instance, can fly, swim, float like a swan or a frigate. It is one bird, single and whole. Then of a sudden it goes to pieces and is nothing but a bunch of metal rods shaken by meaningless quiverings.

The "mobiles", which are neither wholly alive nor wholly mechanical, and which always eventually return to their original form, may be likened to water grasses in the changing currents, or to the petals of the sensitive plant, or to gossamer caught in an updraft. In short, although "mobiles" do not seek to imitate anything because they do not "seek" any end whatever, unless it be to create scales and chords of hitherto unknown movements — they are nevertheless at once lyrical inventions, technical combinations of an almost mathematical quality, and sensitive symbols

*The old barn across from the house at Saché. A.C.: 'I worked on smaller things here* ▶
*before I built the big studio up the hill. Now I use this mainly for painting gouaches.'*

45

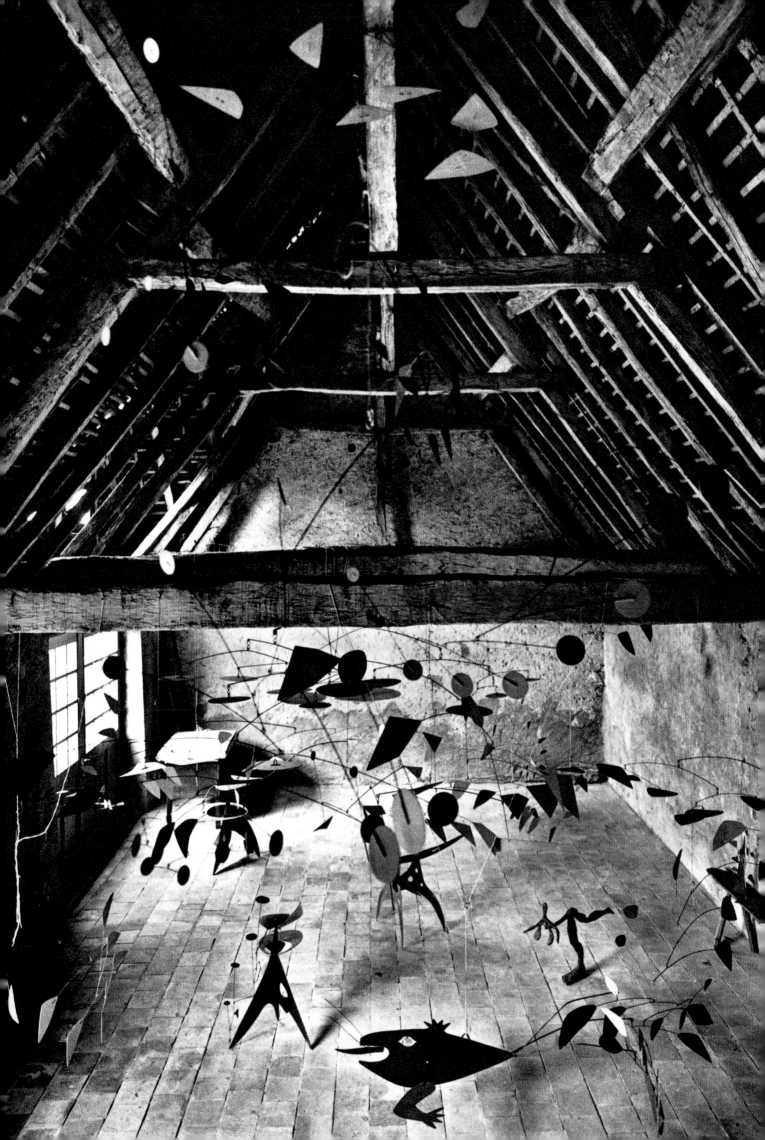

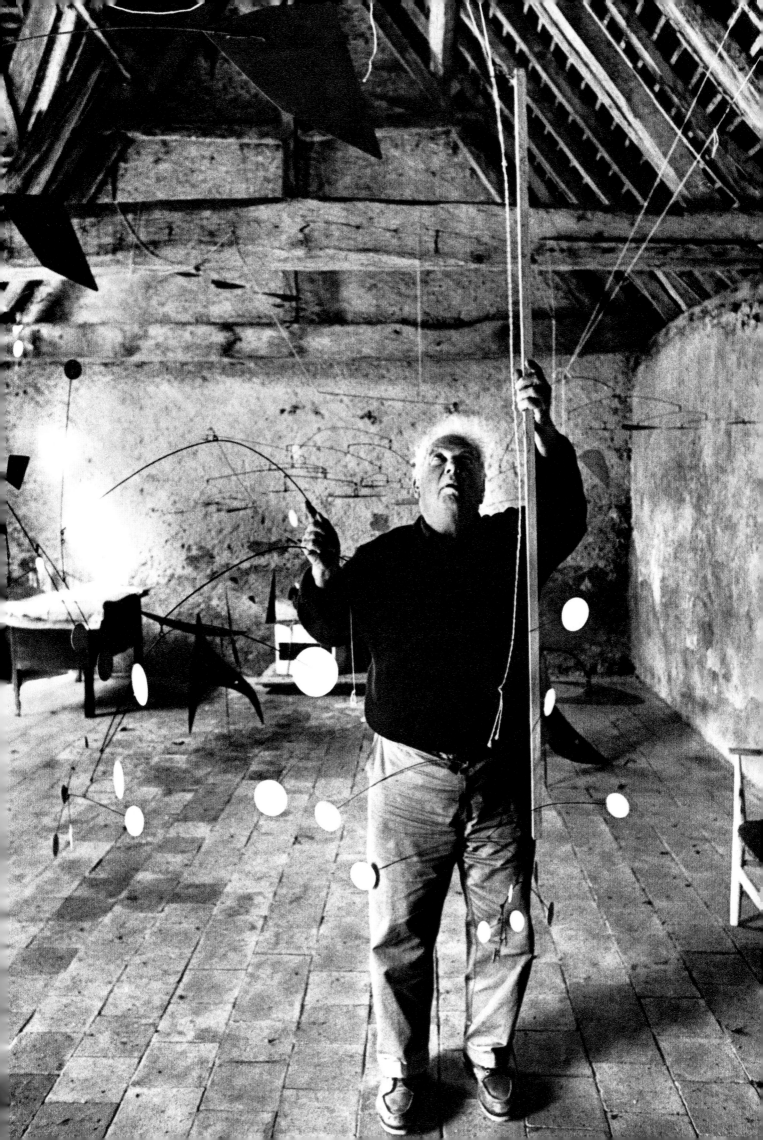

of Nature, of that profligate Nature which squanders pollen while unloosing a flight of a thousand butterflies; of that inscrutable Nature which refuses to reveal to us whether it is a blind succession of causes and effects, or the timid, hesitant, groping development of an idea.

<div align="right">Jean-Paul-Sartre, 'Calder's Mobiles', Buchholz Gallery, 1947.</div>

Later that year Calder returned to New York:

I had left Pierre Matisse at the time of my show at the Museum of Modern Art, after some misunderstanding, and for a year or so had been without a dealer.

Curt Valentin inquired about me several times, through André Masson, and I finally joined his stable. He had very few Americans. He had Lipchitz, but he used to purchase things in Europe — Moore, Piper, Beckmann, Picasso, Miró, Juan Gris and so forth — and he sold these things in the United States.

The first thing we decided to do was to put out a book that I would illustrate.

Previously, I had done one for Monroe Wheeler in Paris, in 1931: *Les Fables d'Aesope*, translated by Sir Roger Lestrange and published by Harrison of Paris.

This time, we got James Sweeney to collect the material, the basis of which was old English rhymes. I worked hard at the drawings and repeated many of them several times. Finally we chose the title from one of the rhymes for which I had done the most complicated and successful drawing: *Three Young Rats* . . . .

Curt exhibited the original drawings when he presented the book to the public in the fall of 1944. As most of the figures are naked, there was one in particular climbing up a chimney that Peggy Guggenheim, in her own manner, discovered as being very obscene.

The previous spring, Wally Harrison had suggested I make some large outdoor objects which could be done in cement. He apparently forgot about his suggestion immediately, but I did not and I started to work in plaster. I finally made things which were mobile objects and had them cast in bronze — acrobats, animals, snakes, dancers, a starfish, and tightrope performers. These I showed that fall at Curt's, I guess it was at the same time *Three Young Rats* came out.

Calder again ventured into the theatre in 1946, executing mobiles for Padraic Colum's play, *Balloons*, and during these early post-war years, the literature on Calder proliferated. In addition to serious studies, the artist inspired numbers of eulogies and poems, as though his mobiles could only be properly interpreted by their translation into literature. Here are excerpts from several:

Up to seven or eight years of age — rarely later — all children love to play around with color and know how to express themselves by making drawings. They draw with as much humor and energy as any primitive man sculpting fetishes or carving bracelets.

The warping of taste and sensibility happens later, when the child is no longer alone with his imaginings, when education and heredity take over. But real artists, even the most serious of them, keep till the very end the freshness of youth, its gay laughter, limpid gaze, and candor.

You are an American, and you studied to be an engineer. You studied motors, mechanics, the nature of pulleys and cables. In this humoristic *Circus* of yours, you have endowed these things with all the poetry that is in you.

I love your constructions which are so well balanced that the softest breath starts them going, setting in motion those delicate metal plates with a strange music, and those supple arms, completed by a large ball, which gravely and unhurriedly maintain the stability of these sculpture-objects of iron and copper.

This sensitive engineer's art is truly the product of your country, inhabited mainly by Nordic peoples, who have created the non-figurative art also referred to as "abstract" . . . .

<div align="right">Pierre Loeb, 'Letter to Calder', *Voyages à travers la peinture*, 1945.</div>

◀ *Calder with a mobile in the old barn.*

48

...Calder's object (the mobile) is an illogical, but emotionally coherent metaphor. It helps us to understand the power a smoke-ring has over the smoker who is blowing it; to understand the power running water has over the being watching it; to understand how, after watching water flow by for a long time, one might arrive by induction at a perception of the *rhythm* at which the water is flowing.

Calder's object is a poem.

George Mounin, 'Calder's "Object"', *Cahiers D'Art*, 1946.

When one leaf, left hanging on a bough
Pruned sharply by the quickness of the frost,
Fluttering, turns sideways and is lost,
The watcher's eye is opened and sees, now
One shape becoming many as it moves.
In arranged patterns the slow planets turn
But do not alter, so that the eye can learn
Movement controlled in unseen grooves.
Here leaf and planet can combine
To shift upon their slender wires,
Can circle, searching for a line
Or soar around sharp metal spires ....

Ruthven Todd, 'Alexander Calder', *Garland for the Winter Solstice*, 1962 (written *c.* 1948).

### After the war began a period of world-wide travel:

In New York in 1944, we had met a Brazilian—Henrique Mindlin. He had been intrigued by a small mobile he had seen somewhere, and wanted one for himself. It was sort of a little chair, made out of a bent piece of metal, with three legs and a feather sitting in a notch in the top.

I made him a similar one which could be taken to pieces—legs taken off, metal feather removed—so he could fly it to Rio without any trouble. I often regret not having made him a cloth vest with pockets, each the color of the part contained.

As a result of Mindlin's enthusiasm, the Calders took off for Brazil in 1948, making stops in Mexico City, Panama, and Trinidad. In Rio de Janeiro, Calder held an exhibition in the Ministry of Education building, designed by Le Corbusier, Niemeyer, and others. The exhibition was also shown in São Paulo. Mindlin contributed a substantial essay for the catalogue, which concluded:

...In all of these works Calder attempts to introduce a fourth dimension, that of Time, yet he still manages to preserve an incontestably human element. Given the contagiously joyous spirit with which Calder works it is easy to understand how he and Mark Twain might be compatriots. Expressing his admiration for Calder, Lipchitz once remarked to me that "only an American could attempt, with such success, the mechanization of Poetry." In fact, to a visitor, Calder's studio does look, at first glance, like a mechanic's office. And the precision and economy with which the mobiles are articulated and constructed reveal Calder's early training as an engineer.

But Calder's work shows more than just the youthful, inventive American spirit. Their "humor", their instability, their accidental quality also betray the anxieties of our era. And the subtle, elusive lyricism of his forms bespeaks our disillusionment with the obvious and the explicit. In conclusion, Calder's sculpture can be beautifully integrated with modern architecture, and would be ideally situated in the open, light-filled spaces of some of our new Brazilian buildings.

Henrique E. Mindlin, 'Alexander Calder', *Ministry of Education*, Rio de Janeiro, 1948.

*'Snow Flurries', later called '32 White Disks' (1953), Perls Galleries, New York.* ▶

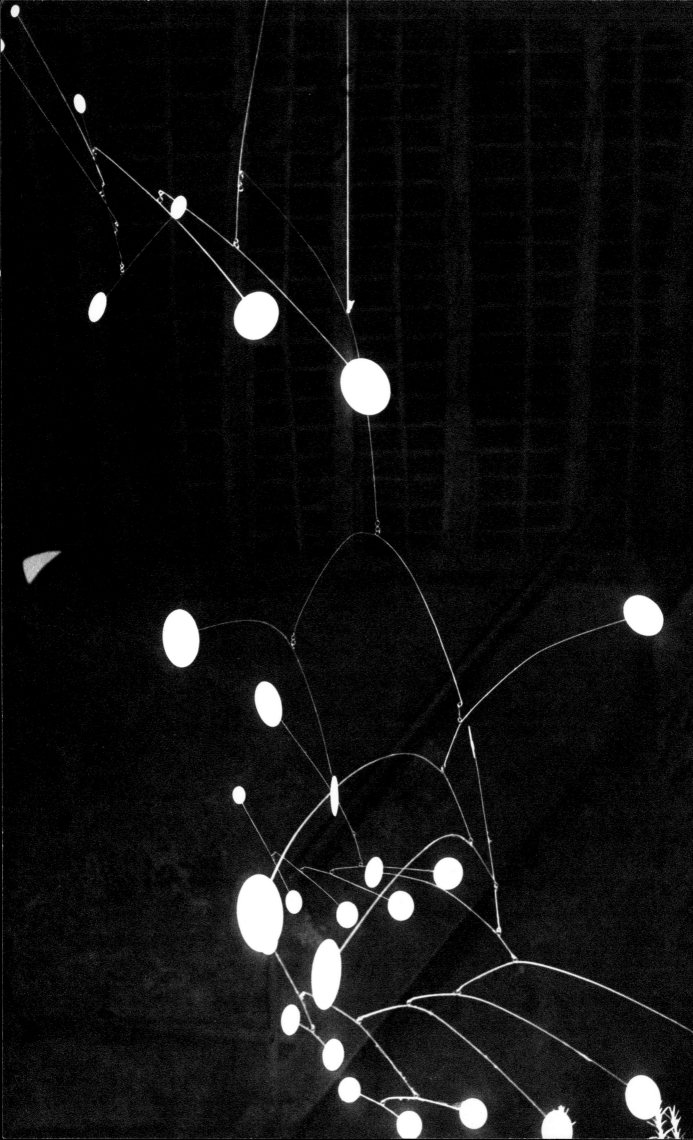

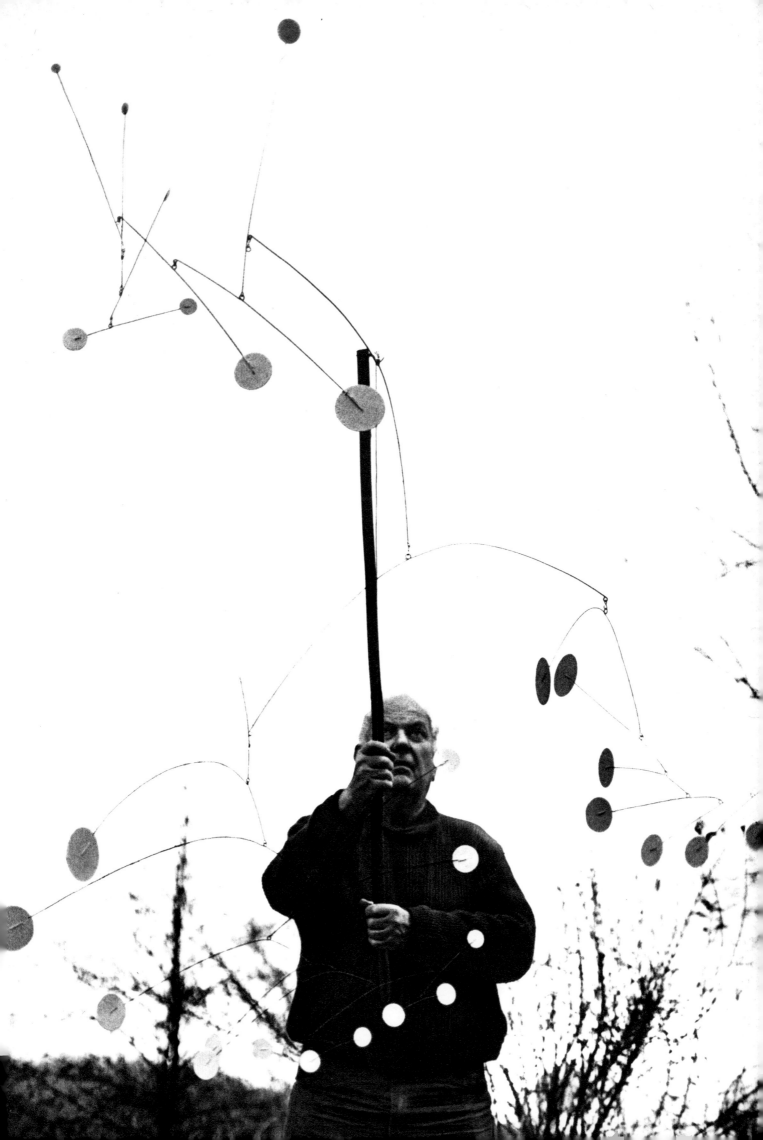

André Breton supplied a brief statement for the same occasion:

Calder's object, from which every anecdotal element has been banished, and which is reduced to a few simple lines intersecting primary colors, is, through the use of pure non-figurative rhythms, miraculously allied to real life, and recalls to us the movements of the heavenly bodies and the rustling of leaves, as well as the memory of a caress.

André Breton, 'The Pure Joy of Equilibrium', *Ministry of Education*, Rio de Janeiro, 1948.

In 1948 Calder began experimenting with printmaking, at first with few positive results:

It's a far cry back to my first visit to Paris, in 1926, and a seance in the sketch class of the Academie de la Grande Chaumière. A young lady from one of the Southern States entered the room, and cried out 'I don't know which it is, but I want to etch or sketch'.

Most of the time ever since I've felt pretty sure that I knew what I wanted to do — but for the past few weeks I've been rather in the predicament of the above young lady — for, for the past several weeks, I've been making etchings — and what with the acid spots, which itch, and the black of the "ground" all over my hands, the stickiness of everything, and the mass of dirty rags and newspapers, to say nothing of the fire hazard, I feel rather as though I were once again in the "black gang" of a ship (in which capacity I once worked my way to San Francisco — we were supposed to go on to Honolulu, and then back to the West Coast — but the ship's officers and I agreed that I would do best to stay in San Francisco on the first visit).

On a few occasions, quite long ago, I have witnessed etchers rubbing and caressing their copper plates, with what might have almost passed for affection. But I have been content to spit on the plate, and then dump a little acid on it, and then watch the solvent and the dissolvent fume and bubble, all the while tickling the plate, and brushing away the bubbles, with a partridge feather.

In my instance, the removal of the ground, of which I almost invariably had a thick black slab, often with great lumps, was the grimiest part of the operation. So much so that at the last I did a dozen or more plates, and let them pile up, and then cleaned them all at once.

At the outset I managed to get a few trial proofs — but since then I have been navigating on dead reckoning — and I am still to see proofs of the last 15 or 20.

However, in spite of all this lamentation, I have quite enjoyed the whole thing.

'Alexander Calder', *The Tiger's Eye*, June 1948.

In 1949, back in Roxbury, he undertook a series of silk screen mural scrolls on canvas, in company with Matisse, Miró, and Matta.

I like to work in any medium where I am free to do as I choose.

Of course, I wish I had invented this medium of Mural-Scrolls myself. — But as I didn't — the Orientals having been doing this for many years — I am still very enthusiastic about smearing up somebody's wall.

I would neither wear it, as Matta, nor collaborate it, as Miró, but just spit on the back of it, and stick it up where it can best give pleasure, or diminish gloom.

Alexander Calder, 'A Piece of My Workshop', *Mural Scrolls*, Katzenbach and Warren, Inc., 1949.

Studies and articles on Calder now appeared in even greater numbers. Three of the most suggestive were by Siegfried Giedion, James Thrall Soby, and Lionel Goitein:

◄ *Calder with a mobile.*

52

... From this hovering system [the hammock], ever ready to change its poise, there is but a step to the art of the American sculptor, Alexander Calder. Both are intimately rooted in the American environment. Indeed, Calder's art — and herein lies its strength — is deeply at one with the broad stream of modern evolution.

It was Calder's instinct that led him to spend year after year in Paris, steadily growing. There he experienced the only creative schooling for the man of our day: living week in, week out, in contact with the men who had created our new means of expression. There his eyes were opened to the bounds of naturalistic representation. Along this path, he clearly saw, whatever stirred within him would never find its artistic outlet. Nor was it one artist or another: it was the plane upon which artistic problems were to be met that carried Calder to the creative sources within himself. This self was rooted in the nature of American experience. America had produced a tremendous body of inventions strongly affecting everyday life. But artistically, on the emotional side, they had not spoken. The inventions were at hand. They were useful. They yielded returns. But no one had pointed to them. No one had hit upon the symbolic content underlying their everyday usefulness.

None other in contemporary art was born into this American experience, which lies, as we often stress here, in a particular relation, a gearing of the American man with the machine, with mechanism, with the mobile. No other people is in such close touch with these abstract structures. Calder absorbed the modern means of expression, slowly amalgamating them with his own background until, by 1931, he had attained a sensitivity to states of equilibrium that he stressed in his 'mobiles'. He was carrying on the tradition of his artistic forerunners, now blended with the American consciousness....

Siegfried Giedion, 'The Hammock and Alexander Calder', *Mechanization Takes Command*, 1948.

Alexander Calder prefers the terse, descriptive titles used by Klee (and by Miró customarily, except in the latter's very recent works)....

Far more than Klee or Miró, Calder depends on an uncanny sense of observation to generate his sculptured forms, especially when these forms refer to animals, birds and fish, as they very often do. (It may be argued in fact that *his American vision is matter-of-fact*, in the literal sense of the phrase, by comparison with Klee's Germanic cabalism or Miró's Catalan fantasy.) ...

By comparison with Klee, both Miró and Calder are earthy in humor. The art of both abounds in sexual references which are altogether physical in nature. Both men, indeed, show a simple, animal pleasure in the physiological aspects of life, a directness of response to natural forms which contrasts with Klee's immense cultivation of spirit. Their art is less meditated than Klee's and narrower in emotional scope, but within its limits it is extraordinarily fresh and vigorous; it has a carrying power and heartiness to which Klee did not aspire. Both men have proved time and again that abstract art can be a vehicle for rare humor, and it was in part their historical function to break away from the deadly seriousness of the cubists and of later artists like Mondrian, and to restore playfulness and comedy to the repertory of abstraction. In so doing, however, they have sacrificed nothing but austerity; their humorous works are as inventive in the formal sense as those which they have completed in a more solemn vein.

James Thrall Soby, 'Three Humorists: Klee, Miró, Calder', *Contemporary Painters*, 1948.

This dynamic sculpture in time of Calder is no trick, except on the dormant senses. We are stirred by its swirling motions and elaborate activity. The work has the character of waterweeds in a current, leaves on a branch, baubles on a Christmas tree, in other words, toys with all the potentialities of movement. The structure is a balanced system set in motion at will, giving the sculpture liveliness, meaning and power. For all its gravity it is a whimsical phantasy, a pleasant happening, a just coming-to-life. At the flick of a moment it is no longer inert; hence its unique appeal and charm. The work is kaleidoscopic in its possibilities. Here the sensations are shared by eye and muscle. It evokes the most primitive memory-traces. Such operations dance, flash,

*Calder with two of his wire sculptures.* ▶

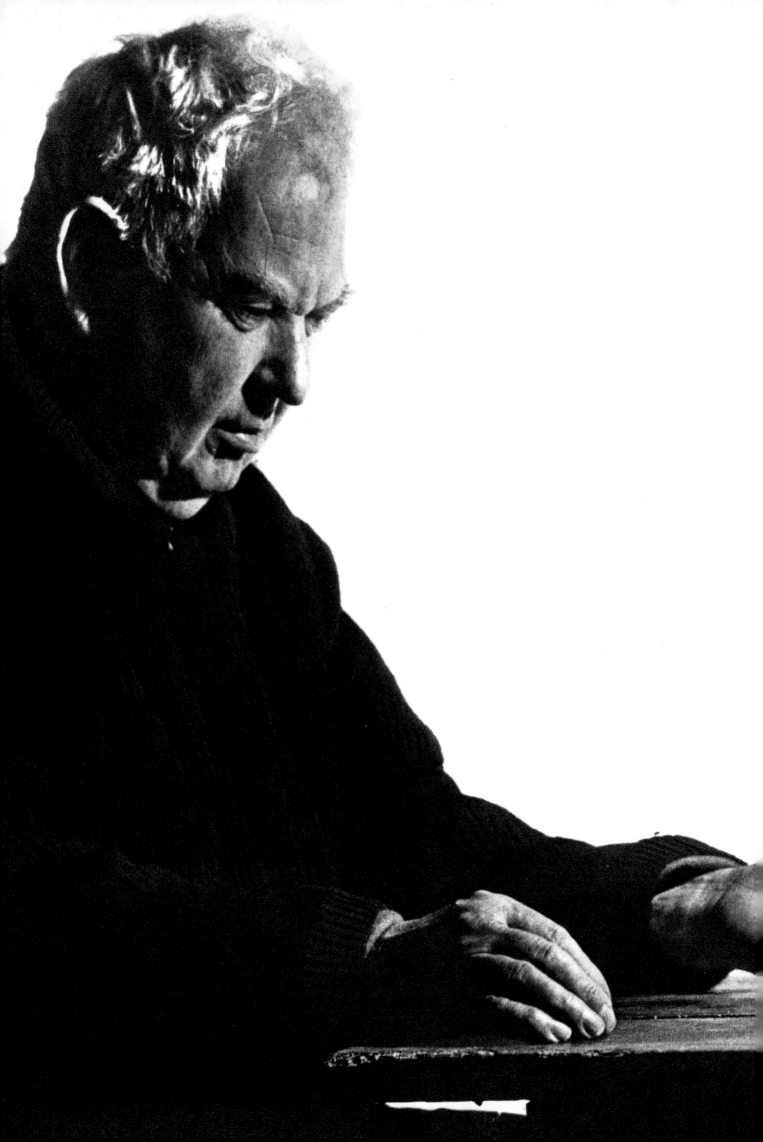

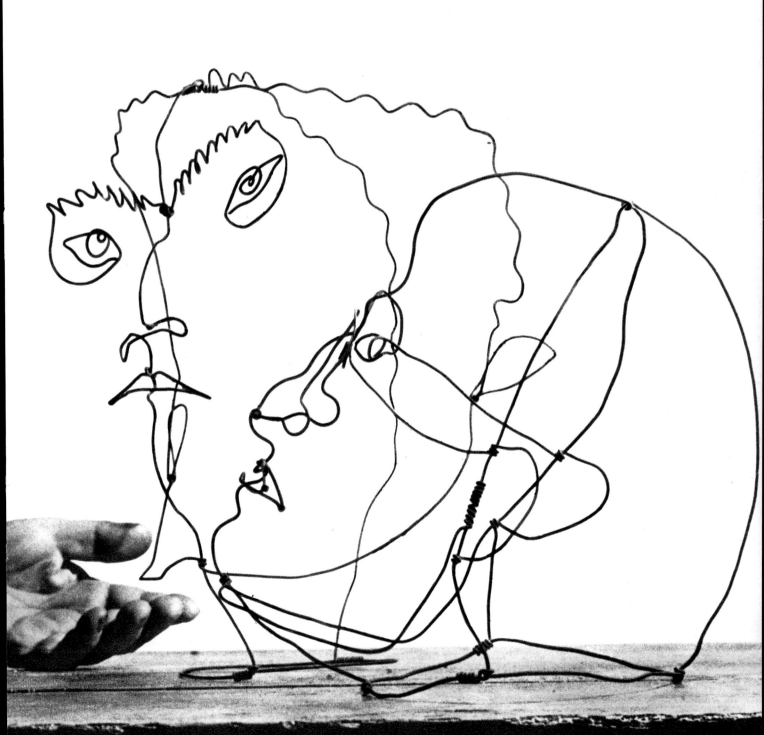

pivot and oscillate.... It is not by accident that early cave-man's drawings show superimposed transparencies of the same or another animal (often in reverse direction). This was the earliest intimation of the start of successive motion, the origin of movies.

<div align="right">Lionel Goitein, 'Lobster Trap and Fish Tail', <em>Art and the Unconscious</em>, 1948.</div>

André Masson, an old friend, visited the Calders at Roxbury and wrote a poem to the artist. Calder recently explained the circumstances to me:

During the war André Masson and his family came to Connecticut and lived near us. One winter day André and I came out from N.Y. on the train to New Milford, and he spent the night with us, on a bed in my studio. He wrote, and decorated, a little poem to thank me. This was printed in *Cahiers d'Art*—I forget when....

I had seen an orange bird chasing a blue bird—(or perhaps the contrary) and the reference is to that.

## The poem follows, in the translation made for Curt Valentin (1949):

### 'The Studio of Alexander Calder'

*Newcomer from Europe, as they say,*
*It is true that over there iron and copper are*
*        instruments only of evil*
*adding death to death and to degraded life*
*I fled, a fortunate fugitive,*

*The day and the night opened before*
*Wings — algae — mobile leaves.*
*I salute you forger of giant dragon-flies*
*Mercury-diviner your spring disclosed*
*A water heavy as tears.*
*But a merry-go-round of little scarlet moons*
*        fills me with joy*
*I think of a transparent circus*
*It is a leaf traversed by the sun.*
*One green day you saw a red bird*
*Pursuing a yellow bird:*
*You know that we are bound to nature*
*That we belong to the earth.*
*Hung from the studio's rafters,*
*in the striped light a gong sensitive to*
*        the whims of the air*
*is struck with extreme caution*
*Its note is the footfall of a dove: what hour does*
*                it strike?*
*This is the hour of the child with the cherries.*
*Here the seconds have not the weight of the clock*
*nor do they lie quiet in the grass*
*for they cannot conceive of immobility*
*they love the rustling of reeds*
*and the cry of the tree-toad so expert at*
*                musical breathing*
*and they play between your fingers, Calder, my friend.*

<div align="right">André Masson<br>English translation by Ralph Manheim</div>

During 1948 and 1949, Herbert Matter made a film on Calder, with music by John Cage, produced and narrated by Burgess Meredith. This remains perhaps the finest motion picture on Calder and his mobiles, although the artist did object somewhat to all the effects from nature that were used as analogies.

The Calders returned to Paris in the spring of 1950 with their two daughters, Sandra, now 15, and Mary, aged 11. Christian Zervos, publisher of the *Cahiers d'Art*, had put Calder in touch with the dealer Aimé Maeght and, as a result, the artist showed at the Maeght Gallery in June 1950, and has continued to show there ever since. At this initial exhibition appeared the first of Maeght's elaborate catalogue series *Derrière Le Miroir*, devoted to Calder, including articles by James Johnson Sweeney, Henri Laugier, Henri Hoppenot, and Fernand Léger.

It is impossible to find a greater contrast than Calder the man who weighs two hundred pounds and his mobile, delicate, transparent creations. A sort of tree trunk in movement he stirs up a lot of talk, gets in the way of the wind—he's not born to go unseen! Smiling and curious he sways in the air as part of nature itself. Left to himself in an apartment he is a real danger to any fragile object. His place is rather outside in the air, the wind and the sun. You would not think it, but he has a sharp eye. Nothing escapes him. He sees everything. We have often roamed along the dead ends of certain New York streets looking for picturesque elements. There where the American disorder begins the brazen quality of the discarded objects, the rubbish, the scraps (that are often plastically valid) of garbage cans entwined with wire and blooming with green stuff. If you look up you can see on the top of the roofs geometric fantasies—thousands of metallic structures are silhouetted in the sky and play with the light. Calder has his eye on them also. I have already written somewhere that Calder is a realist. He uses all these elements scattered throughout our daily life and it is wonderful that this big man, this 100% American should be the one to realize it. He has amalgamated and coordinated everything. With them he has created plastic objects, then still smiling he puts his finger on a magic push button and quietly and gracefully everything moves! Mobile sculpture has been invented. This was some time ago. Is he going to give us anything else?

Calder's work is bound to stay popular. Why not? This reminds me of an amusing story about another geometrical master, Mondrian. I had bought a linoleum adorned with designs visibly inspired by his paintings. (It is I think a sign of creative authenticity to inspire a minor decorative art.) The next time I saw Mondrian I said to him, "Mondrian, did you know that you are very popular?" He looked at me with surprise and I told him the story of the linoleum. Well strangely enough he didn't seem at all pleased. But all the same I am very sure that on the sly he went to the shop where I had found the linoleum. And everybody else thought as I did.

Translation by Dolly Chareau

Fernand Léger, 'Calder', reprinted from Calder exhibition Catalogue, *Curt Valentin Gallery*, 1952.

There also appeared in 1950 the catalogue of the Société Anonyme, Yale University Art Gallery, with the entry on Calder by Marcel Duchamp:

Among the "innovations" in art after the First World War Calder's approach to sculpture was so removed from the accepted formulas that he had to invent a new name for his forms in motion. He called them *mobiles*. In their treatment of gravity, disturbed by gentle movements, they give the feeling that "they carry pleasures peculiar to themselves, which are quite unlike the pleasures of scratching," to quote Plato in his *Philebus*. A light breeze, an electric motor, or both in the form of an electric fan, start in motion weights, counter-weights, levers which design in mid-air their

*Two stages in the making of a gouache.* ▶

57

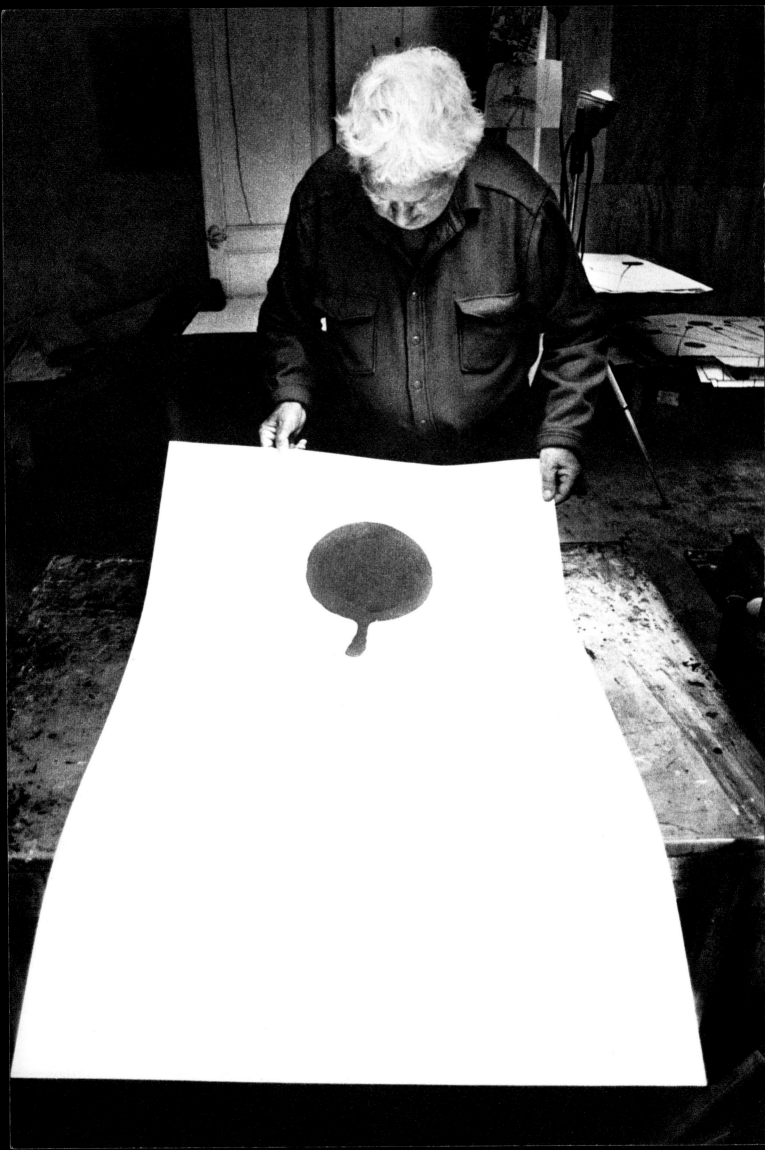

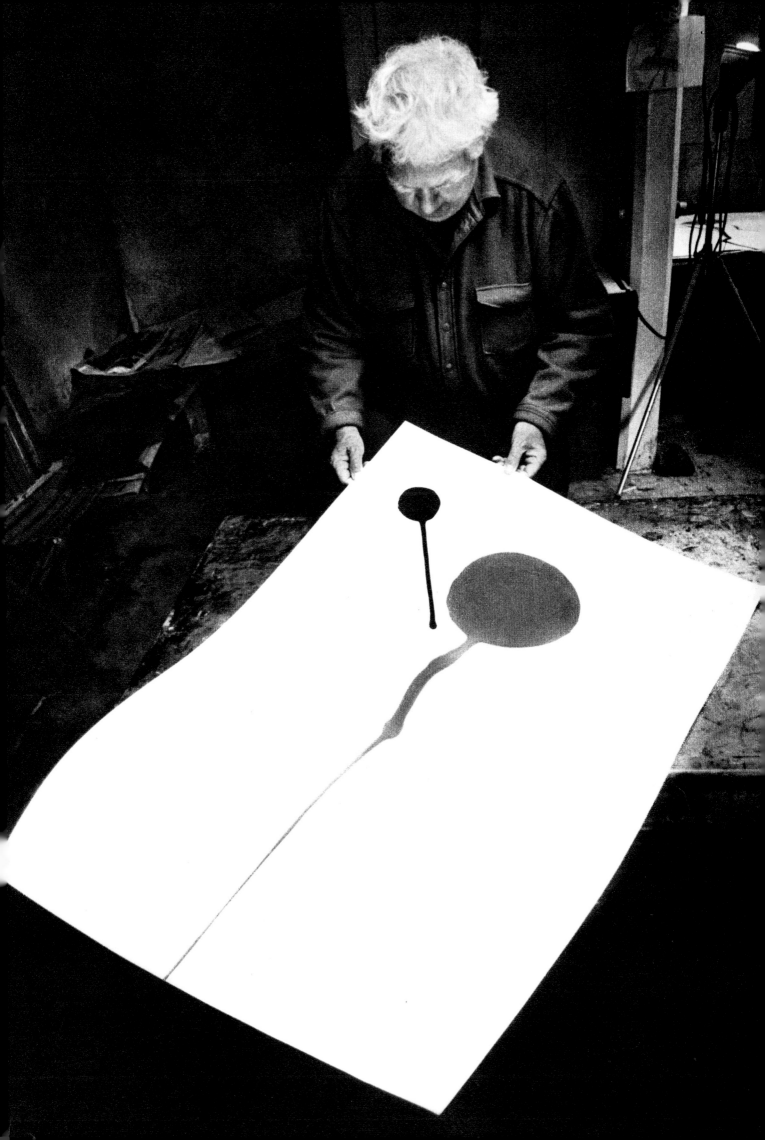

unpredictable arabesques and introduce an element of lasting surprise. The symphony is complete when color and sound join in and call on all our senses to follow the unwritten score. Pure *joie de vivre* . . . .

In September 1950 the Calders returned to the United States after a trip to Finland and Scandinavia, and the artist began work on a retrospective exhibition at the Massachusetts Institute of Technology. Soon after, there was an exhibition at the Gallery of Contemporary Arts in Washington, D.C., and another exhibition was held at the Lefevre Gallery in London in January 1951.

Back in New York in the spring of 1951 the artist participated in a symposium at the Museum of Modern Art with Willem de Kooning, Stuart Davis, Fritz Glarner, and George L. K. Morris, which resulted in one of his increasingly rare statements on his sculpture.

My entrance into the field of abstract art came about as the result of a visit to the studio of Piet Mondrian in Paris in 1930.

I was particularly impressed by some rectangles of color he had tacked on his wall in a pattern after his nature.

I told him I would like to make them oscillate — he objected. I went home and tried to paint abstractly — but in two weeks I was back again among plastic materials.

I think that at that time and practically ever since, the underlying sense of form in my work has been the system of the Universe, or part thereof. For that is a rather large model to work from.

What I mean is that the idea of detached bodies floating in space, of different sizes and densities, perhaps of different colors and temperatures, and surrounded and interlarded with wisps of gaseous condition, and some at rest, while others move in peculiar manners, seems to me the ideal source of form.

I would have them deployed, some nearer together and some at immense distances.

And great disparity among all the qualities of these bodies, and their motions as well.

A very exciting moment for me was at the planetarium — when the machine was run fast for the purpose of explaining its operation: a planet moved along a straight line, then suddenly made a complete loop of 360° off to one side, and then went off in a straight line in its original direction.

I have chiefly limited myself to the use of black and white as being the most disparate colors. Red is the color most opposed to both of these — and then, finally, the other primaries. The secondary colors and intermediate shades serve only to confuse and muddle the distinctness and clarity.

When I have used spheres and discs, I have intended that they should represent more than what they just are. More or less as the earth is a sphere, but also has some miles of gas about it, volcanoes upon it, and the moon making circles around it, and as the sun is a sphere — but also is a source of intense heat, the effect of which is felt at great distances. A ball of wood or a disc of metal is rather a dull object without this sense of something emanating from it.

When I use two circles of wire intersecting at right angles, this to me is a sphere — and when I use two or more sheets of metal cut into shapes and mounted at angles to each other, I feel that there is a solid form, perhaps concave, perhaps convex, filling in the dihedral angles between them. I do not have a definite idea of what this would be like, I merely sense it and occupy myself with the shapes one actually sees.

Then there is the idea of an object floating — not supported — the use of a very long thread, or a long arm in cantilever as a means of support seems to best approximate this freedom from the earth.

Thus what I produce is not precisely what I have in mind — but a sort of sketch, a man-made approximation.

60

That others grasp what I have in mind seems unessential, at least as long as they have something else in theirs.

<div align="right">
Alexander Calder, 'What Abstract Art Means to Me', 1950<br>
(translated in 1951 in *Témoignages pour l'art abstrait*).
</div>

Curt Valentin held a major exhibition of Calder's work in January 1952, and in the spring of the same year Calder returned to Paris to do the designs for a play, *Nuclea*, by Henri Pichette, whom he had met earlier through Giacometti. His interest in architectural and stage designs has persisted to the present day.

Through José Luis Sert, Calder had met the Venezuelan architect Carlos Villanueva at Roxbury in 1951. He saw him again in Paris in 1952, where Villanueva told him that he was designing an auditorium for the University of Caracas and wanted Calder to make a mobile for the lobby:

> I said, 'I'd rather be in the main hall.'
> And he said, 'Oh! No! You can't do that because the ceiling is taken up with ribbons of acoustical reflectors.'
> I said, 'Let us play with these acoustical reflectors'. And I made him a sketch.
> Carlos had engaged Bolt, Bereneck, and Newman, of Cambridge, Massachusetts, as acoustical engineers. I had to collaborate with them, and had to redraw the whole layout all over, once or twice, for Carlos. Newman kept saying:
> 'The more of your shapes, the merrier and the louder.'
> So we drew large round and oval shapes, some of them to be thirty feet or so long, painted different colors, and hung from the ceiling on cables from winches. There were also some of these shapes on the side walls.

Calder was given a one-man exhibition at the Venice Biennale in 1952, and he won first prize. This resulted in innumerable articles and reviews throughout the world, including a feature in *Life*, which described him as 'a Live Wire with Pliers.'

By this time Calder, who had of course begun his career as a painter, was beginning to resume the production of gouaches. Travels continued, including a long trip to the Near East in January 1954 and a trip to India during the winter of 1954–55. This latter was the result of an invitation from Gira Sarabhai, member of a wealthy family in Ahmedabad; she offered the Calders a visit to India in exchange for some mobiles. Calder produced eleven works in payment for his trip. He remains almost the only American, or even Western, sculptor to have enthusiastic patrons in the Near and Middle East.

During the early 1950s, exhibitions were held throughout the world. These included a retrospective at Curt Valentin's Gallery in New York and another at the Lefevre Gallery in London. Lawrence Alloway reviewed the latter:

> ···Calder has something of the fiesta-feeling of another American artist, Stuart Davis, whose egg-beater pictures touched a Calder-type subject (and who paints with the TV set on in the studio). Davis is a sort of Radio City Veronese. Sweeney has pointed out a similar mixture in Calder when he said that Calder is not, in any real sense, a 'machine age sculptor', though he uses wire cutters and a welding torch, basically he is like a traditional comedian on the radio, using a new channel of communication for popular and pleasant purposes.

<div align="right">
Lawrence Alloway, 'Amos 'n' Remus', *Art News and Review*, 1955.
</div>

<div align="right">

*A recent gouache in the making.* ▶

</div>

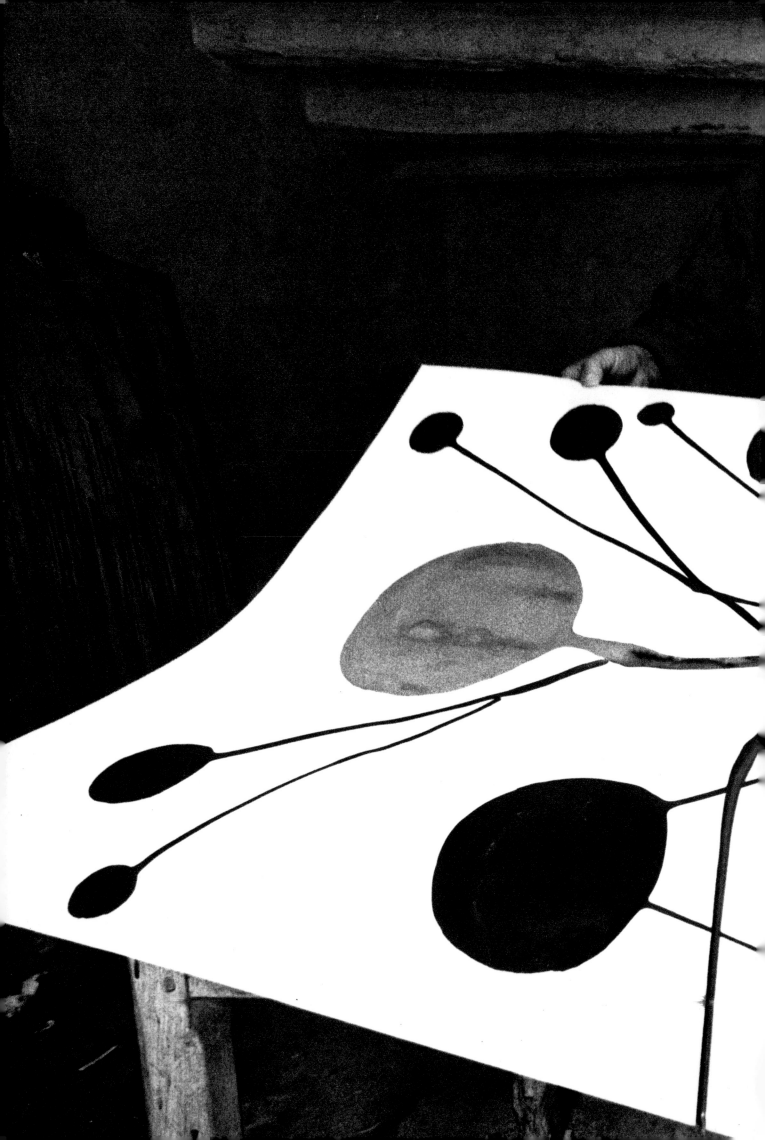

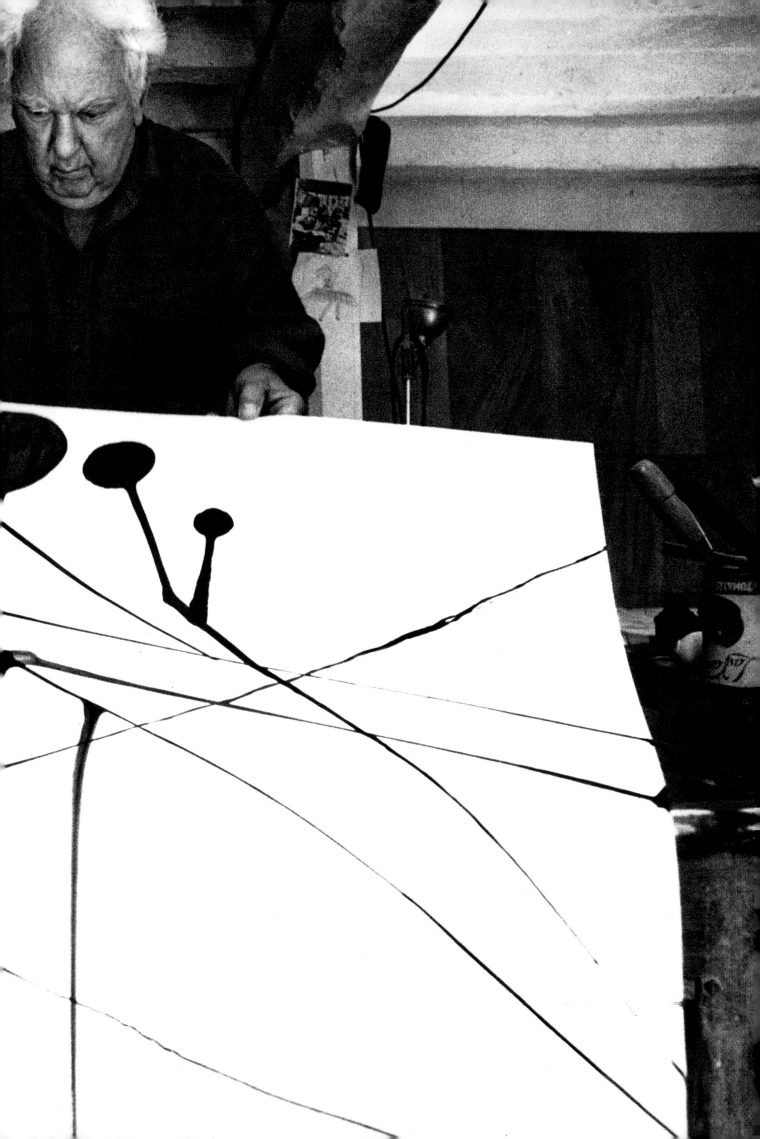

In August 1955, Calder flew to Caracas for an exhibition organized by Carlos Villanueva.

> During my stay, Carlos had arranged for me to work in the metal shop of the university, and I made, among others, two large mobiles. In my show at the Museo de Bellas Artes, everything was sold, most of it right after the opening, and I even had to send some more objects to Caracas when I got home in Roxbury. It is the only time I witnessed a complete sellout of a whole show, and it was in complete contrast to my last show at Valentin's gallery, after his death.
> One of the larger mobiles I had made in Caracas was bought by some engineers who worked for Jiménez, the president-dictator. He placed this somewhere near his beach house. When he was chased out, the art authorities looked for this object and could not find it anywhere.
> Could he have taken it with him into exile?
> The other big object I had painted red, yellow and blue. This caused a certain amount of consternation among my friends—I had painted it unwittingly in their national colors. So I substituted black for the blue, making it either German or Belgian, and everyone was happy.

The exhibition, held at the Museo de Bellas Artes in September-October 1955, included reprints of the famous articles by Sartre and Léger, as well as the following statement by the artist himself:

> From the beginnings of my abstract work, even when it might not have seemed so, I felt there was no better model for *me* to choose than the Universe.... Spheres of different sizes, densities, colors and volumes, floating in space, traversing clouds, sprays of water, currents of air, viscosities and odors—of the greatest variety and disparity.

On his return to Roxbury, Calder learned that his daughter Sandra and Jean Davidson, son of the sculptor Jo Davidson, were planning to get married. The marriage took place at the old mill on the Indre River near Saché, south of Tours, which the Calders had recently bought. Shortly thereafter Calder went to Frankfurt where he had a commission to create a large stabile, the *Hextoped.*

Since the late 1930s the artist had become more and more interested in the problem of the stabile or static work of sculpture. These he conceived on an ever more monumental scale, and, because of the various physical problems of construction, he began to work with foundries, creating his designs in terms of small models and then supervising the enlargement of these models, to a scale that has now reached 50 or 100 feet. It is partially the existence of an excellent foundry at Tours, not far from Saché, which has led him in recent years to live most of the time in France.

In the later 1950s there were a number of major commissions including the mobile *The Whirling Ear* for the Brussels Exposition, the standing mobile *The Spiral* for the UNESCO building in Paris, and the great hanging mobile for Idlewild (now Kennedy) International Airport in New York, all created in 1958.

In 1957, World House Galleries in New York held a '4 Masters Exhibition': Rodin, Brancusi, Gauguin, and Calder. He contributed the following statement (partly with tongue in cheek):

> A long time ago I decided, indeed, I was told that primitive art is better than decadent art. So I decided to remain as primitive as possible, and thus I have avoided mechanization of tools, etc. (in spite of having been trained as an engineer).

This, too, permits of a more variable attack on problems, for when one has an elegant set of tools one feels it is a shame, or a loss, not to use them.

When I am at a loss for inspiration I think of what Sweeney, or Sartre, or perhaps one or two others, have written on my work and this makes me feel very happy, and I go to work with renewed enthusiasm.

Klaus Perls had become Calder's New York dealer after Curt Valentin's death in 1954, and held an exhibition of large stabiles in 1958. The Perls exhibition was particularly significant as marking the point when Calder really began to envisage stabiles on a monumental scale constructed from heavy gauge steel. He had made large stabiles as early as 1937 ('Whale', in the Museum of Modern Art, New York, is 6′6″ high; other early ones included 'Black Beast', 1940, 8′9″ high), but these were to be dwarfed by the great stabiles of the 1960s.

Eliot Noyes, the architect, once came to me and wanted a certain stabile — "The Black Beast". It was at the time the biggest thing I'd ever made — eleven feet long by nine feet high, but in fairly light material. Noyes's interest encouraged me to have it done in heavy material, that is, one-quarter-inch iron plate. This, furthermore, encouraged me to do other things as well in heavy material and also supplied some funds with which to do so.

So, I decided to have a show at Klaus Perls's, of fairly large stabiles, in the winter of 1958. We sold three of these, which made things seem to glisten.

In the winter of 1959, I sent the remainder of the Perls show to Paris with quite a number of other objects. I had a show of about ten large stabiles at Maeght's in February 1959. Madame Maeght, who was a great enthusiast for these objects, was quite surprised and said to me:

'Tu as dû te racler la cervelle pour trouver ça?' (You must have picked your brains to find this?)

Maeght must have agreed with Gigitte, because he bought the whole show, outright, before the opening, the first time a dealer had done this to me!

After the show at Maeght's, I had another show in New York, at Perls's, where there was "The City", a large stabile with a little mobile element in its center. Carlos Villanueva saw this and got it for the Museo de Bellas Artes in Caracas.

The following winter, I had still another show at Perls's, little more than two large objects. One of these was a stabile painted red, called "The Crab". Sweeney got this for Houston; he is director of the modern art museum there. The other, "Clouds over the Mountains", eventually went to the Chicago Art Institute . . . .

When I embarked on stabiles and heavier objects, following Noyes's purchase of "The Black Beast", I often worked several metal shops at the same time. In 1958, I had three metal shops working for me, two in Waterbury and one, ten miles away, in Watertown. I got a sense of being a big businessman as I drove from one to another.

In one shop, I was making the head of the object for UNESCO, "The Spiral"; in another shop, I was making the forty-five-foot mobile for Idlewild; in Watertown, in the third, I was making "The Whirling Ear" for the Brussels Fair. It is still in Brussels, a gift of the United States.

In the Waterbury Ironworks, I was aided by Chippy Peronimo, and in the other Waterbury shop, by Carmen Segree. I say I was aided, but actually I took the place of the helper and worked under their direction, keeping my eye open to achieve the desired result.

A helper I was, except for using the sledge. Chippy tried me out once and our hammers met in mid-air — so he kicked me out of that job.

In 1959 Calder interrupted his regular commutation between Roxbury and Saché with a trip to Rio de Janeiro for an exhibition at the new Museu de Arte Moderno. The tour of Brazil included a visit to the spectacular new capital city of

*The foundry at Tours at the time Calder was working on 'Têtes et Queue' (1965) for* ▶
*the National Gallery designed by Mies van der Rohe in Berlin.*

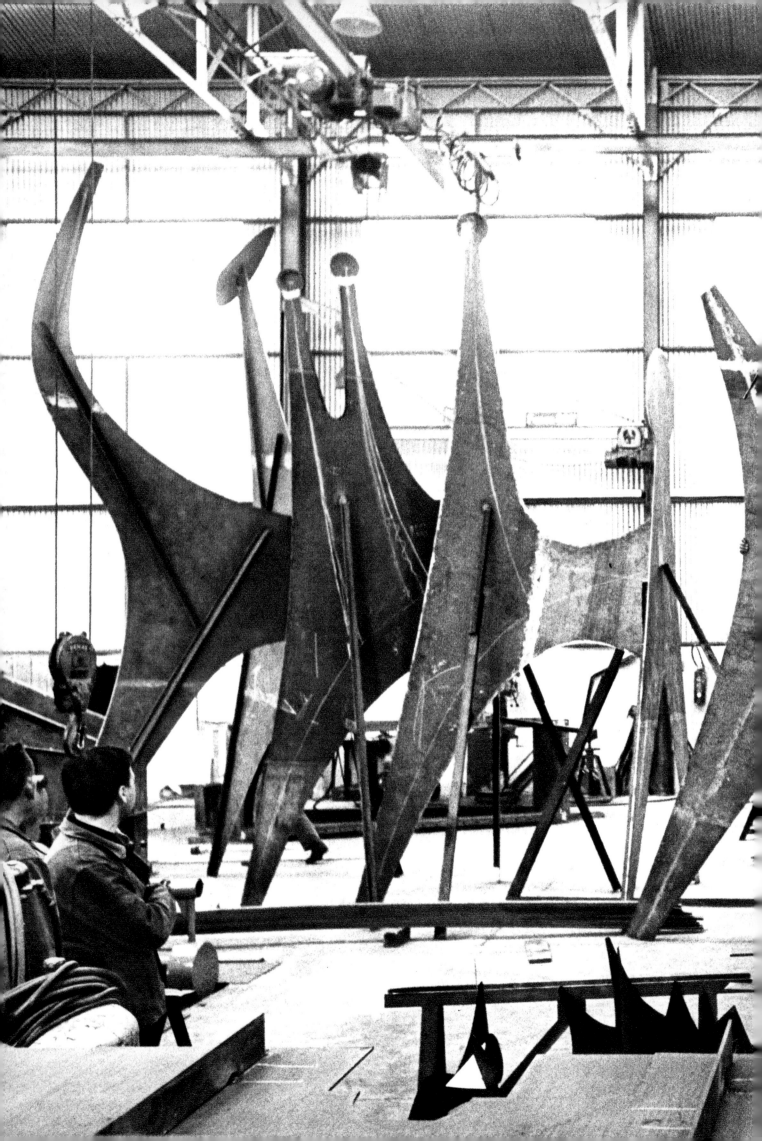

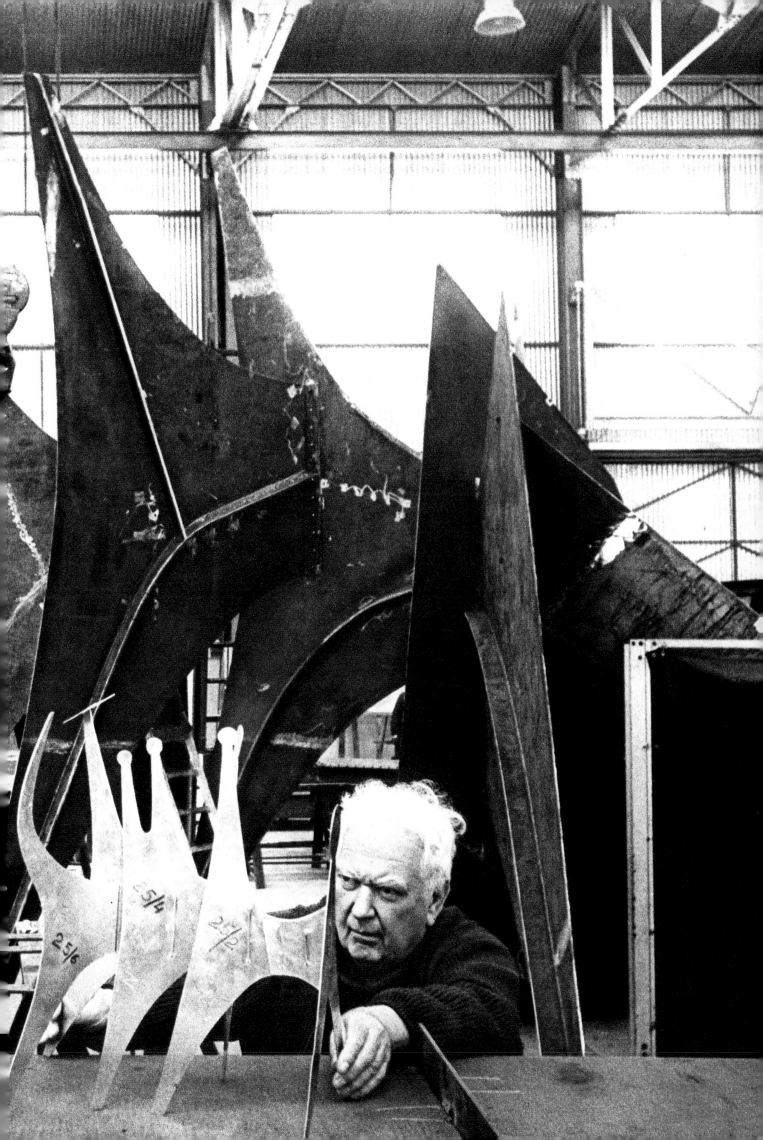

Brasilia where Oscar Niemeyer, its architect, discussed the possibility of a large-scale mobile. Calder made a small model and gave it to Niemeyer on another visit in February 1960, but heard no more of the project.

Early in 1959 the Galerie Maeght held an exhibition of large stabiles for which George Salles, Director of the National Museums of France, wrote the introduction.

··· What is a stabile? Having adopted Jean Arp's unusual appellation, what did Calder himself mean by stability? Is a stabile more stable than a statue? The key to the riddle does not lie there. A stabile conjures up its opposite, the mobile. Its opposite? Yes, since the latter moves, or is moved, and the former is, by definition, static. And no, for both are members of the same family, of which Calder is the author, and which is made up of creatures of a new species, assemblages of metal leaves which, depending on their arrangement, are capable or not capable of motion. Thus by forcing a definition one could say that a stabile is a mobile in repose, and a mobile a stabile in action. Jean Arp baptised the stabiles in 1932, after Duchamp had named the mobiles that same year....

Georges Salles, 'Stabiles', *Derrière Le Miroir,* 1959.

On this occasion an interview with Calder appeared in *XX Siècle,* 15 March 1959, by Yvon Taillandier.

When I began to make mobiles, everyone was talking about movement in painting and sculpture.

In reality, there wasn't much movement, only actions.

My mobiles are objects in space; I say I'm a sculptor to avoid a fuss.

What I want to avoid is the impression of mud piled up on the floor.

I'd like to sculpt a guy on a horse. But no one calls on me when there's a horse to be done.

My purpose is to make something like a dog, or like flames; something that has a life of its own.

The idea of making mobiles came to me little by little. I worked with whatever I had at hand.

My Scottish grandfather was a stone-cutter. He worked in London, then in America. My father was a sculptor. I never worked for him, except to pose for him.

I studied to be an engineer. But I didn't like figures. My boss gave me geographical maps to paste up.

After leaving school, I worked as an engineer for four years.

Finally I came to the conclusion I was more of a painter.

Sometimes I paint for three and four months at a time.

I'd like to do more painting. But even in a big studio, like the one I have in America, the points of my mobiles threaten to puncture my canvases.

Sometimes I make sketches for my mobiles. But I can never know in advance what I'm going to do.

I cut out plates of different thicknesses, so that some will be heavier than others.

In 1932, a wooden globe gave me the idea of making a universe, something like the solar system.

That's where the whole thing came from.

I went from wooden globes to flat forms out of laziness.

Laziness is a product of leisure. You have to know how to use your free time, which is a good climate for invention.

I weld and cut out my metal plates myself. I cut out the big plates with a welding torch (acetylene torch). I get people in to help me.

You need a lot of patience to do all that cutting.

I haven't got that kind of patience.

When I cut out my plates, I have two things in mind. I want them to be more alive, and I think about balance.

Which explains the holes in the plates.

The most important thing is that the mobile be able to catch the air. It has to be able to move.

A mobile is like a dog-catcher. A dog-catcher of wind.

Dog-catchers go after any old dog; my mobiles catch any kind of wind, bad or good.

Myself, I'm like my mobiles; when I walk in the streets I latch onto things, too.

In 1959–60, the Stedelijk Museum in Amsterdam held an exhibition which then travelled to several museums in Germany and Switzerland.

During April, 1960, another major exhibition appeared at the Palais des Beaux-Arts in Brussels. Later that year, Katharine Kuh's collection of interviews, *The Artist's Voice*, appeared:

Question: Does your work satirize the modern machine?
Calder: No, it doesn't. That's funny, because I once intended making a bird that would open its beak, spread its wings and squeak if you turned a crank, but I didn't because I was slow on the uptake and I found that Klee had done it earlier with his Twittering Machine and probably better than I could. In about 1929, I did make two or three fish bowls with fish that swam when you turned a crank. And then, of course, you know about the Circus. I've just made a film of it in France with Carlos Vilardebo.
Question: Which has influenced you more, nature or modern machinery?
Calder: Nature. I haven't really touched machinery except for a few elementary mechanisms like levers and balances. You see nature and then you try to emulate it. But, of course, when I met Mondrian I went home and tried to paint. The simplest forms in the universe are the sphere and the circle. I represent them by disks and then I vary them. My whole theory about art is the disparity that exists between form, masses and movement. Even my triangles are spheres, but they are spheres of a different shape.
Question: How do you get that subtle balance in your work?
Calder: You put a disk here and then you put another disk that is a triangle at the other end and then you balance them on your finger and keep on adding. I don't use rectangles—they stop. You can use them; I have at times but only when I want to block, to constipate movement.
Question: Is it true that Marcel Duchamp invented the name "mobile" for your work?
Calder: Yes, Duchamp named the mobiles and Arp the stabiles. Arp said, "What did you call those things you exhibited last year? Stabiles?"
Question: Were the mobiles influenced by your Circus?
Calder: I don't think the Circus was really important in the making of the mobiles. In 1926 I met a Yugoslav in Paris and he said that if I could make mechanical toys I could make a living, so I went home and thought about it awhile and made some toys, but by the time I got them finished my Yugoslav had disappeared. I always loved the circus—I used to go in New York when I worked on the *Police Gazette*. I got a pass and went every day for two weeks, so I decided to make a circus just for the fun of it.
Question: How did the mobiles start?
Calder: The mobiles started when I went to see Mondrian. I was impressed by several colored rectangles he had on the wall. Shortly after that I made some mobiles; Mondrian claimed his paintings were faster than my mobiles.
Question: What role does color play in your sculpture?
Calder: Well, it's really secondary. I want things to be differentiated. Black and white are first— then red is next—and then I get sort of vague. It's really just for differentiation, but I love red so much that I almost want to paint everything red. I often wish that I'd been a *fauve* in 1905.
Question: Do you think that your early training as an engineer has affected your work?

*The foundry at Tours: intermediate model of 'Crossed Blades' (1967). A.C.: 'The final* ▶
*version is 11 meters high or about 36 feet. It's in Sydney, Australia. For these very big pieces designed for a particular location it is necessary to make an intermediate-sized model to be sure the scale is right. For this one we made two models to show the construction, because Australia is so far away and we had to convince the guy how it was going*
*to look.'*

69

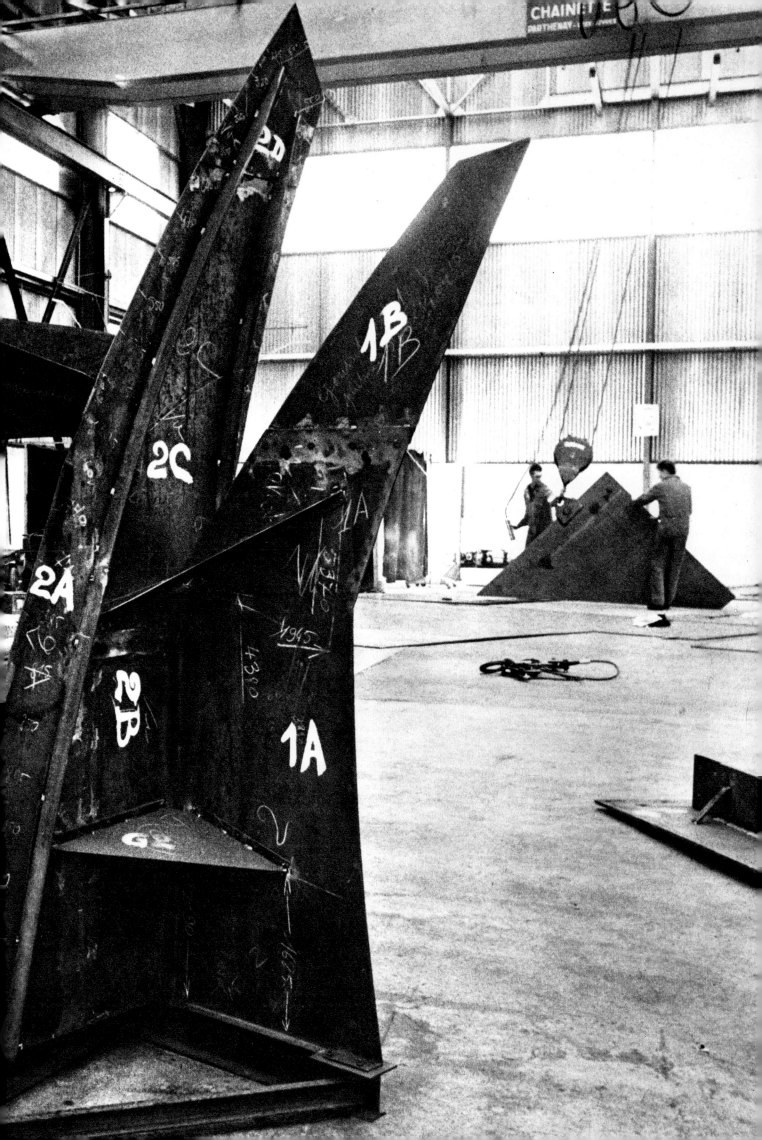

Calder: It's made things simple for me that seem to confound other people, like the mechanics of the mobiles. I know this, because I've had contact with one or two engineers who understood my methods. I don't think the engineering really has much to do with my work; it's merely the means of attaining an aesthetic end.

Question: How do you feel about your imitators?

Calder: They nauseate me.

Question: Do you make preliminary sketches?

Calder: I've made so many mobiles that I pretty well know what I want to do, at least where the smaller ones are concerned, but when I'm seeking a new form, then I draw and make little models out of sheet metal. Actually the one at Idlewild (in the International Arrival Building) is forty-five feet long and was made from a model only seventeen inches long. For the very big ones I don't have machinery large enough, so I go to a shop and become the workman's helper.

Question: How do you feel about commissions?

Calder: They give me a chance to undertake something of considerable size. I don't mind planning a work for a given place. I find that everything I do, if it is made for a particular spot, is more successful. A little thing, like this one on the table, is made for a spot on a table.

Question: Do you prefer making the large ones?

Calder: Yes — it's more exhilarating — and then one can think he's a big shot.

Question: How do your mobiles differ from your stabiles in intention?

Calder: Well, the mobile has actual movement in itself, while the stabile is back at the old painting idea of implied movement. You have to walk around a stabile or through it — a mobile dances in front of you. You can walk through my stabile in the Basle museum. It's a bunch of triangles leaning against each other with several large arches flying from the mass of triangles.

Question: Why walk through it?

Calder: Just for fun. I'd like people to climb over it but it isn't big enough. I've never been to the Statue of Liberty but I understand it's quite wonderful to go into it, to walk through.

Question: Léger once called you a realist. How do you feel about this?

Calder: Yes, I think I am a realist.

Question: Why?

Calder: Because I make what I see. It's only the problem of seeing it. If you can imagine a thing, conjure it up in space — then you can make it, and *tout de suite* you're a realist. The universe is real but you can't see it. You have to imagine it. Once you imagine it, you can be realistic about reproducing it.

Question: So it's not the obvious mechanized modern world you're concerned with?

Calder: Oh, you mean cellophane and all that crap.

Question: How did you begin to use sound in your work?

Calder: It was accidental at first. Then I made a sculpture called Dogwood with three heavy plates that gave off quite a clangor. Here was just another variation. You see, you have weight, form, size, color, motion and then you have noise.

Question: How do you feel about your motorized mobiles?

Calder: The motorized ones are too painful — too many mechanical bugaboos. Even the best are apt to be mechanically repetitious. There's one thirty feet high in front of Stockholm's modern museum made after a model of mine. It has four elements, each operating on a separate motor.

Question: How did you happen to make collapsible mobiles?

Calder: When I had the show in Paris during 1946 at Louis Carré's gallery, the plans called for small sculptures that could be sent by mail. The size limit for things sent that way was $18 \times 10 \times 2$ inches, so I made mobiles that would fold up. Rods, plates, everything was made in two or three pieces and could be taken apart and folded in a little package. I sent drawings along showing how to reassemble the pieces.

Question: You don't use much glass any more, do you?

Calder: I haven't used it much lately. A few years ago I took all sorts of colored glass I'd collected and smashed it against the stone wall of the barn. There's still a mass of glass buried there. In my early mobiles I often used it.

72

Question: Are there any specific works that you prefer and would like to have reproduced?

Calder: What I like best is the acoustic ceiling in Caracas in the auditorium of the university. It's made from great panels of plywood—some thirty feet long—more or less horizontal and tilted to reflect sound. I also like the work I did for UNESCO in Paris and the mobile called Little Blue under Red that belongs to the Fogg. That one develops hypocycloidal and epicycloidal curves. The main problem there was to keep all the parts light enough to work.

Question: Do you consider your work particularly American?

Calder: I got the first impulse for doing things my way in Paris, so I really can't say.

Question: Have American cities influenced you?

Calder: I like Chicago on the Michigan Avenue Bridge on a cold wintry night. There used to be no color but the traffic lights, occasional red lights among the white lights. I don't think that looking at American cities has really affected me. We went to India and I made some mobiles there; they look just like the others.

Question: What's happened to that large sculpture, The City?

Calder: The City was purchased by the Museo de Bellas Artes in Caracas through the kind offices of my good friend, the architect Carlos Raul Villanueva.

Question: I found it great. What do you think of it?

Calder: I'm slowly becoming convinced. I made the model for it out of scraps that were left over from a big mobile. I just happened to have these bits, so I stood them up and tried them here and there and then made a strap to hook them together—a little like *objets trouvés*. ("Found objects" usually refers to articles in nature and daily life, like shells, stones, leaves, torn paper, etc., which the artist recognizes and accepts as art. Ed.) I decided on the final size by considering the dimensions of the room in the Perls Galleries where the work was to be shown.

Question: What artists do you most admire?

Calder: Goya, Miró, Matisse, Bosch and Klee.

Carola Giedion-Welcker paid specific attention to him in her volume on *Contemporary Sculpture*, and Geoffrey Hellman, who had interviewed Calder in 1941, re-visited him for *The New Yorker* in 1960. In his book *Sculpture of This Century*, Michel Seuphor devoted a long chapter to Calder and his place in twentieth-century art.

"Calder's art is the sublimation of a tree in the wind," Marcel Duchamp has written. This is well said, but it does not go far enough. Ben Nicholson, in an article that appeared in 1941, has described a mobile of Calder's in terms that I find so simple and felicitous that I want to quote the entire passage: "The first time I encountered a Calder was in Paris some years ago when I borrowed one and hung it from the center of the ceiling of a white room overlooking the Seine, and at night, with the river glistening outside, this mobile object turned slowly in the breeze in the light of an electric bulb hung near its center—a large black, six white, and one small scarlet, balls on their wires turned slowly in and out, around, above and below one another, with their shadows chasing, round the white walls in an exciting interchanging movement, suddenly hastening as they turned the corners and disappearing, as they crossed the window, into the night—it was alive like the hum of the city, like the passing river and the smell of Paris in early spring, but it was not a work of art as many people think of a work of art—imprisoned in a gold frame or stone-dead on a pedestal in one of our marble-pillared mausoleums. But it was 'alive' and that, after all, is not a bad qualification for a work of art."

Calder dreamed of transcribing the constellations, of creating planetary systems . . . .

"When I have used spheres and disks," he said, "I have intended that they should represent more than what they just are. More or less as the earth is a sphere, but also has some miles of gas about it, volcanoes upon it, and the moon making circles around it, and as the sun is a sphere—but also is a source of intense heat, the effect of which is felt at great distances. A ball of wood or a disk of metal is a rather dull object without this sense of something emanating from it . . . ."

*'Cinq Ailes' ('Five Wings') in construction, 1967.* ▶

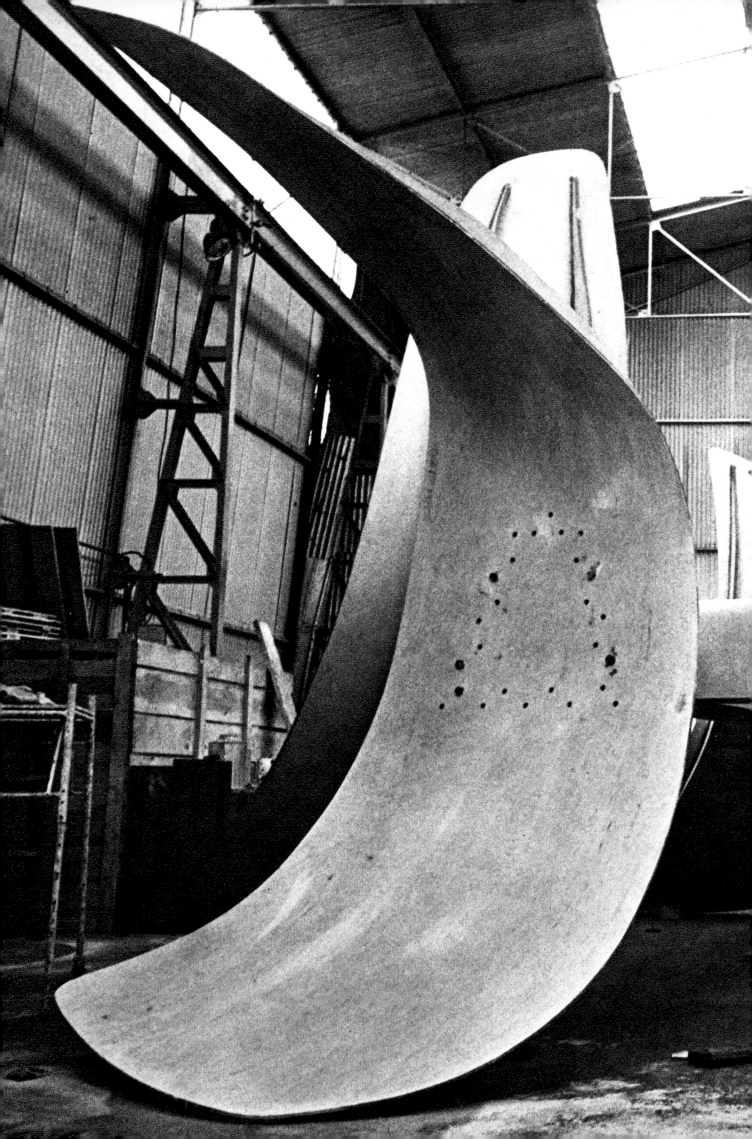

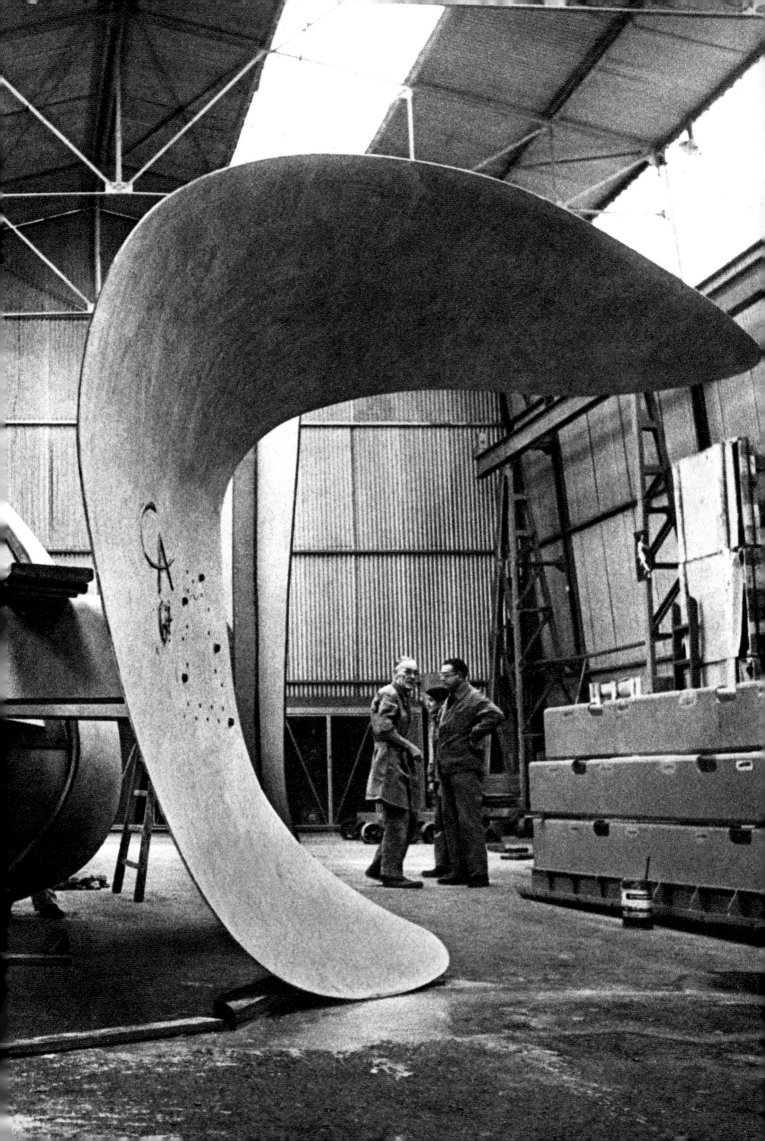

In 1961 the Stedelijk Museum, Amsterdam, the Moderna Museet, Stockholm, and the Louisiana Humbleback, Copenhagen, held an enormous exhibition on motion in art. It was, in effect, an apotheosis of Calder in the light of his influence and his descendants.

During the early 1960s, he was engaged in the creation of a vast studio on a hill close to his home in Saché, a studio which became inadequate for his huge new stabiles almost before it was completed.

I had already asked the Galerie Maeght the precise height of their ceiling several times before. But just to reassure myself, I did it again in the spring of 1962, while the big studio overlooking Saché was being completed. I was dismayed upon being told that the ceiling was about to be lowered, for before that I had made a large "Spider" — which is now in the Basel Museum — and this object would just clear the gallery as it was, and I wanted to do more objects at least that size. But now, Maeght was going to put in a fancy lighting system that would eat up some of the height.

I said, "The hell with this," and cast around for some place out of doors, where the sky would be my ceiling. I modestly chose the square paved court of the Louvre.

It was at this moment that Calder began to look for an adequate iron works in Tours, and established contact with the Etablissements Biémont. But there were, of course, problems in training the workmen to his particular needs:

It is a little difficult at first to get the workmen to understand just what you want. The sympathy seems to be there already, but it takes some repetition to make the hard curves of the silhouette of the objects. When a plate seems flimsy, I put a rib on it, and if the relation between two plates is not rigid, I put a gusset between them — that is, a triangular piece, butting in to both surfaces.

Finally, the men know pretty much what I want and it is a question of a little higher or lower for the reinforcements — that I have to decide.

In a month or so, six of the Biémont objects were transported to Saché and set up in the "big studio". These included "Spiny Top and Curly Bottom", "Thin Ribs", "The Guillotine for Eight", "Cepe", "Triangles", and "Le Guichet",

But hurray, Maeght did not mess up his ceiling. He realized finally, on his own, that the proposed lighting system would spoil his rooms which are so fine. So in November 1963, I had a show there with two big objects, one of which had been set up outside the Saché studio, on the promontory. These were "Le Tamanoir" — The Anteater — (the outside object), and "Triangles".

We also had "Cepe" and "Spiny Top" and two other new objects.

During 1962, he created his most monumental stabile to that date, *Teodelapio* (approximately 60 feet in height), for the outdoor sculpture exhibition at Spoleto, Italy.

The retrospective at the Tate Gallery, London, in the same year led to a number of important magazine articles, including Jean Davidson's historical survey and an appreciation by Pierre Guéguen.

The next year the Galerie Maeght had another exhibition of six large stabiles. James Jones and Michel Ragon contributed introductions to the catalogue.

What is a Calder? A Calder is a sort of chandelier which hangs, like all chandeliers, from the ceiling, but which, unlike other chandeliers, does not hold lighting equipment, but serves as a perch for our reveries. A Calder is an iron spider-web, a "swan" ("cygne" — J.-P. Sartre's phil. pun

on "signe"), a sign which has become a trademark, a feather in the wind, a sculpture that moves . . . .

"The least one can ask of a sculpture is that it stay still", said Salvador Dali.

"The *most* one can ask of a sculpture is that it move", amended Calder. Sculpture has been too long in the hands of plasterers and marble-cutters . . . .

Mobiles are birds on the wing or branches swaying in the breeze. Stabiles are, on the other hand, aggressive or hostile plants or insects, headless cranes with drooping wings. They are also like farm machines, mechanical praying mantises like their contemporaries, the scrapers, bull-dozers and drag-lines.

A stabile is an airplane without a motor, a tractor without a wheel, a tank without a caterpillar. What are they for Calder himself? He must have some ideas on the subject, because he takes them from his studios and sets them outdoors to graze in the fields, like cows. If one were to believe Calder's titles, they are alternately a Dog, a Double Mushroom, a Widow, a Cactus, or even a Coalman.

We think of mechanisms and he thinks of living beings . . . .

Michel Ragon, 'What is a Calder', *Derrière Le Miroir,* 1963.

In 1964 five stabiles were exhibited at the Documenta show in Kassel, Germany; there was an exhibition of circus drawings, wire sculptures, and toys at the Houston Museum; and, opening in November, a great retrospective at the Guggenheim Museum in New York. Then, from July to October 1965, a second major retrospective held at the Museé d'Art Moderne, Paris, included more of the larger new stabiles.

The biggest object was 'Deux Disques' — too big to put inside, so it was erected on the side-walk by the entrance. Buses with visitors stopped and people got out to have their pictures taken in groups under the stabile; others took pictures of the object at various angles . . . .

The exhibition at the Guggenheim Museum travelled in reduced form to the Milwaukee Art Center; the Washington University Gallery of Art, St. Louis; the Des Moines Art Center; and the National Gallery of Canada, Ottawa. It produced a tremendous number of articles, reviews, and comments in both the United States and Europe. These were almost without exception paeons of praise for a great artist. Two of the more perceptive articles were an interview by the painter Cleve Gray, a friend of Calder, and a piece by Barbara Rose. The Gray article, which included a delightful letter from Calder's old friend Miró, dealt particularly with the circus and specifically with a group of recently discovered drawings that had been completed thirty years earlier. This early work was exhibited at the Perls Gallery in November-December 1967 and Calder described the re-discovery:

I think it was in December of 1930, when I came over to marry Louisa, that I brought some drawings with me.

The Museum of Modern Art was located in the Hecksher Bldg. and there was a very pleasant young man there, Pat Codyre.

*Calder with 'Southern Cross', 1963.* ▶

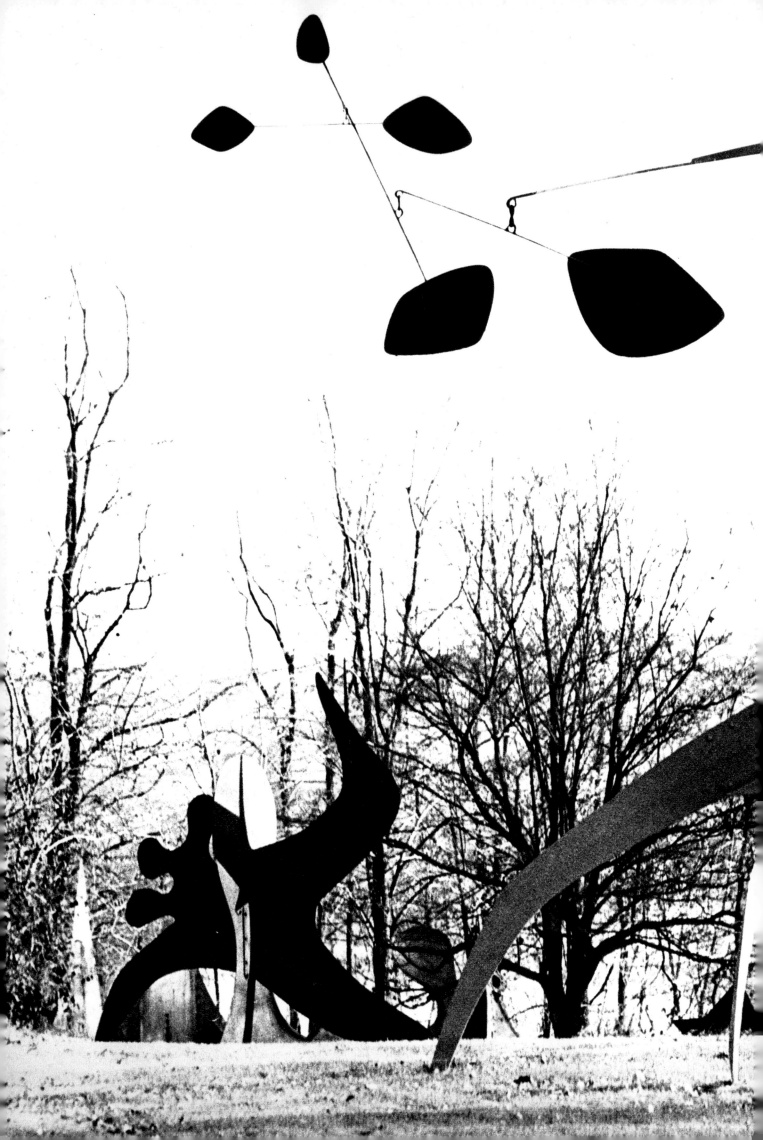

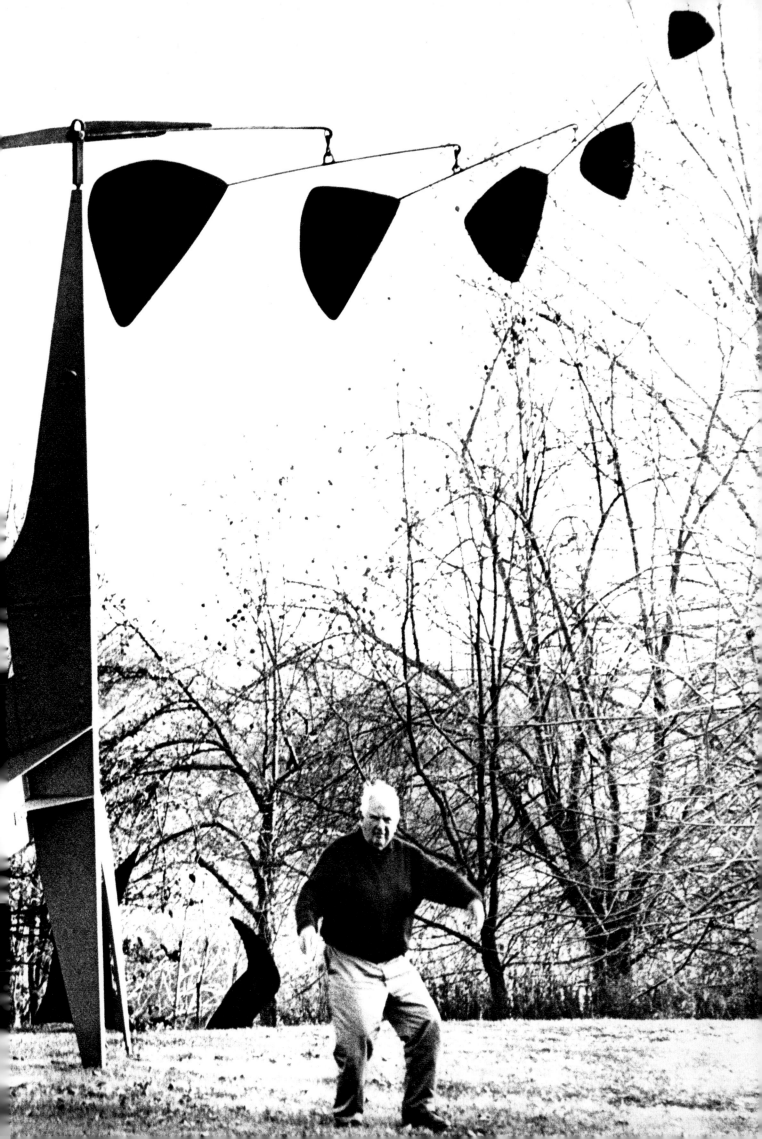

As I was to be in New York only a short time I confided my drawings to Pat in the hopes that he might sell one or two for me.

I never saw Pat again, and when, in Chicago I saw a drawing or two, by me, I thought I was on his traces. But last fall Alfred Barr unearthed these drawings, and they must be the ones I left with Pat.

In January 1965 Calder was commissioned by the architect I. M. Pei to create a monumental stabile for a new building at the Massachusetts Institute of Technology, 'La Grande Voile' ('The Big Sail'), some 40 feet high. Also in 1965, Howard and Jean Lipman presented a large stabile, 'Le Guichet' ('The Ticket Window'), to Lincoln Center, New York.

A clue to the development of Calder's reputation is revealed by two entries on the artist in the authoritative *Current Biography*, the first dated April 1946, and the second July 1966. In the earlier biography the tone is light; the emphasis is on the artist's wit and humour. He is described as '"the sculptural playboy" of modern art'. Newspaper and art magazine reviews were quoted to the effect that 'I don't yet know if it is important as art, but it is certainly a lot of fun.' Although other quotations indicated the degree to which he was being taken seriously by a number of important critics, particularly James Johnson Sweeney, it would be difficult from the biography to realize what important breakthroughs had already been made in his art. The revised biography, in 1966, is entirely serious, with far fewer personal anecdotes, and recognizes the artist as one of the great masters of twentieth-century sculpture.

During 1967 and 1968, Calder was engaged in a number of his most monumental projects for stabiles. The gigantic 'Man', some 70 feet high, commissioned by the International Nickel Company of Canada, was perhaps the most dramatic feature of Montreal's Expo 67. In an interview, he described the development of this and other large-scale stabiles.

The artist said he designed the work by scratchings on paper. Then he built a model about three feet high from sheet aluminum. "After that, I turned it over to the iron workers to magnify."

What was Mr. Calder's "Man" supposed to say to visitors of Expo? Nothing specifically, according to the artist.

"There is no idea I want to express – no meaning. What I have tried to do is just create something interesting to look at," he said.

The six legs arch some 30 feet toward a central "torso". Then, the figure rises in sweeping interlocking triangles, three of them crowned by headlike disks. Although observers might find in it some abstract expression of the brotherhood or the community of man, Mr. Calder advised against it.

"When we first talked about a sculpture 20 meters tall – that's about 64 feet – they asked me to stretch it to 67 feet because it was for Expo 67," Mr. Calder reported.

"But I told them that was like giving me the commission because I was 67 years old. I happened to be 67 then. I'm 68 now, and will be 69 on July 22."

Mr. Calder said he found Expo 67's modern and sometimes bizarre architecture exciting to look at. "But," he added, "I'm so old-fashioned. If I design a house to live in, it turns out to look like a Roman aqueduct."

Jay Walz, 'Calder Oversees Creation of "Man"',
*New York Times*, 9 April 1967.

Between May and July 1967, the Akademie der Künste in Berlin had another major retrospective of the artist, exhibiting some 210 works from all periods. For this, Willem Sandberg revised the poetic introduction he had composed for the 1959 exhibition at the Stejdelik Museum, now presenting it specifically as a prose poem of praise and affection for the artist.

sandy calder
a man resembling a bear
hair white red shirt bright pants
everything round nose mouth body
his warmhearted wit not excepted
out of the corner of his mouth
fall
short
jaggy
sentences
from coarse fingers
flows gentle movement
the elements steel wire
tin and balance
delicate branches
with large autumn leaves
yellow
black   red
white   blue
driven by a breath of air
describing above
cheerfully colorfully
twisting forms
without beginning
or end
but
at once
we witness
the growth of
dark gigantic and
strong stable figures
'signals' 'coal merchant' 'dog'
'long nose' 'black widow' 'black beast'
'spider' 'shoe' 'cactus' 'guillotine for eight'
alexander calder as the first american contributed
in the early 30's to the development of the visual arts
: balance and movement without a machine
his life work belongs to history as well as to the present

*Calder at the time of 'Hello Girls!' (1964)* ▶

81

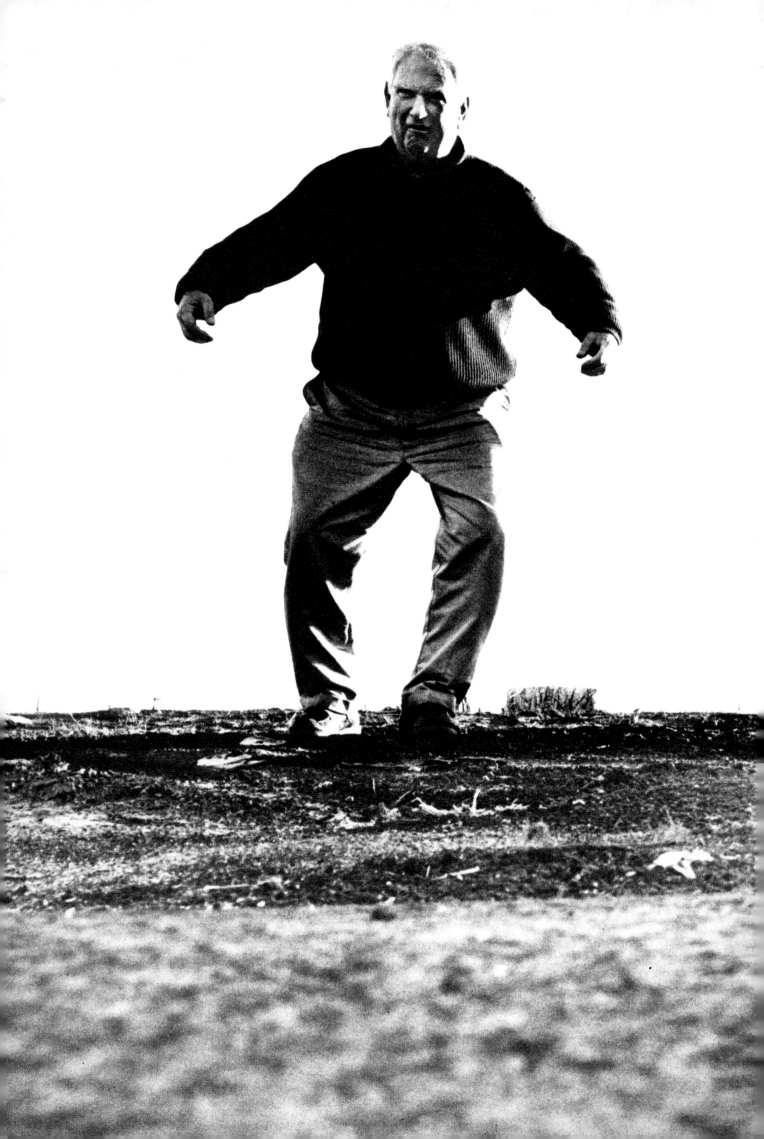

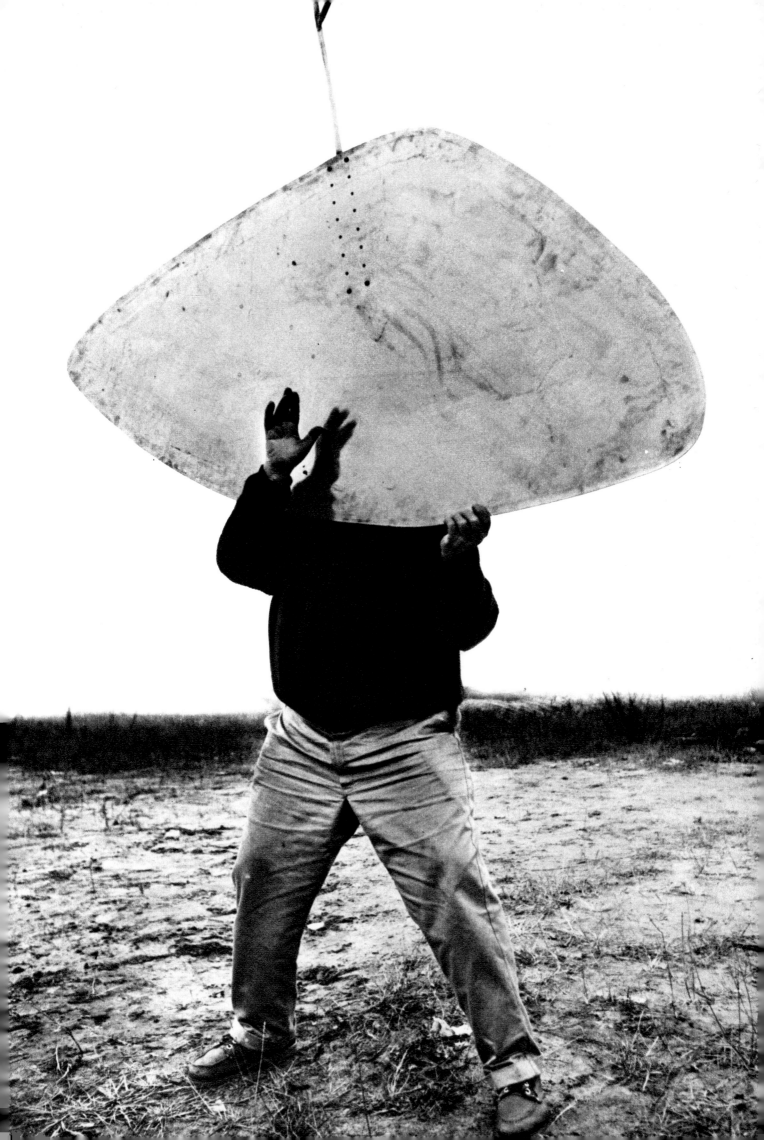

In the autumn of 1967, he was asked to lend a work to a project for placing large contemporary sculptures on public sites throughout New York City. Most of the artists invited quite naturally chose prominent sites in central Manhattan, but Calder, in a characteristic gesture, chose Harlem.

During the early part of 1968 Calder was invited to return to an early, largely unfulfilled, passion — that of designing for the theatre. This was, of course, evident in his famous circus as well as in innumerable drawings for the circus. In 1935 and 1936 he had made mobile settings for Martha Graham; also in 1936, mobile settings for Erik Satie's *Socrate*; in 1946 mobiles for Padraic Colum's play *Balloons*; in 1949 mobiles and other effects for a play by Donagh MacDonagh, *Happy as Larry*; and the same year mobiles for a ballet in Rio de Janeiro, *Symphonic Variations*.

In recent years, however, the enormous expansion of his sculptural activities left little time for theatrical experiments. Thus it was with particular delight that he embarked on the commission offered him by the Royal Opera House in Rome. In this instance, Calder was no longer simply the set designer. He was the main event, the entire ballet. *Newsweek* described the venture on 25 March 1968:

> The glittering Rome Opera House audience was agog with curiosity last week. They had no idea what sculptor Alexander Calder had in store for them. Was it an opera? But there were no singers. A ballet? But there were no dancers. Perhaps it was a happening.
> The 69-year-old Calder calls his first stage piece "Work in Progress." It's old hat, he told Newsweek's Jeanne Molli. "But noncommittal." To the lyric leaps and cacophonous bleeps of electronic music by Niccolo Castiglioni, Aldo Clementi and Bruno Maderna, Calder's colored sculptures danced and sang, from abstract mobiles in all sizes and shapes to a Noah's ark of birds, beasts and fish.
> But this new venture of Calder, the man who made art move, is anything but noncommittal. The nineteen-minute work is a cosmic romp that begins with a galaxy of mobiles high above the stage like the universe before genesis. On the white screen of Part Two, the blue line of the sea is projected, across which swim black sea creatures and a giant red starfish. The firmament has been divided. Then comes land, with birds of every hue, followed by man — fourteen bicyclists in brightly colored stretch suits.
> Finale: In the next to last part, dominated by a black pyramid and an enormous jolly sun beneath which a man waved a long red flag, Calder seemed to be noting the first stirrings of religion and politics. "Several people suggested I change the flag's color," says Calder. "I think red's the only color. There's no social significance." In this finale, a heaven and earth of mobiles and stabiles, of objects seeking and finding innocent and joyful communion, Calder once more affirmed his faith in the human spirit and his belief that art is the highest expression of man's imagination.
> The Roman audience responded enthusiastically. Novelist Alberto Moravia said: "As a sculptor he revealed a great sense of theatre. It was done with delicacy, with elegance, or maybe the word I mean is magic." Calder's new work is not only cosmogonical but personal, reflecting in the circusy bike riders and in the several replicas of past mobiles his creative life from its beginning. "Maybe I should have called it 'My Life in Nineteen Minutes'," said the artist.

It was also discussed in Giovanni Carandente's article, 'A Child Giant', written for the Maeght catalogue of October, 1968 for a new group of standing mobiles, or 'Totems'.

... In Rome, during these last months, a production was mounted which was created and designed entirely by Calder—his life in 19 minutes, as he called it after seeing it on stage for the first time. He confided to Massimo Bogianchino (artistic director of the Rome Opera) that this spectacle "had lain hidden under the ashes for a long time, and seemed almost extinguished." The production, called *Work in Progress*, an ensemble of incomparable scenic inventions and forms, was the liveliest thing that had happened to the theatre since Diaghilev....

The same catalogue contains an essay by Jacques Dupin dealing specifically with the 'totems'.

The stabiles, black silhouettes assaulting the sky, display the tensional contradictions of their complex structure. But they are unconditionally, in the last analysis, tied to their spatial boundaries. The mobiles, on the other hand, have no determinate boundaries, and inscribe ephemeral patterns in the air until the impulse that started them in motion is spent. The 'arrows',* however, behave in a more disturbing manner, both optically and spatially. There is a kind of secret vibration at their summit, by which internal resolution is finally achieved. The 'arrows', which rise up from the earth and also describe luminous orbits in the air, are weighted in a fashion which defies the calculations of balance.

An 'Arrow': that which is born of the marriage and opposition of the stabile base and the mobile upper part; a 'fixed' sculpture which thrusts itself above and beyond its earth-bound base, which supports the circular and aerial motion of the summit. A sculpture which surpasses all notions of equilibrium, and is endowed with an energy and a lightness that the sum of its parts cannot explain, deriving its upward movement from the resolution and suspension of conflicting elements....

Today, Calder continues to live and work and travel, while museums and galleries exhibit his work ever more frequently. Perhaps it is appropriate to conclude with the final paragraph of Bernice Rose's perceptive essay in her 'Salute to Alexander Calder' at the Museum of Modern Art, in late 1969:

Fernand Leger once called Calder a realist; Calder's reply is: "If you can't imagine things, you can't make them, and anything you imagine is real."

*The standing mobiles that Calder calls 'totems'.

H.H.A.

*Beware of the dog!* ▶

# A SURVEY OF CALDER'S WORKS

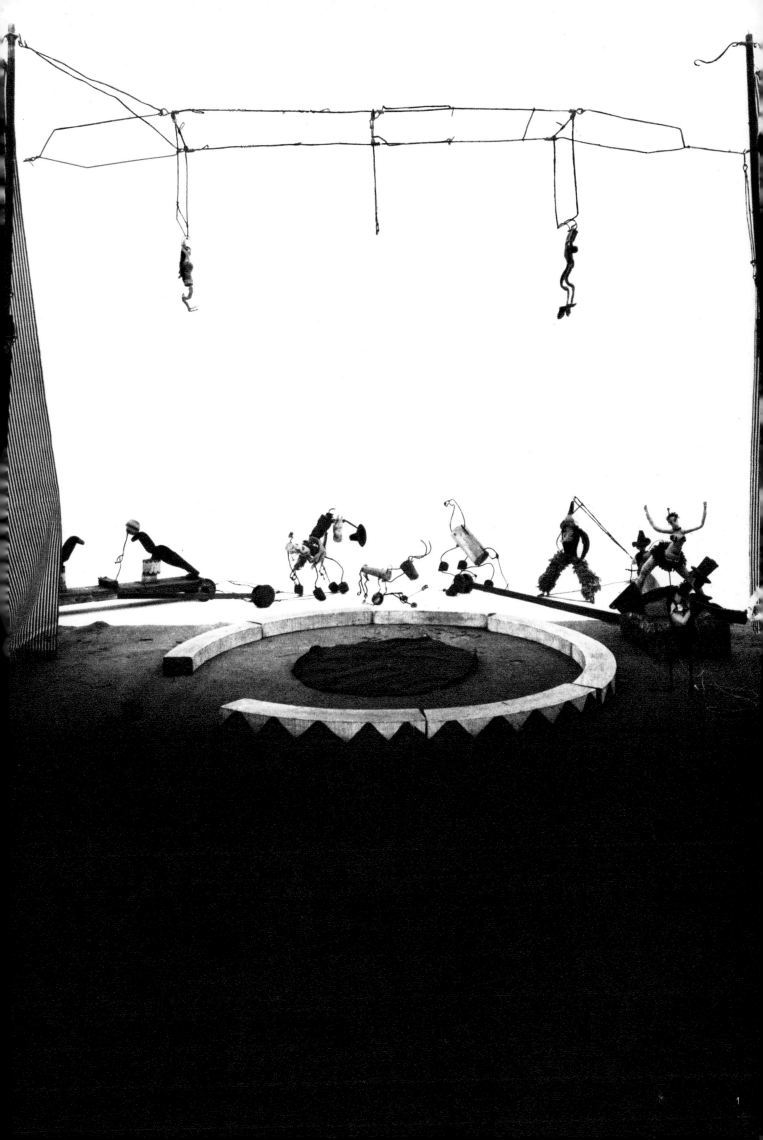

1

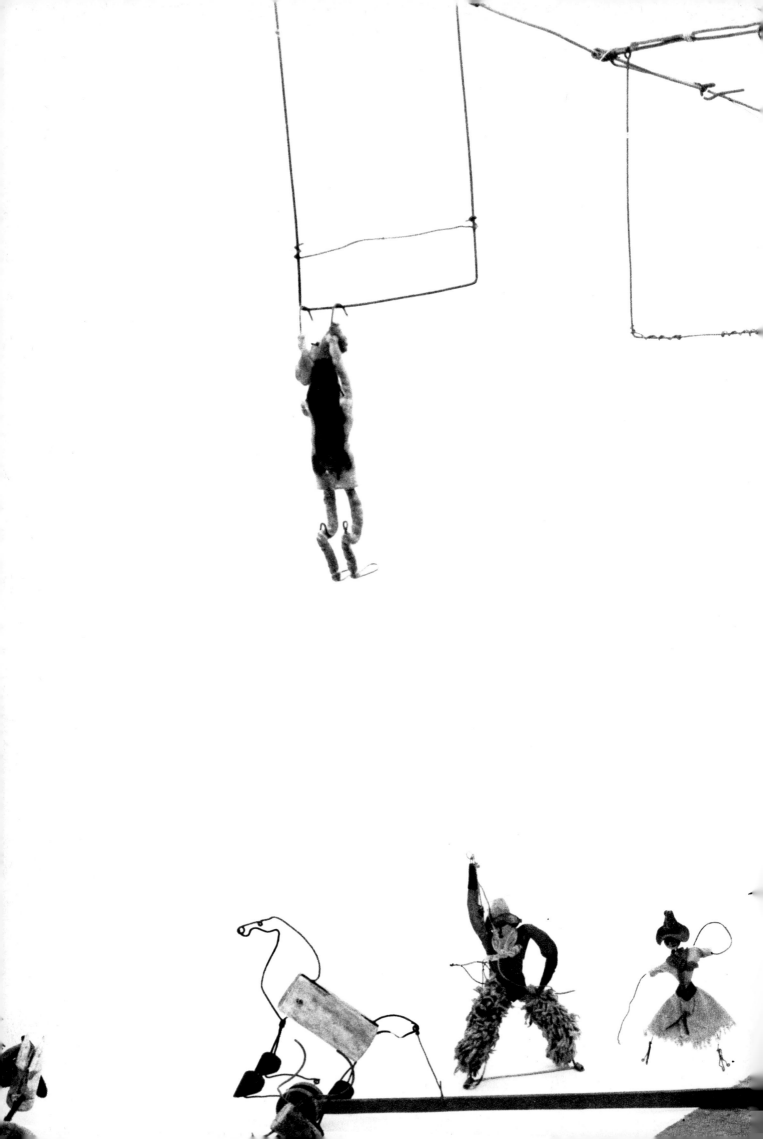

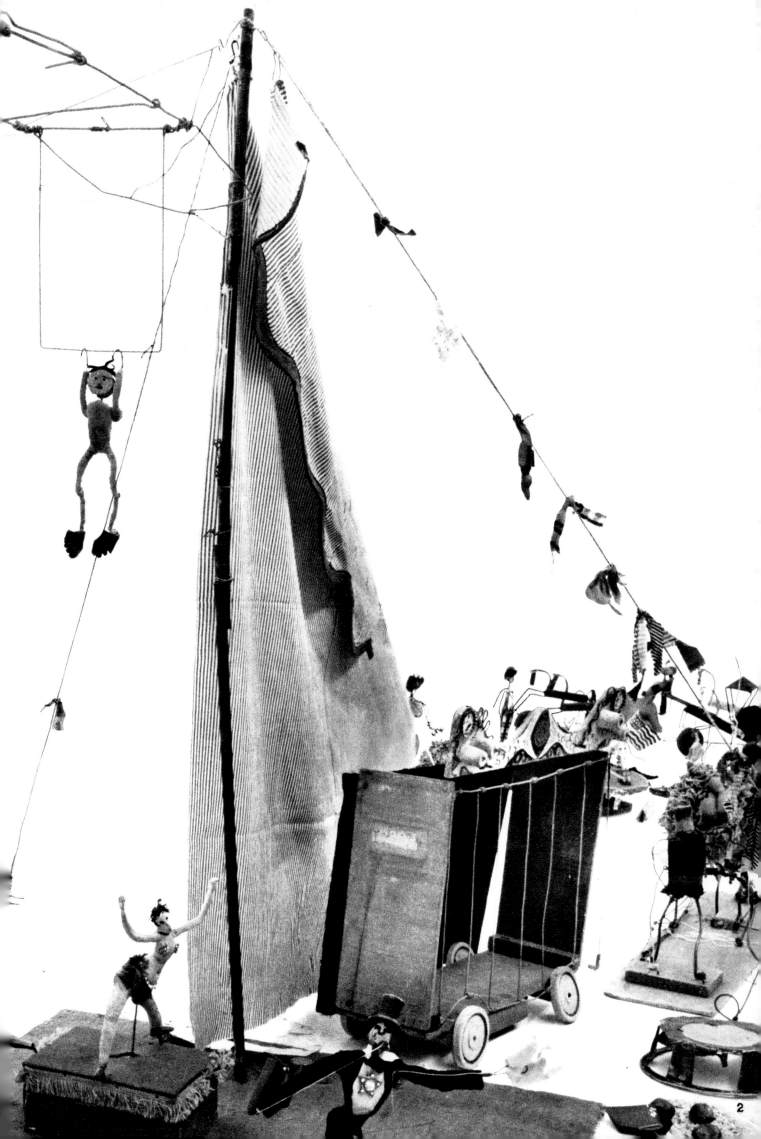

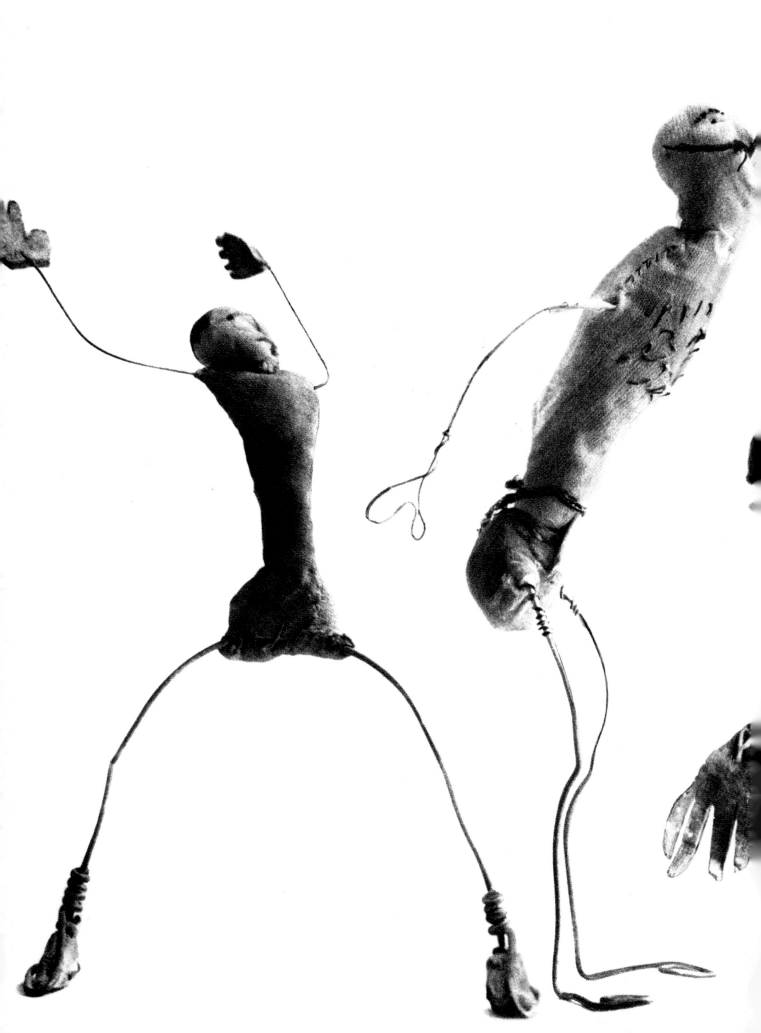

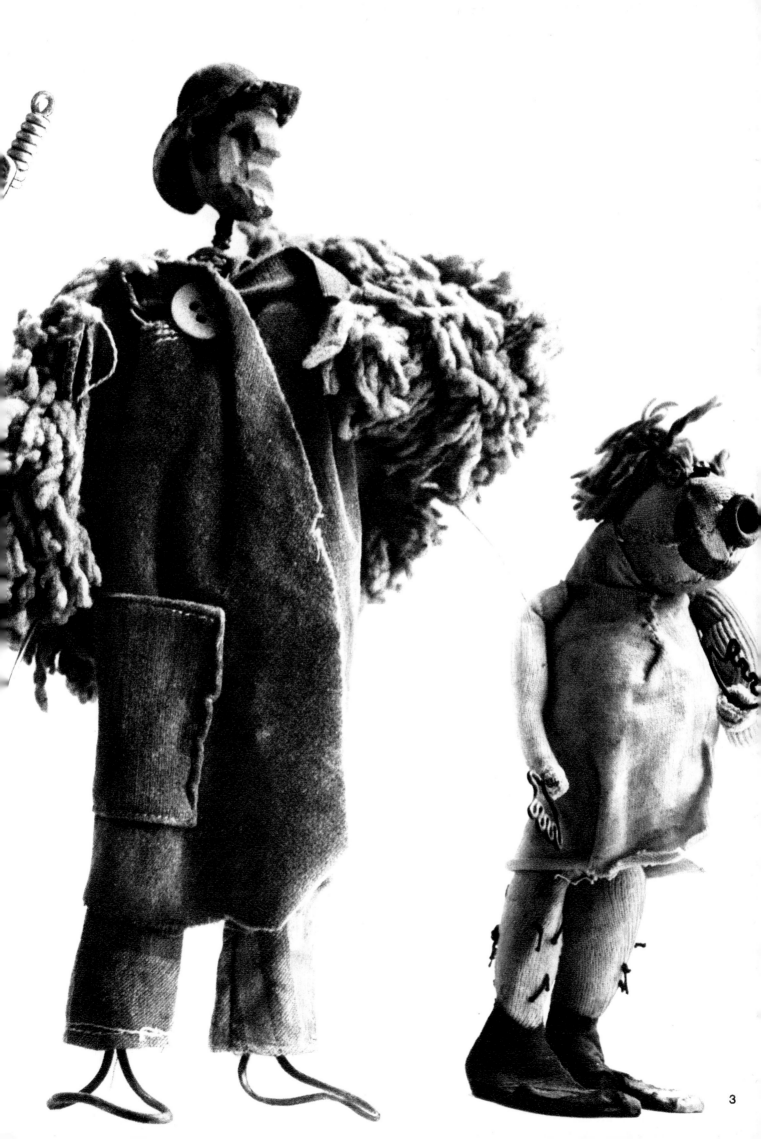

3

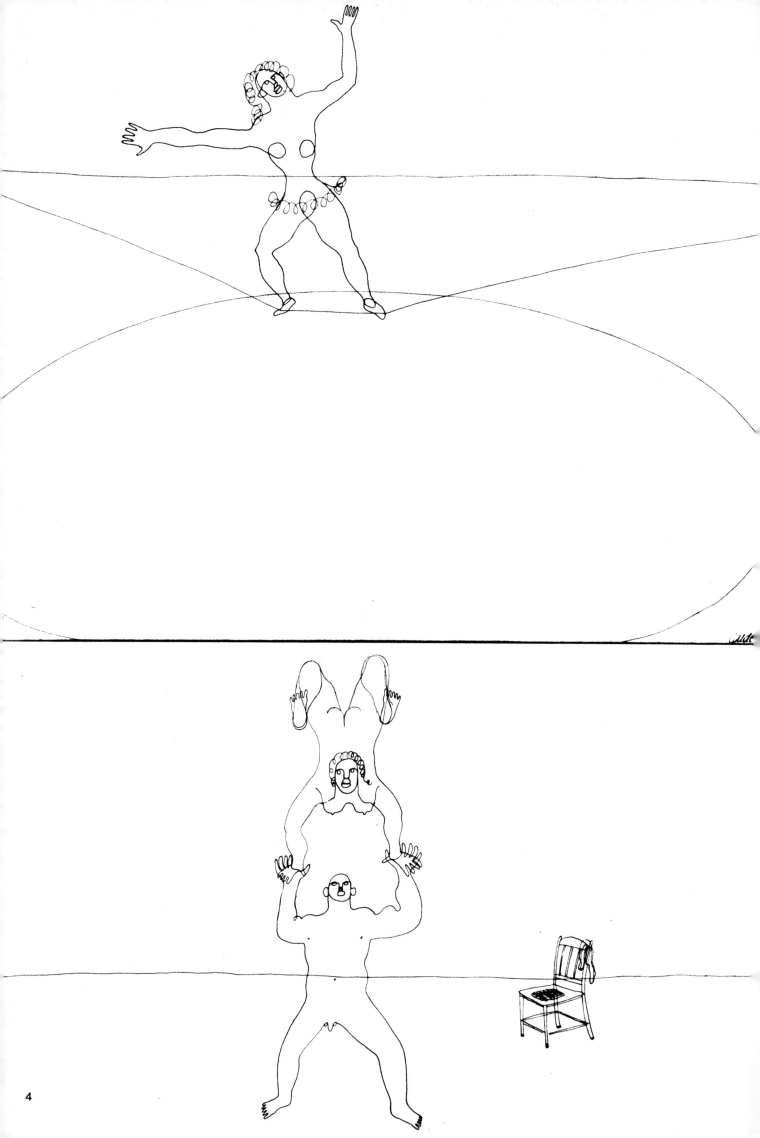

4

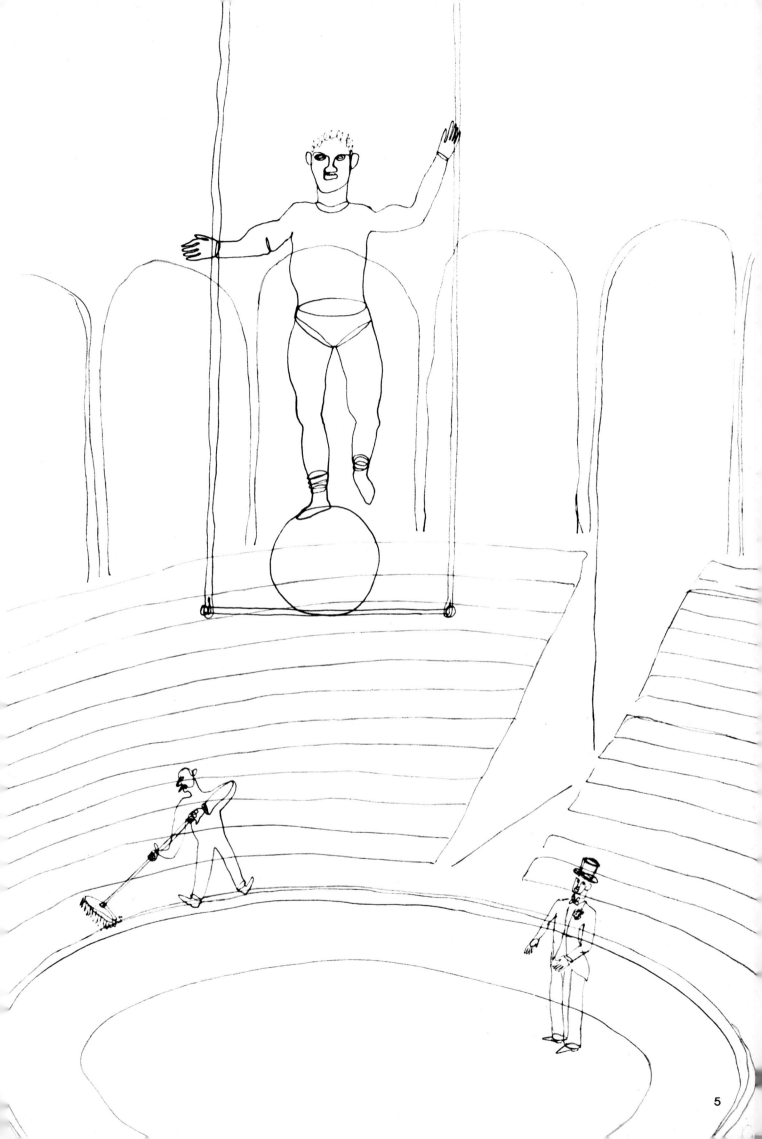

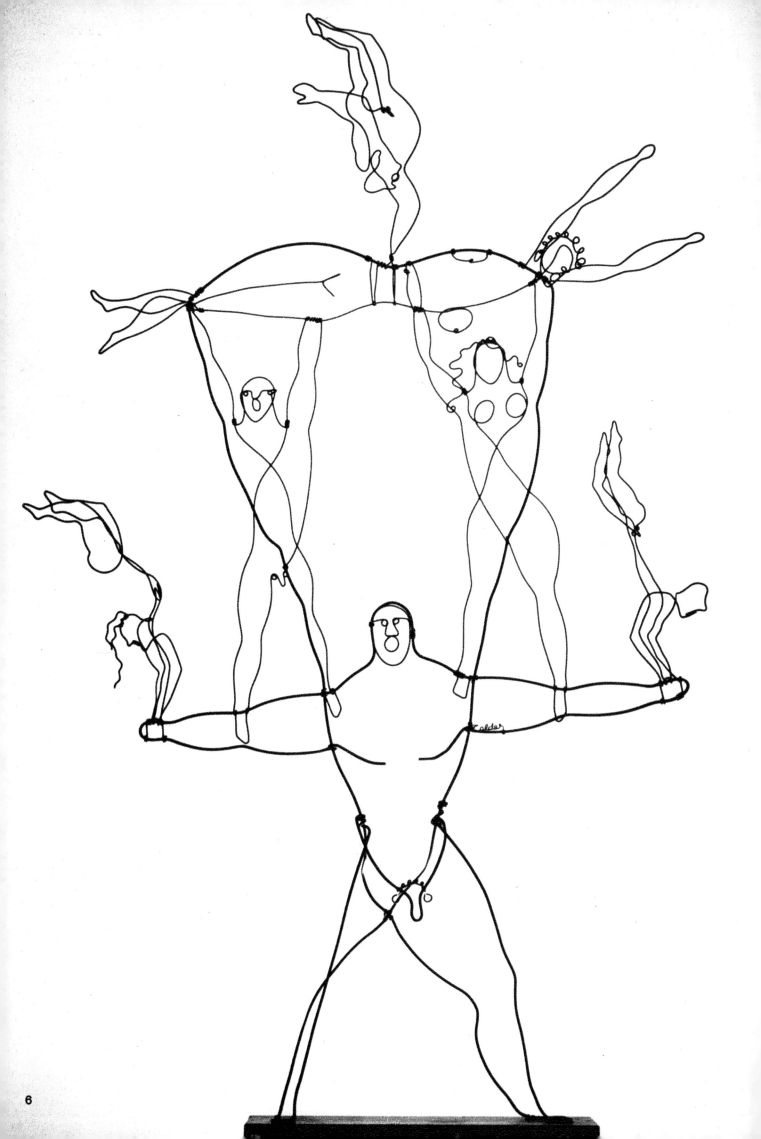

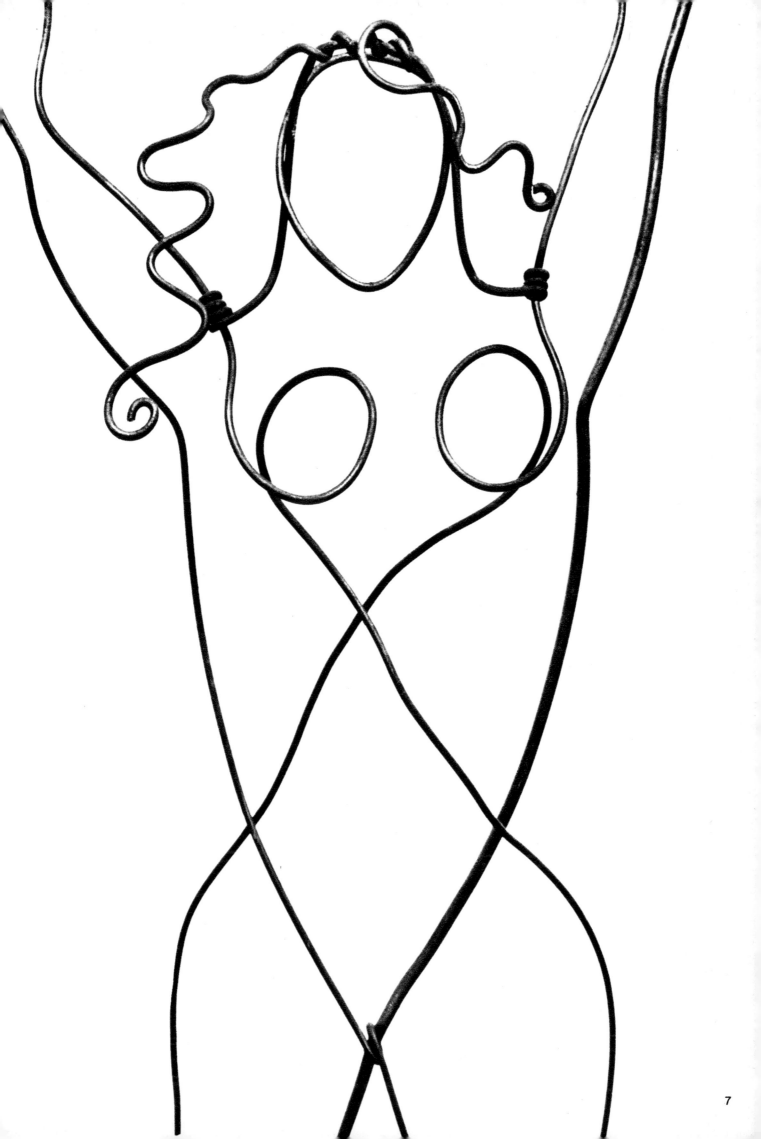

10

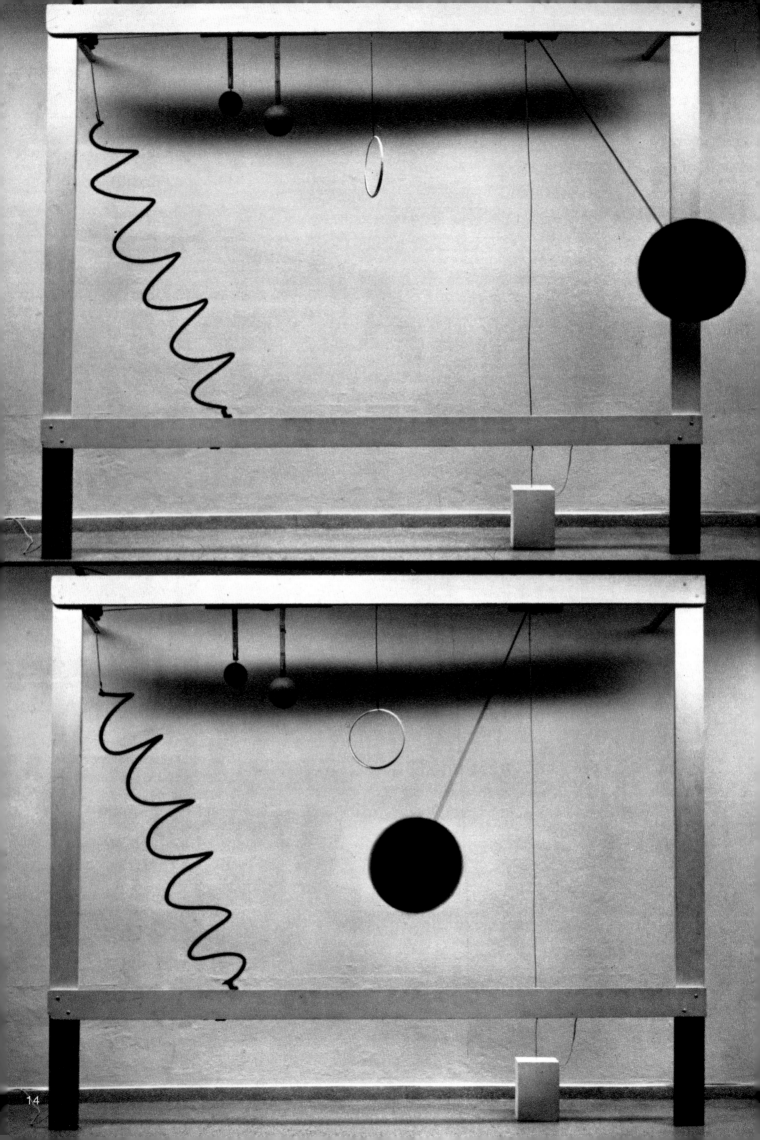

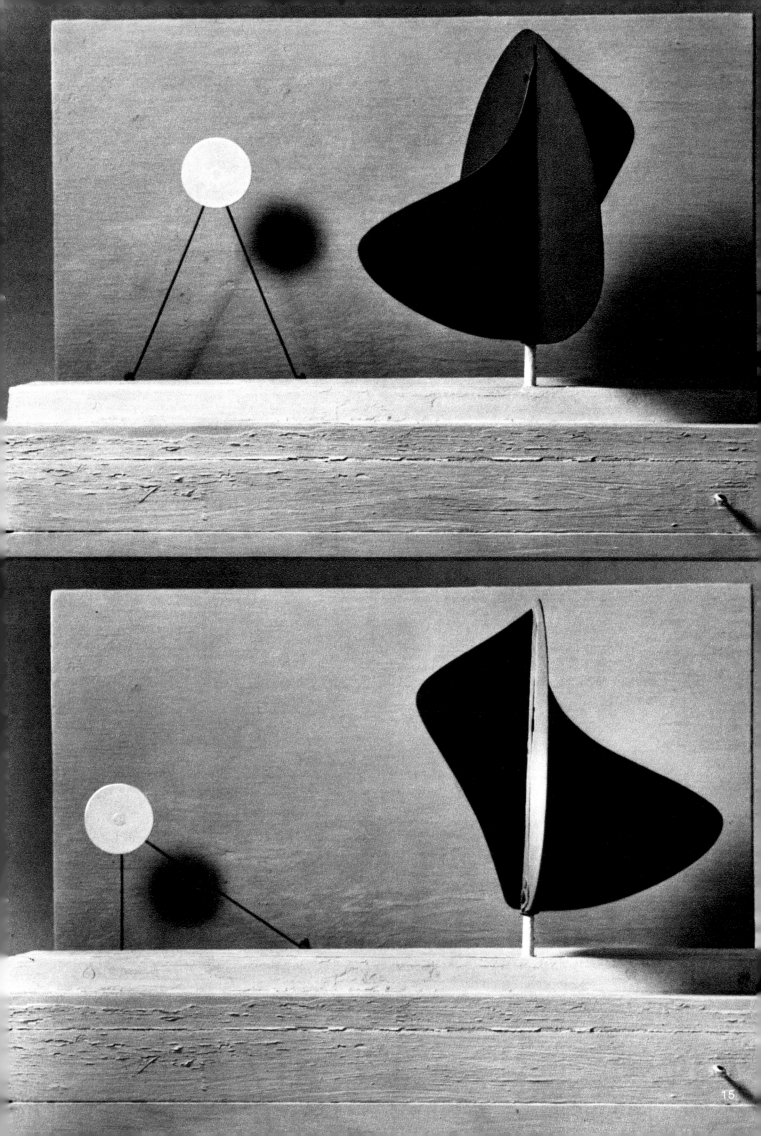

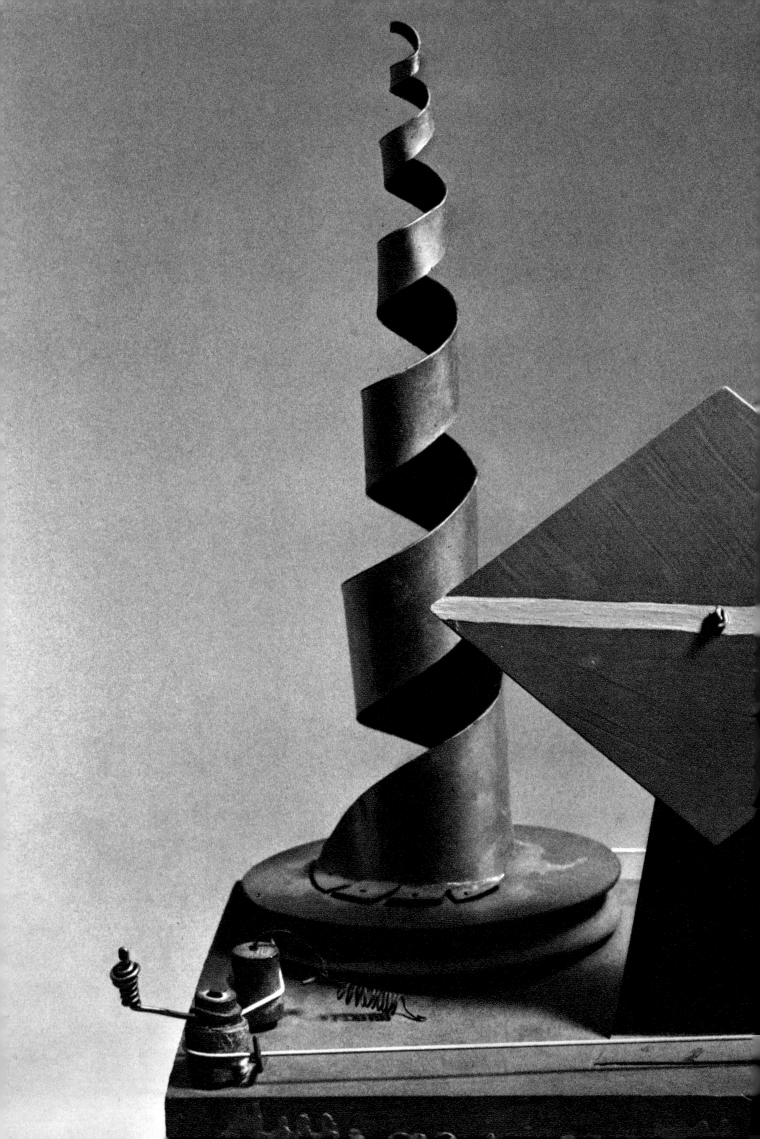

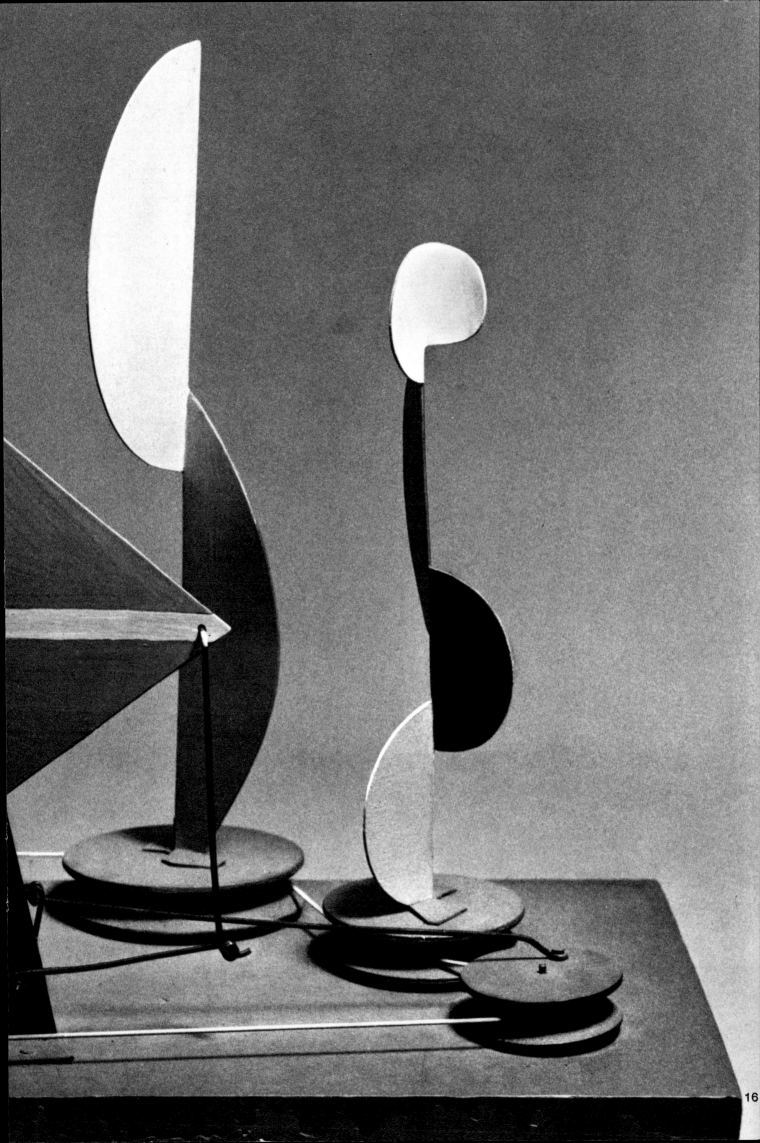

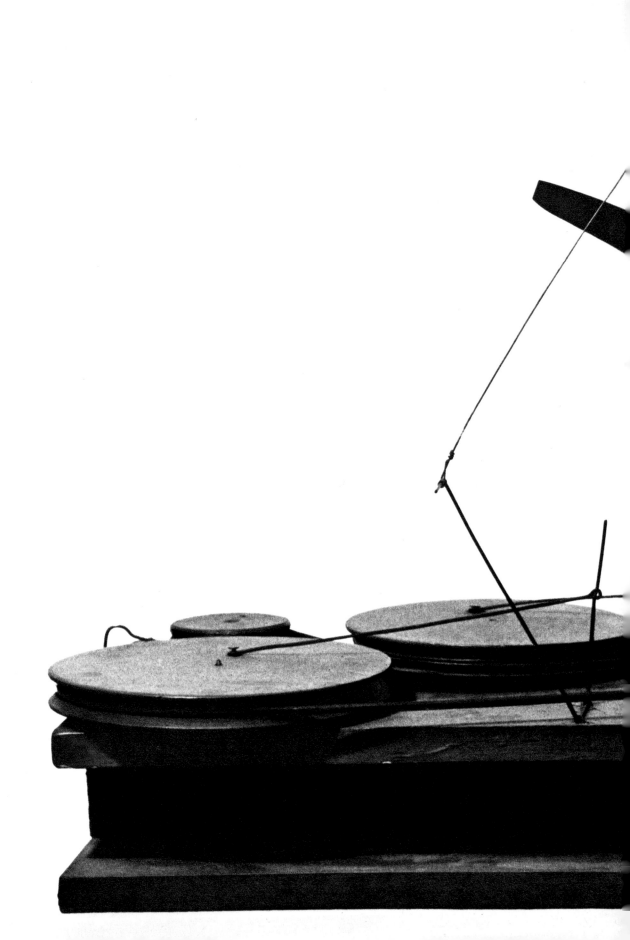

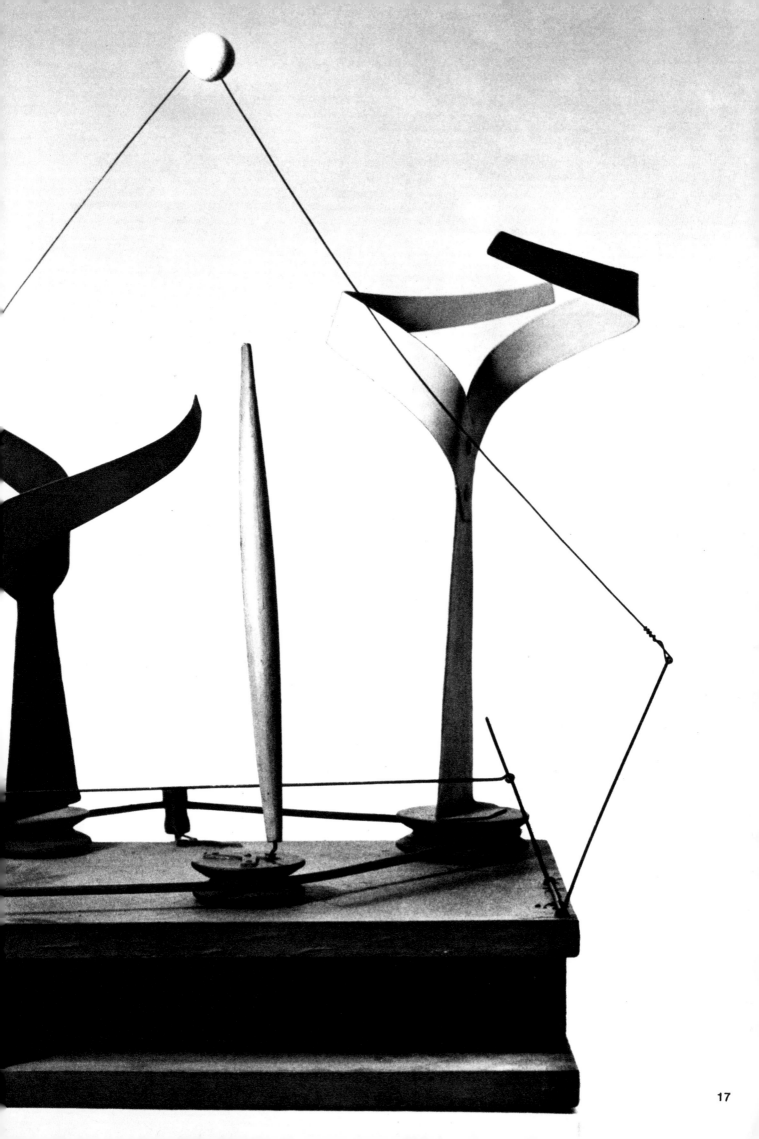

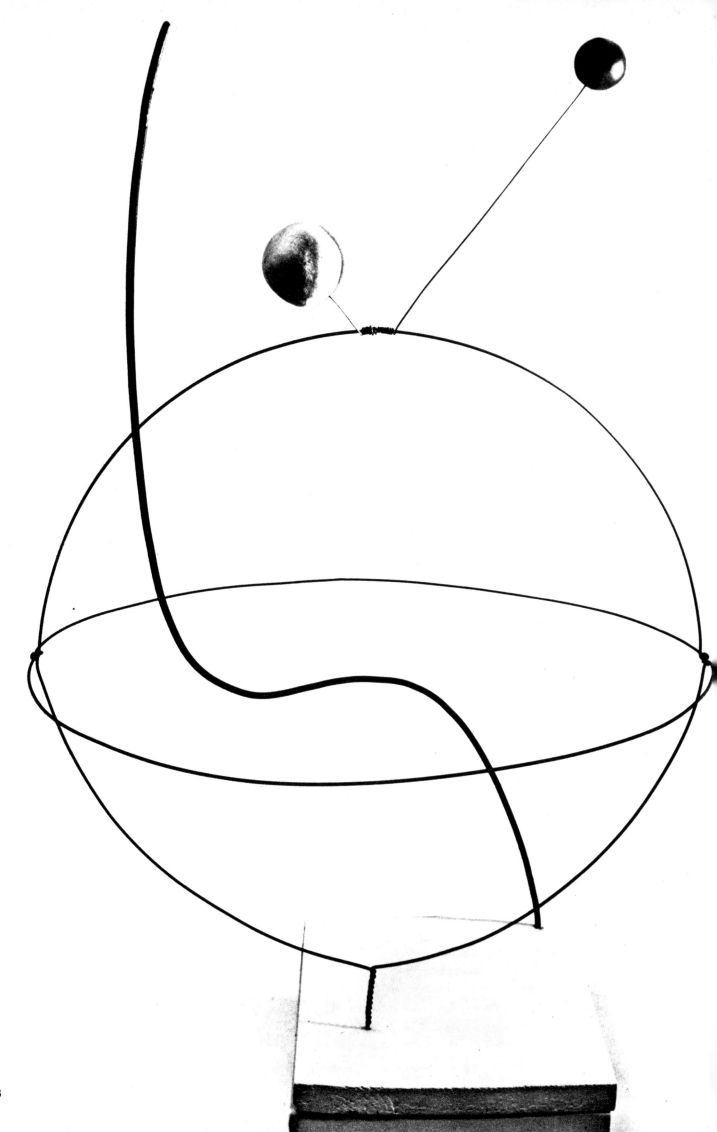

18

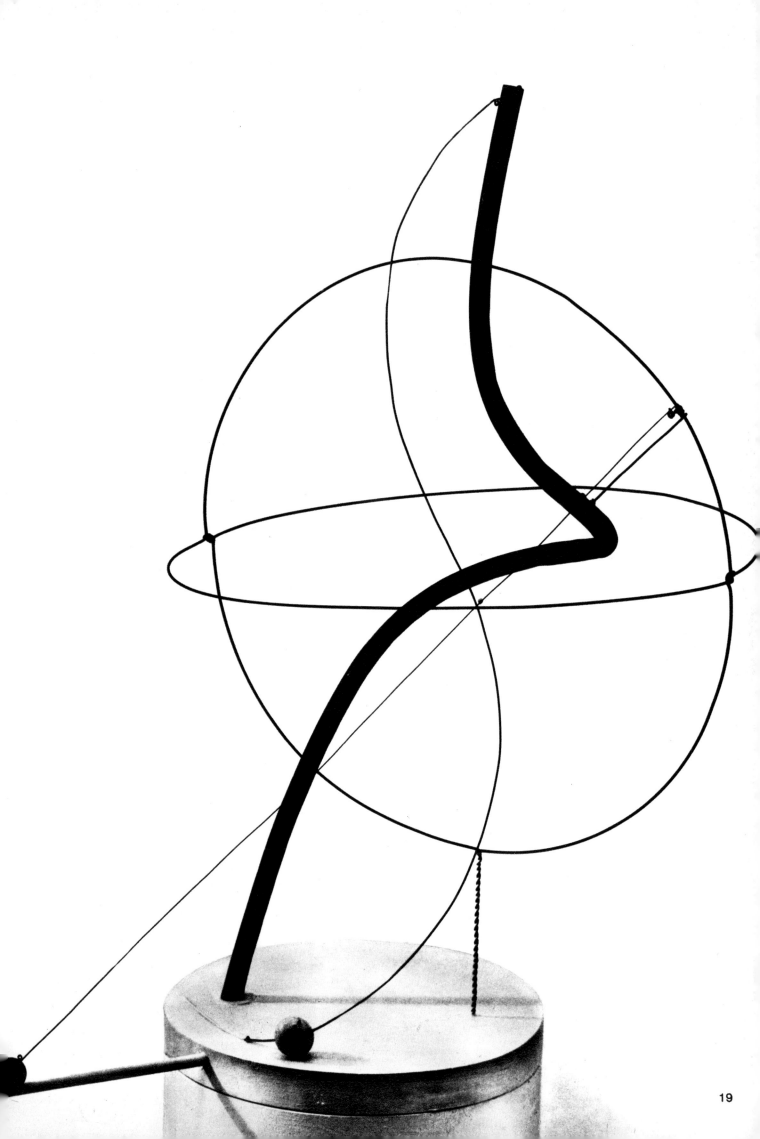

19

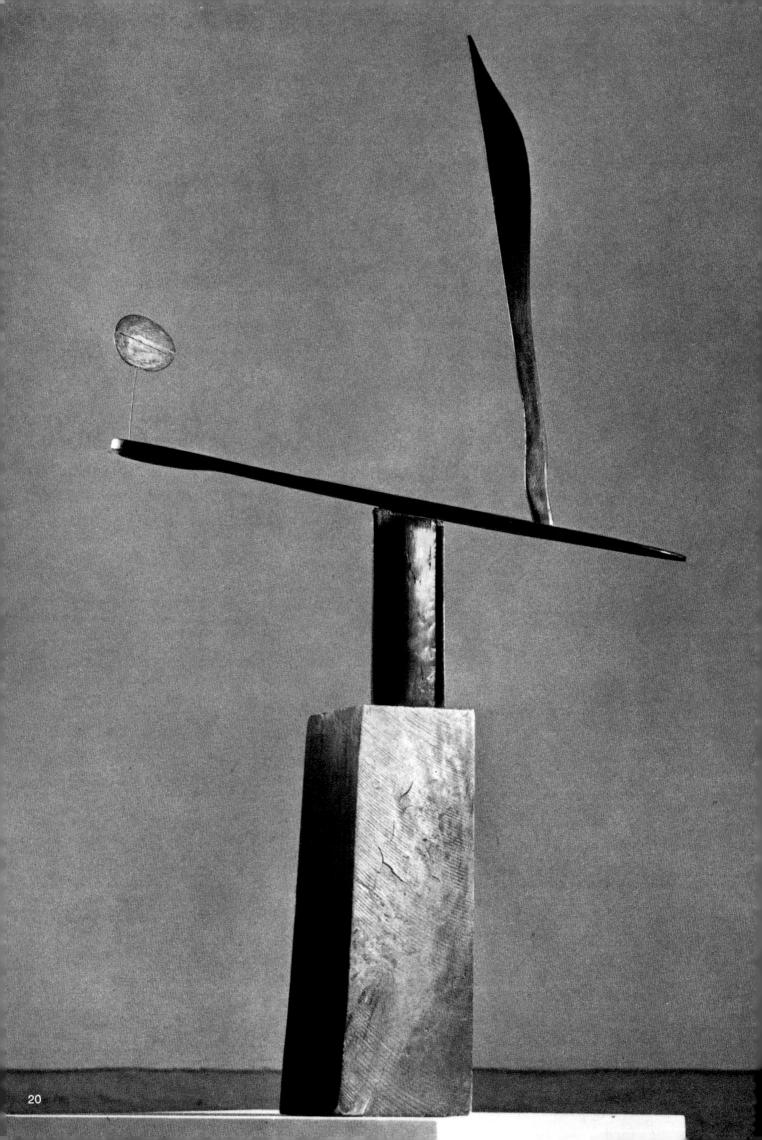

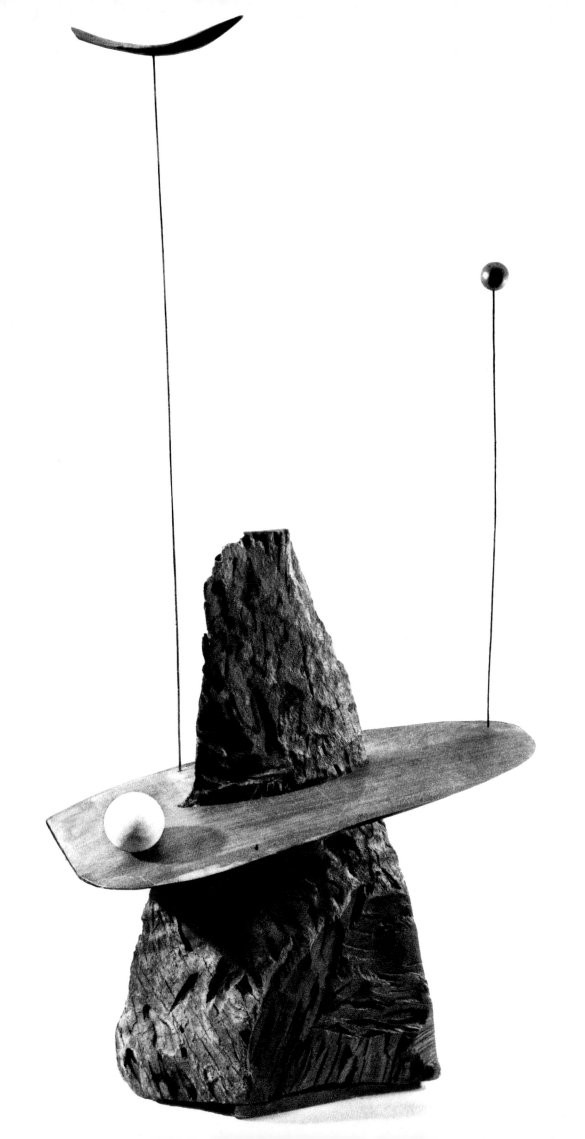

21

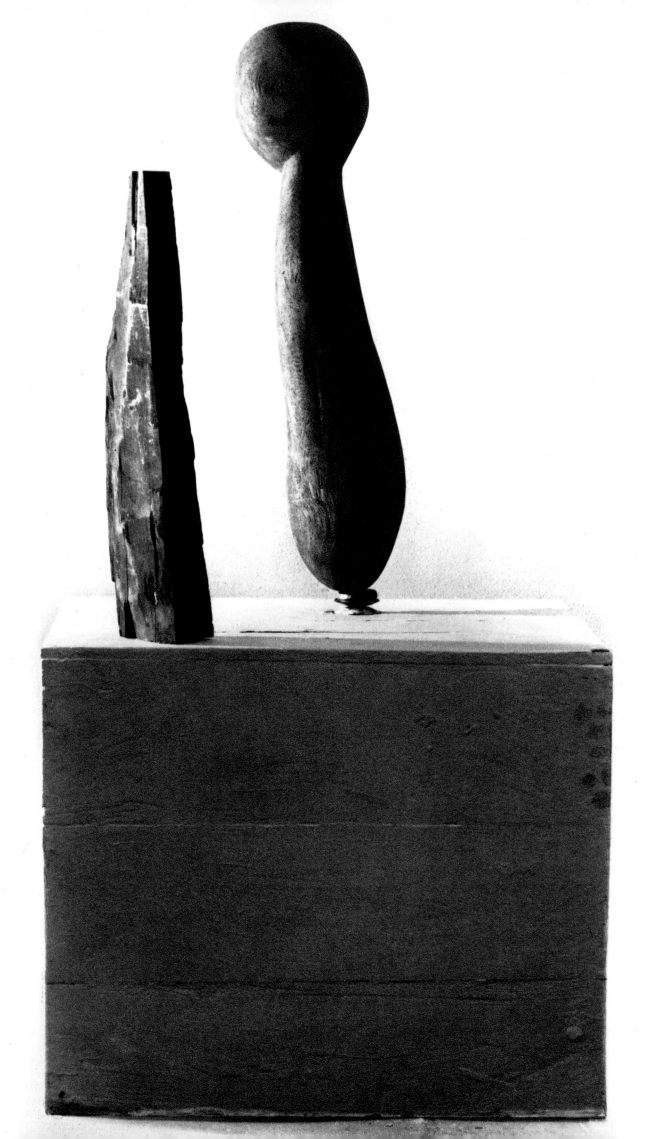

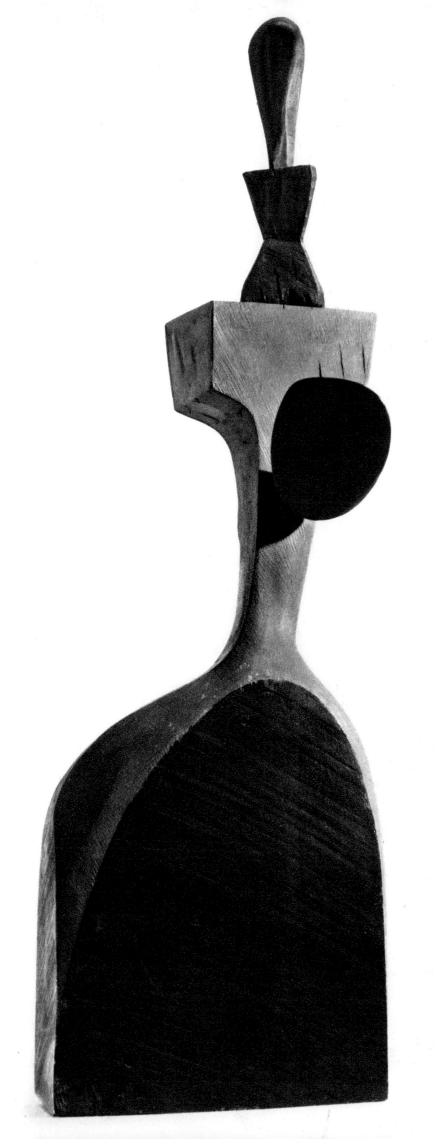

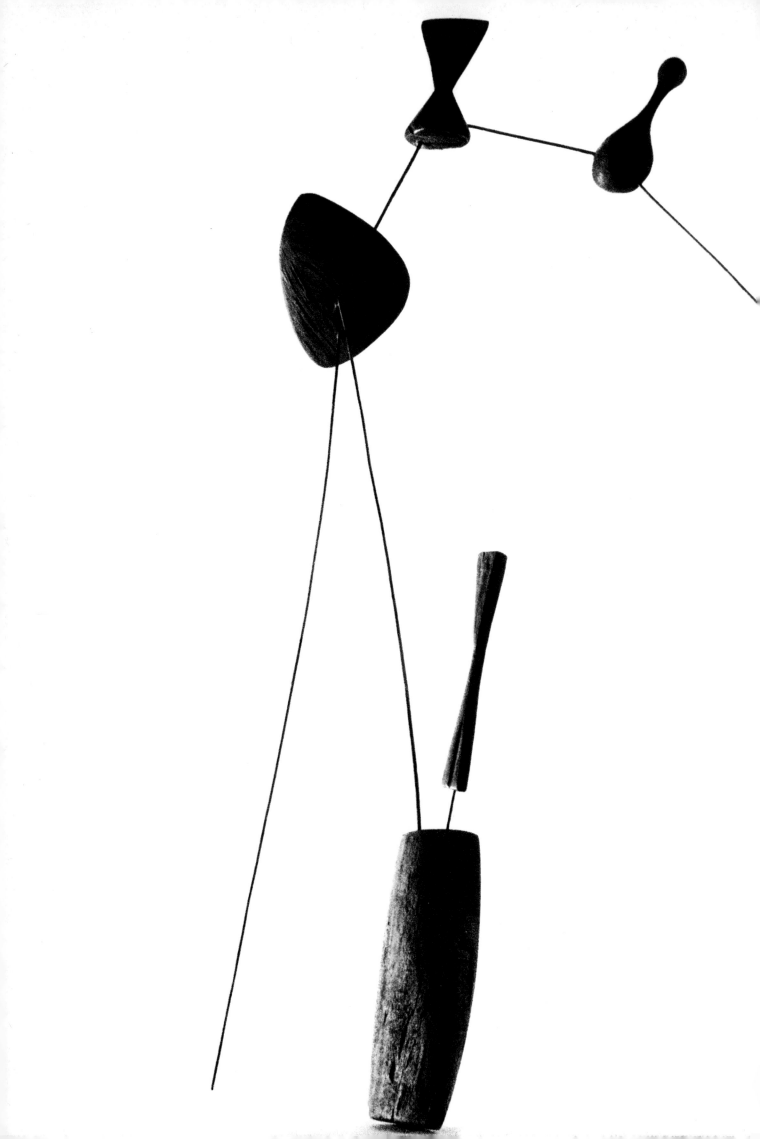

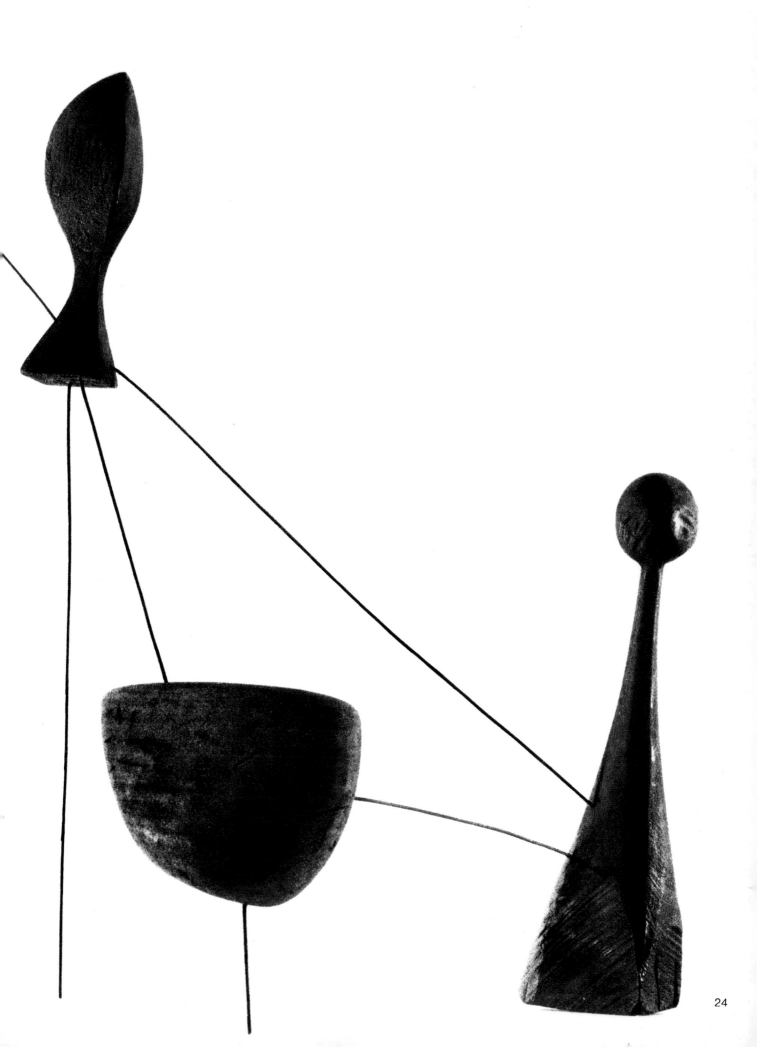

24

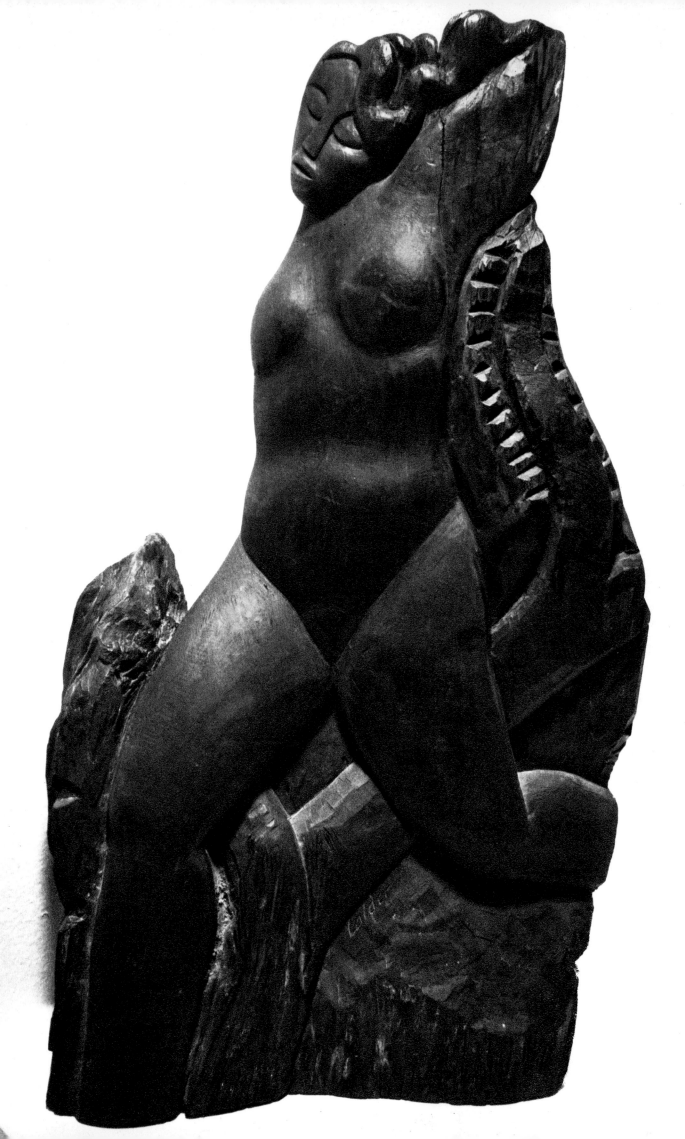

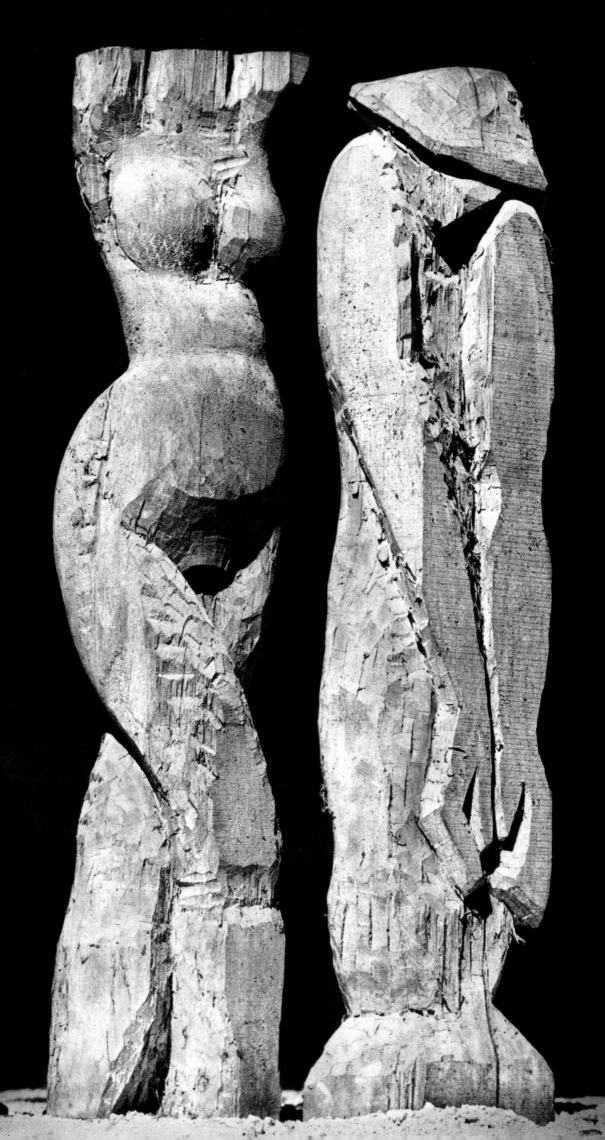

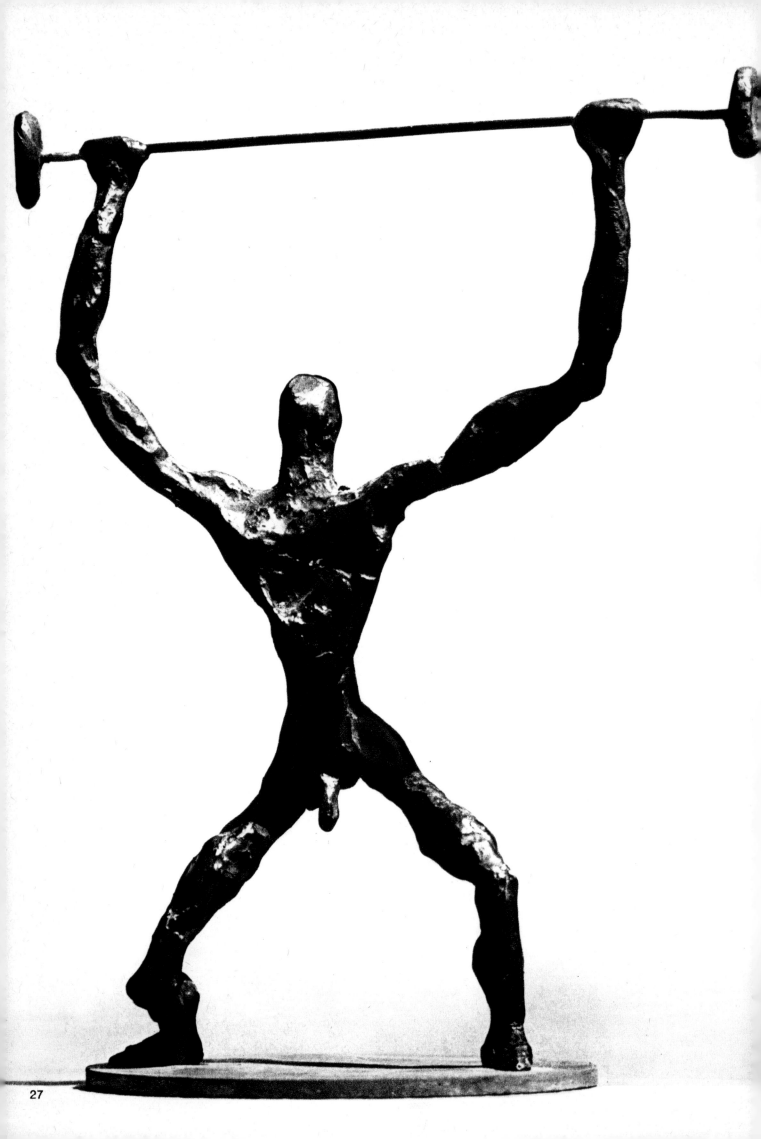

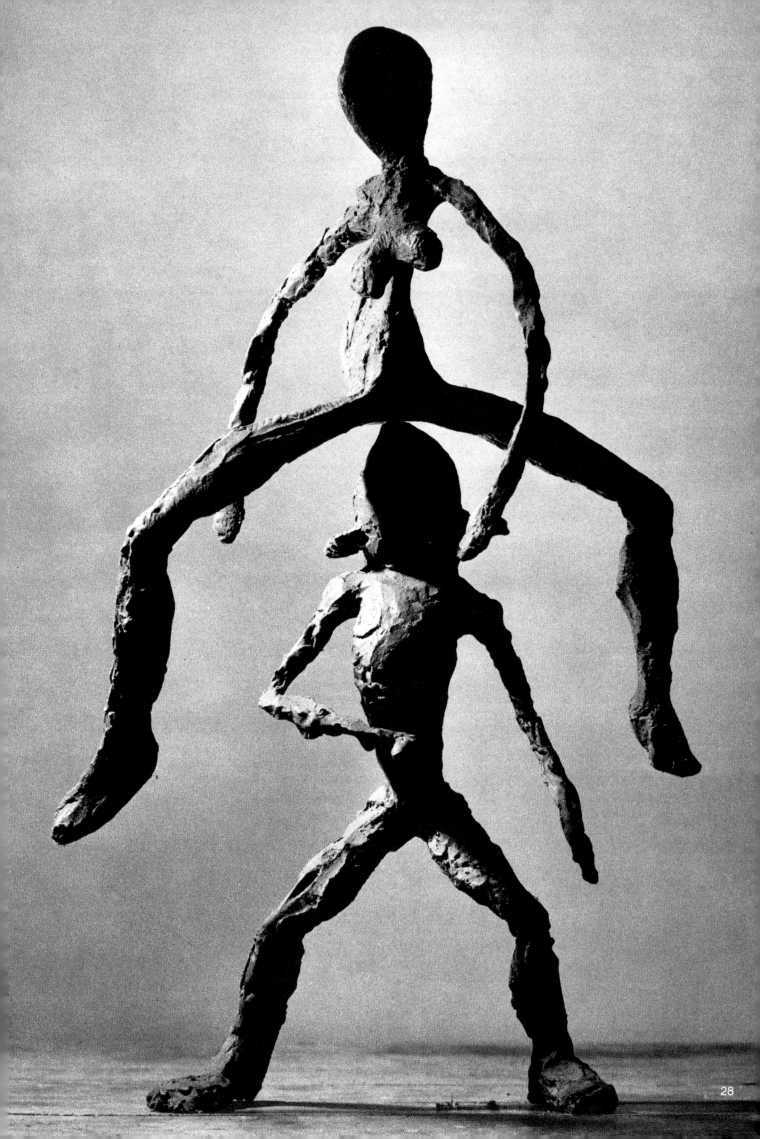

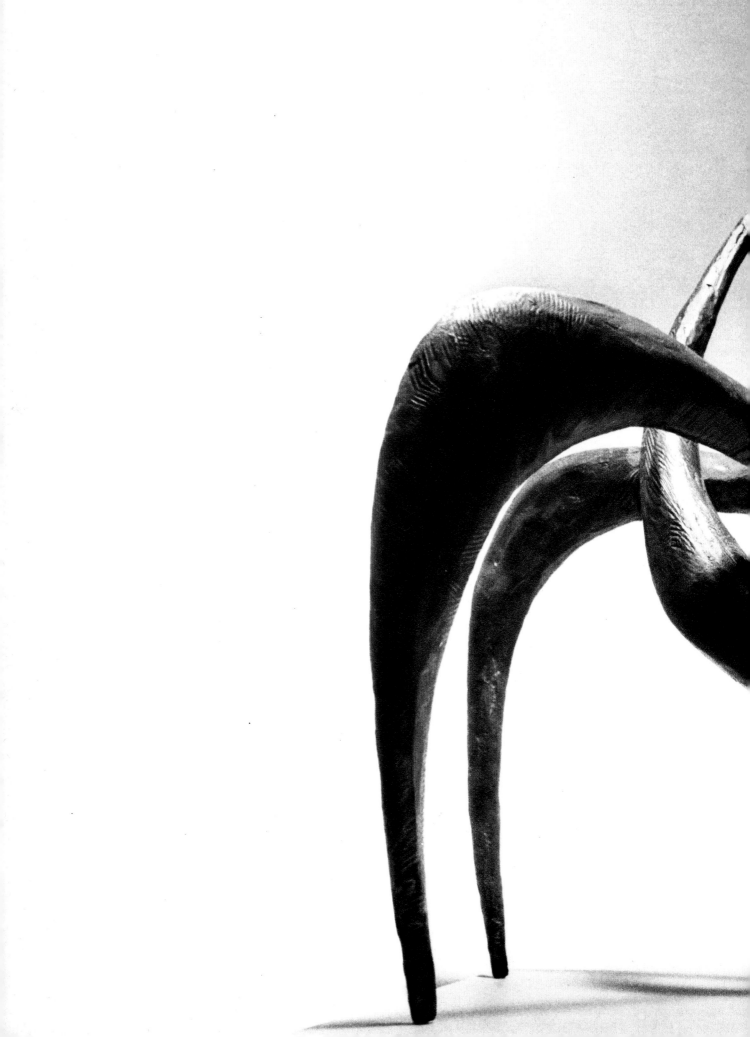

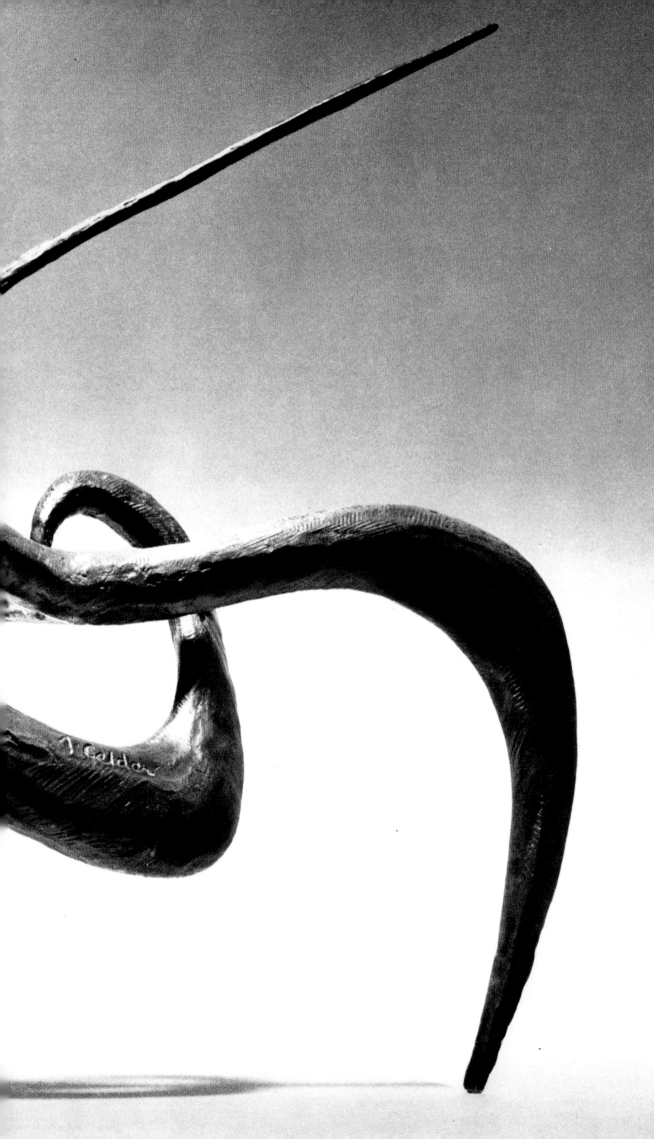

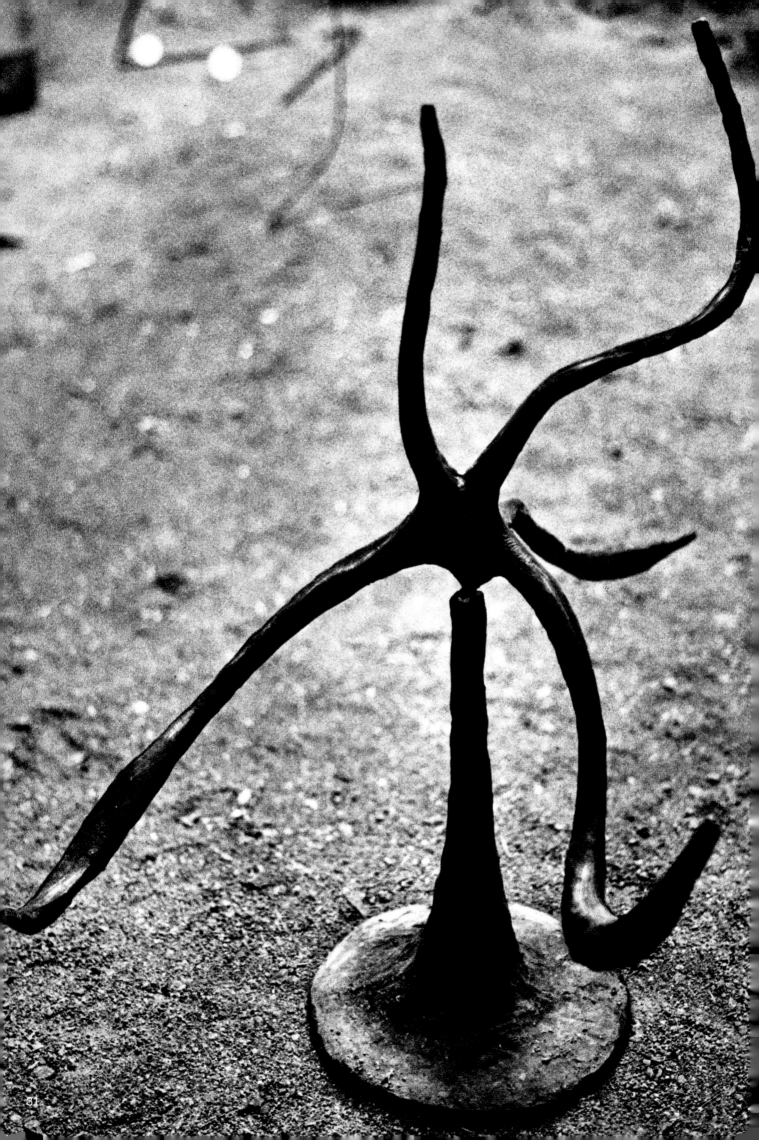

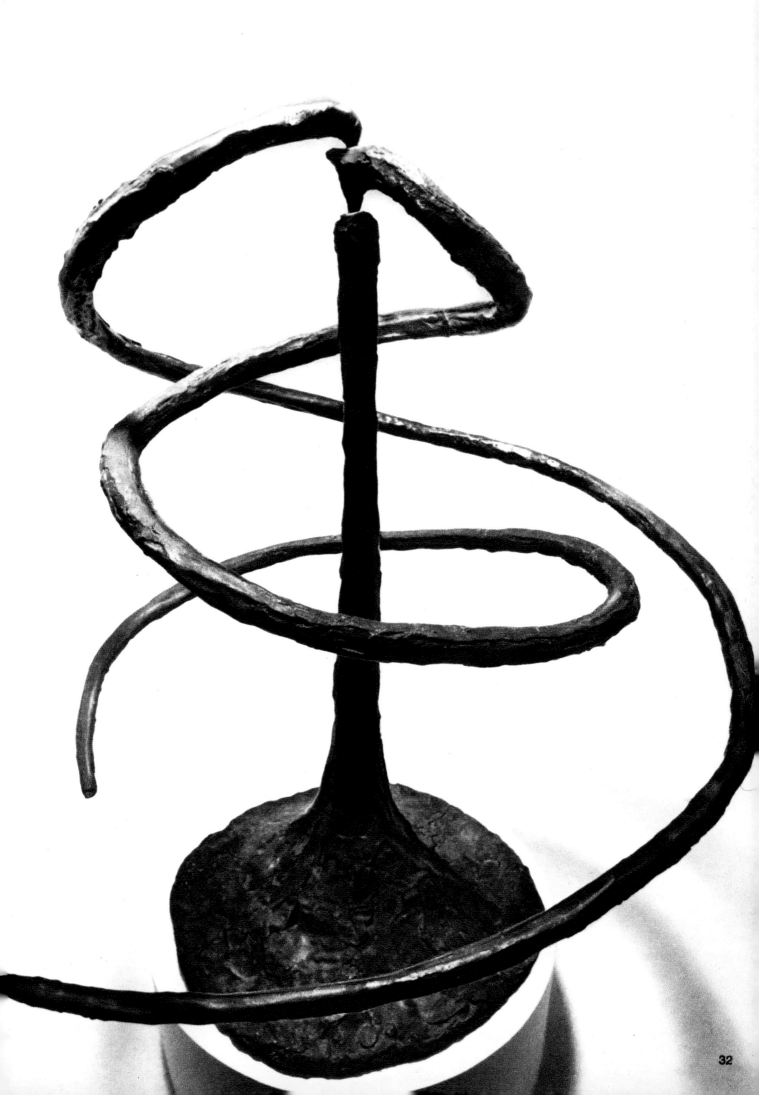

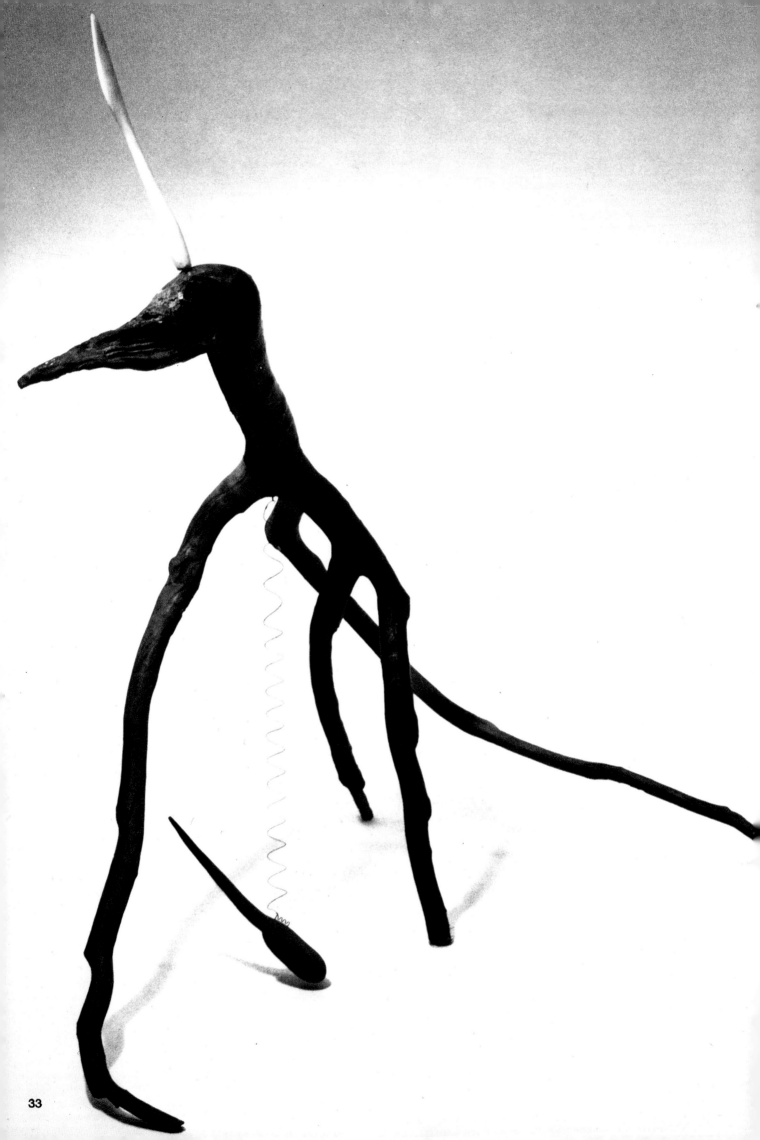

33

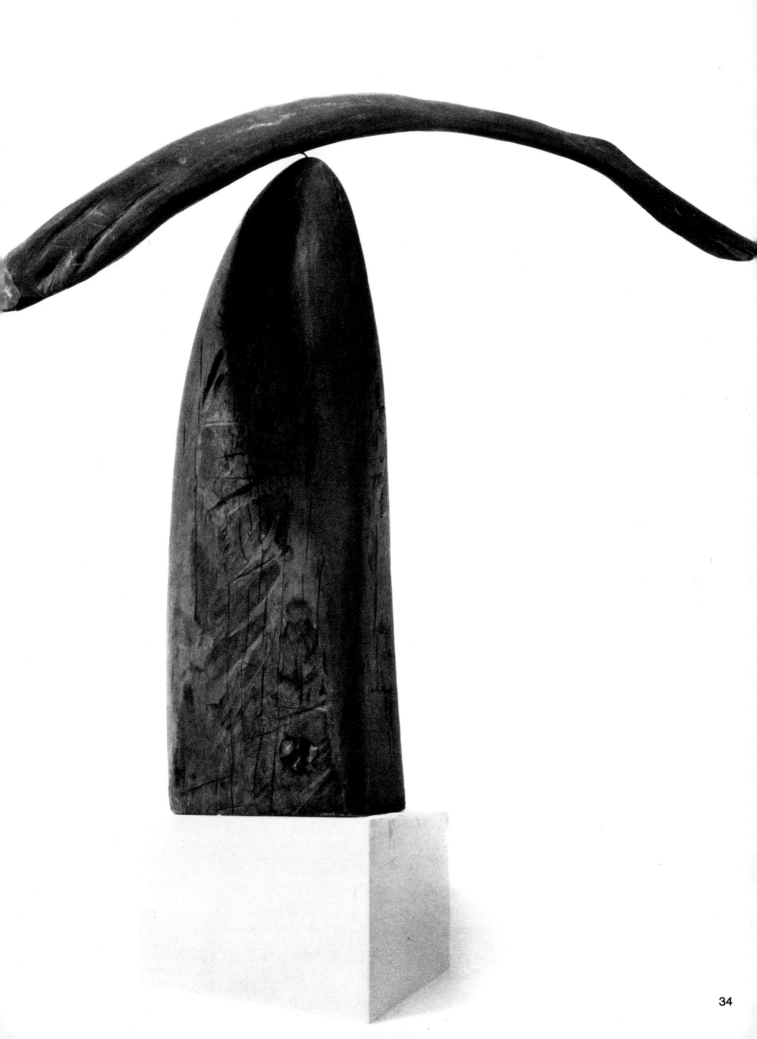

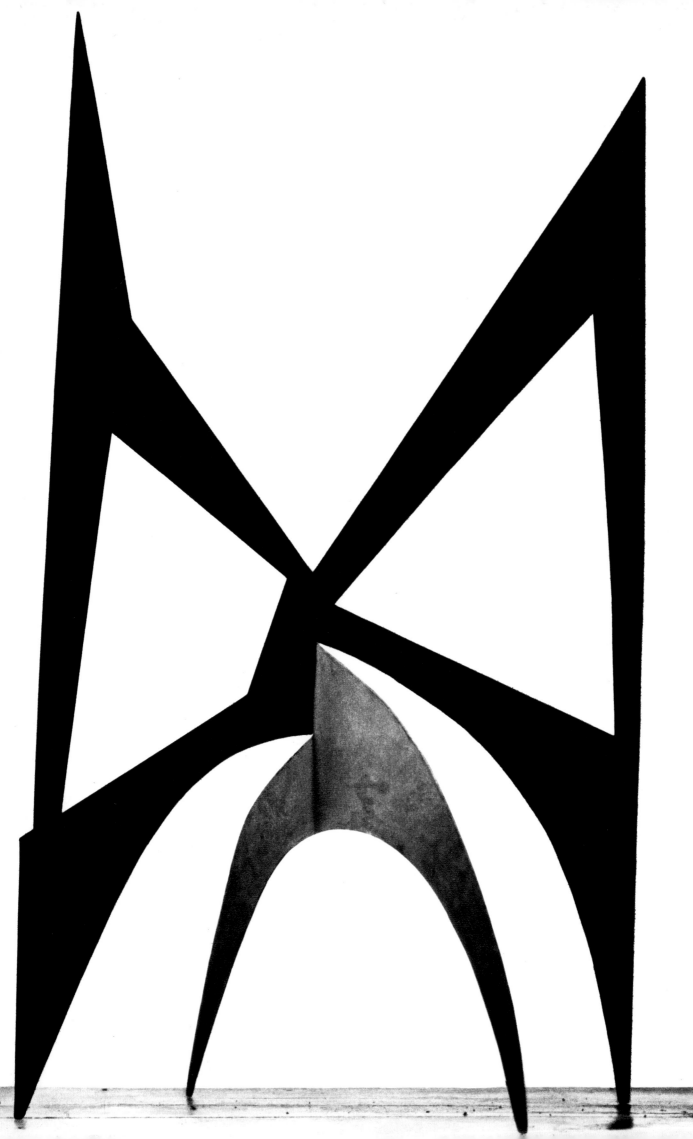

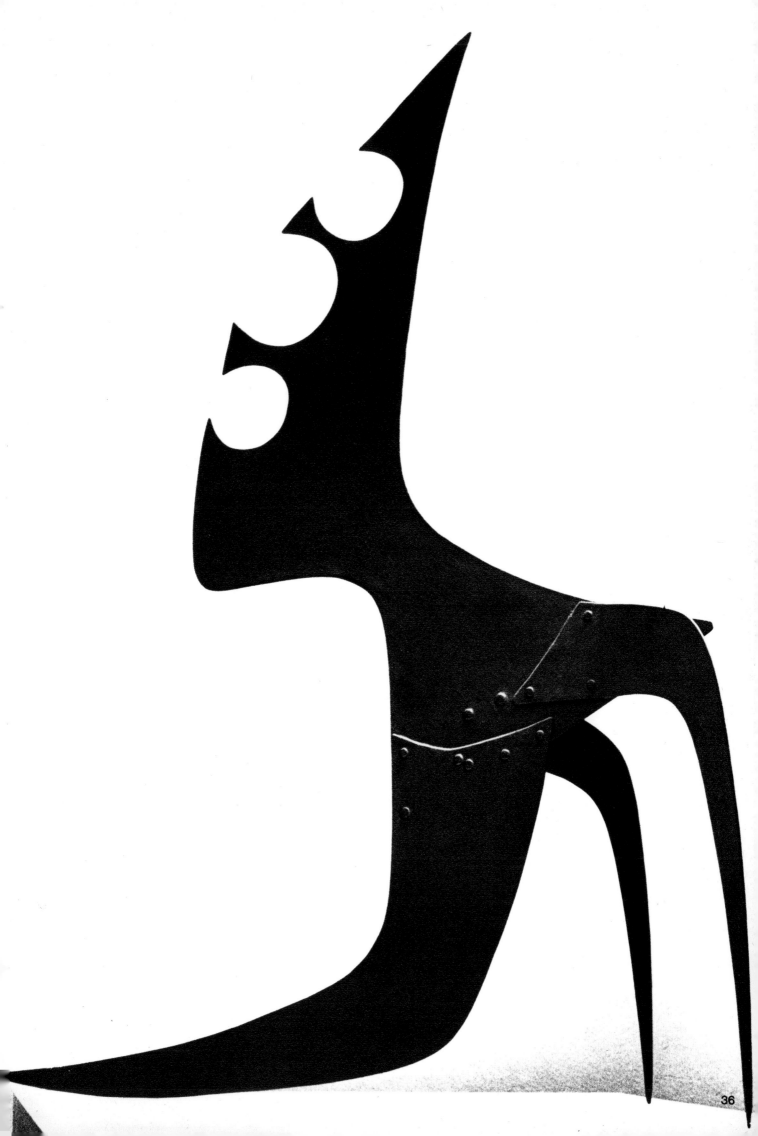

36

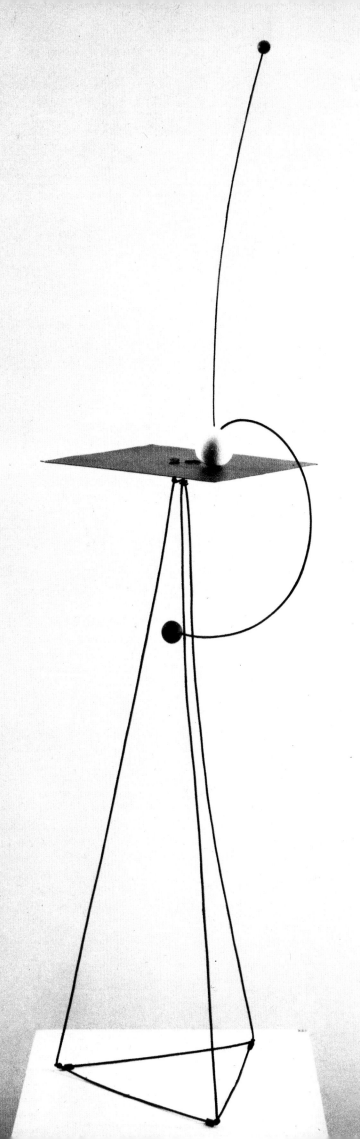

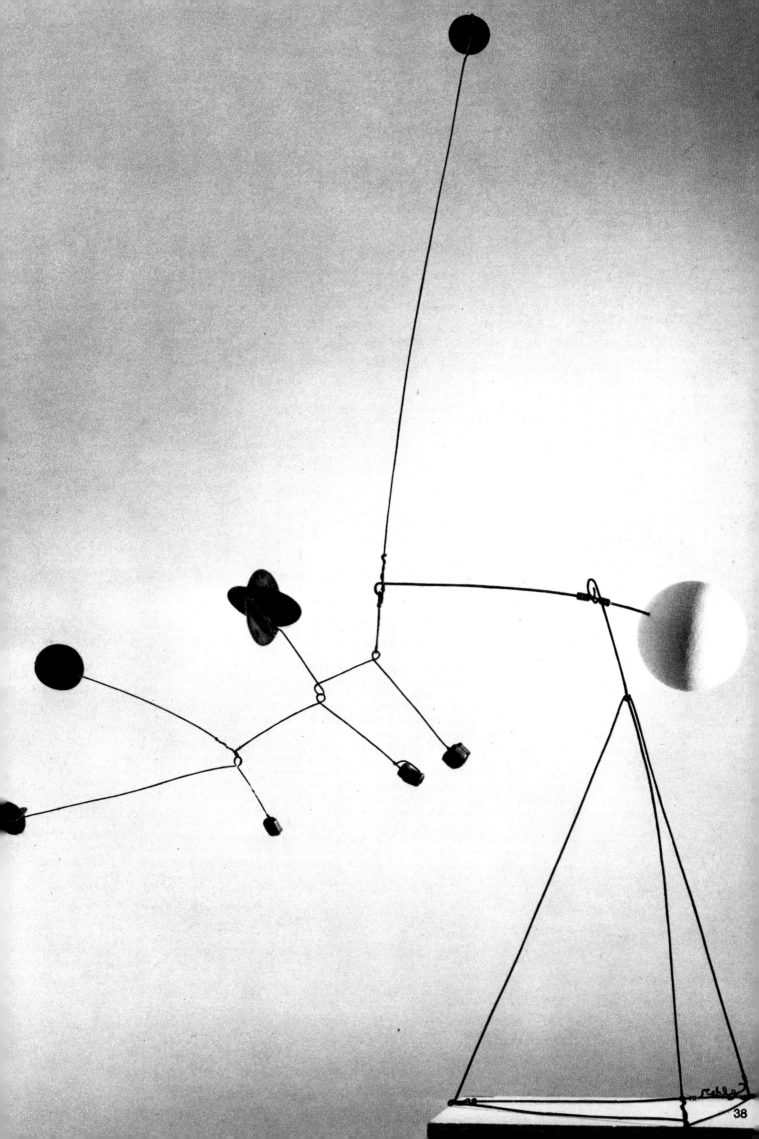

38

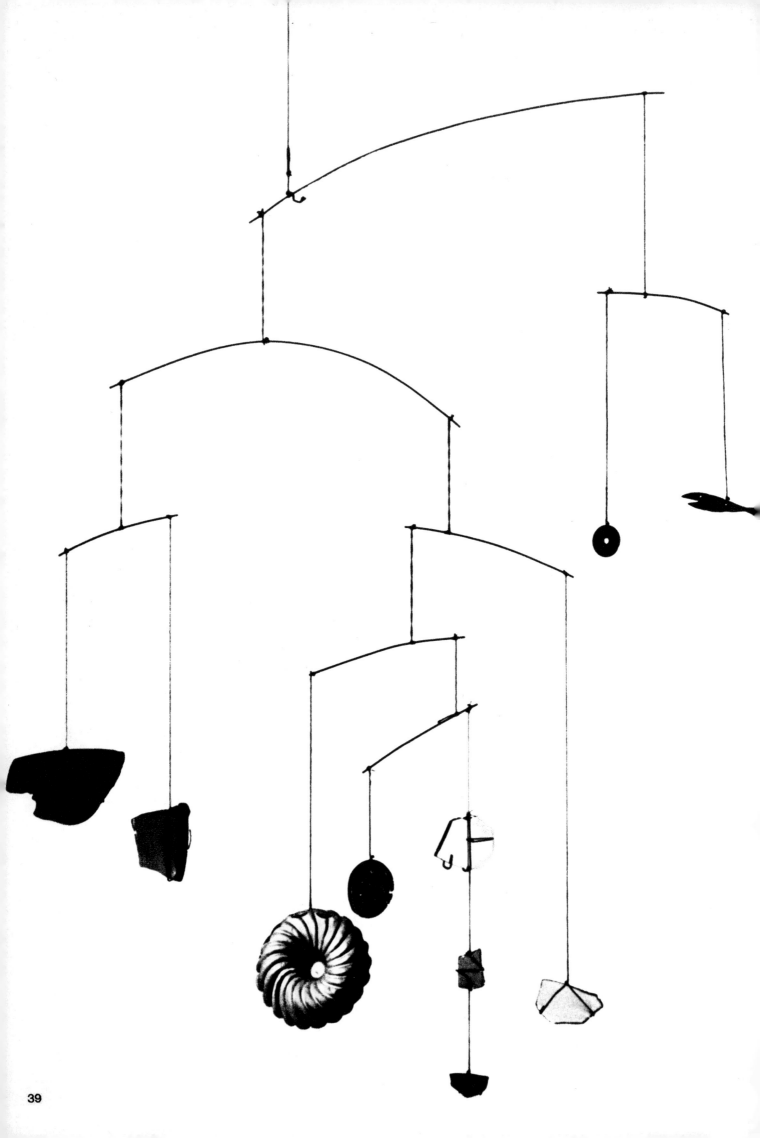

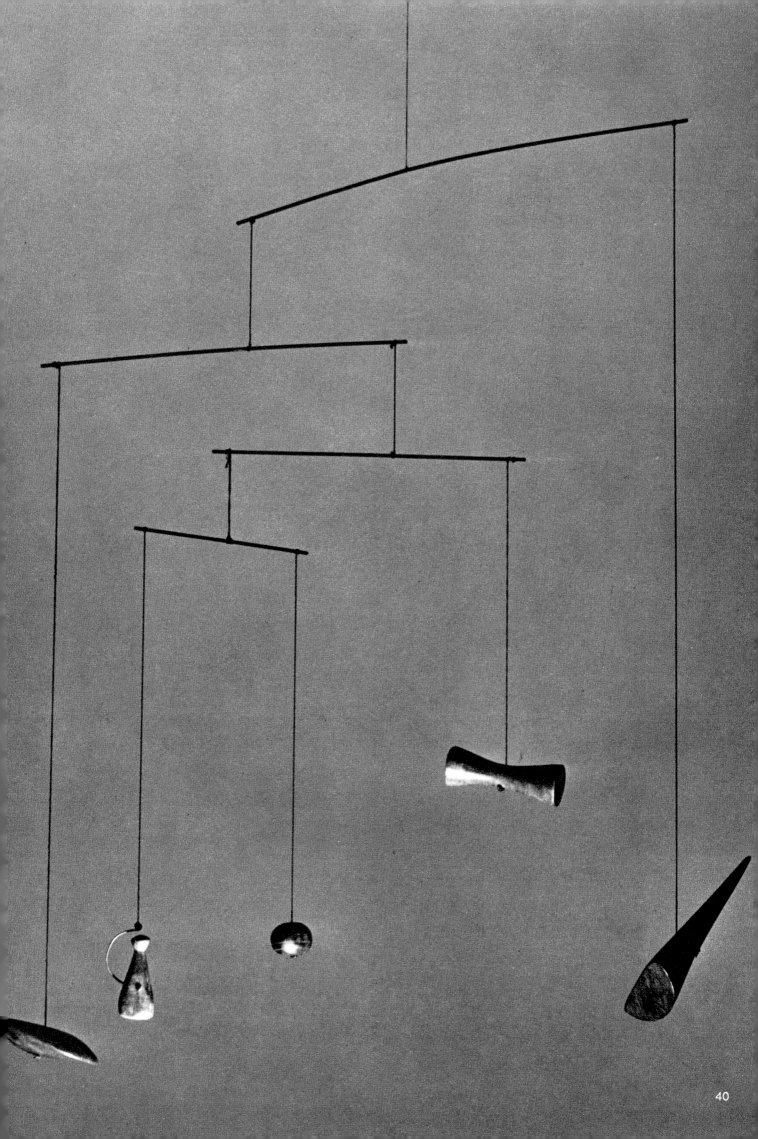

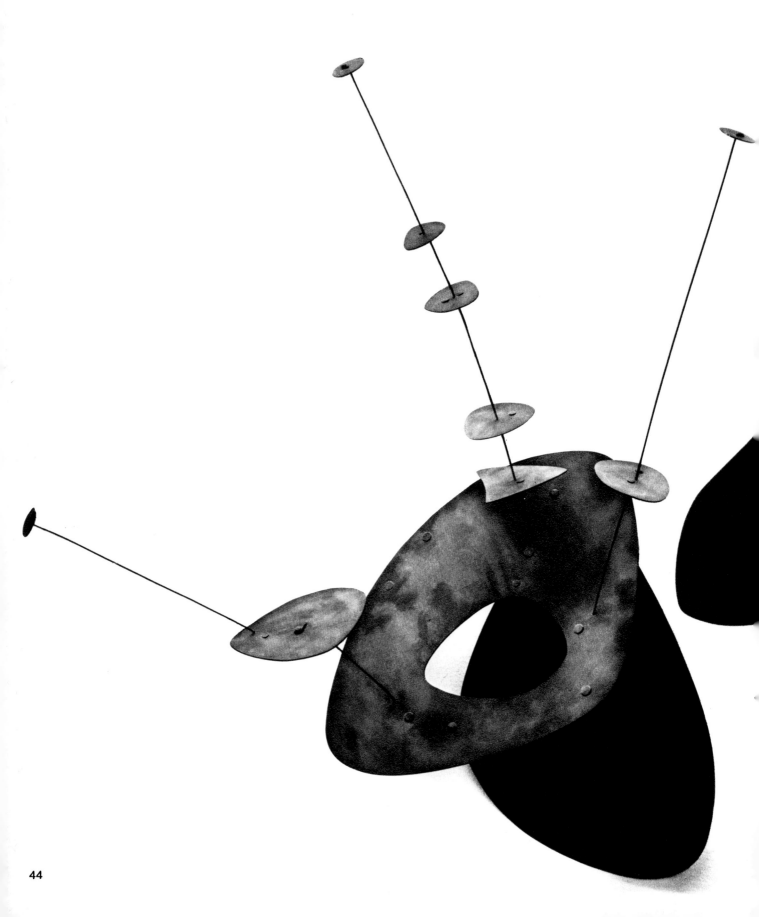

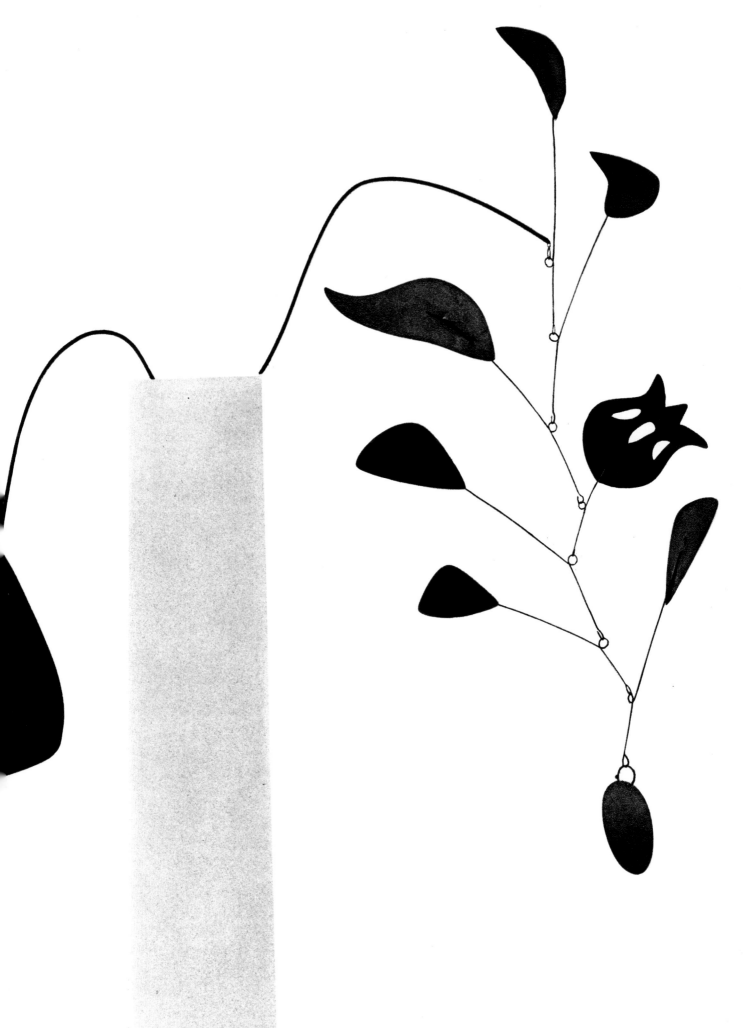

45

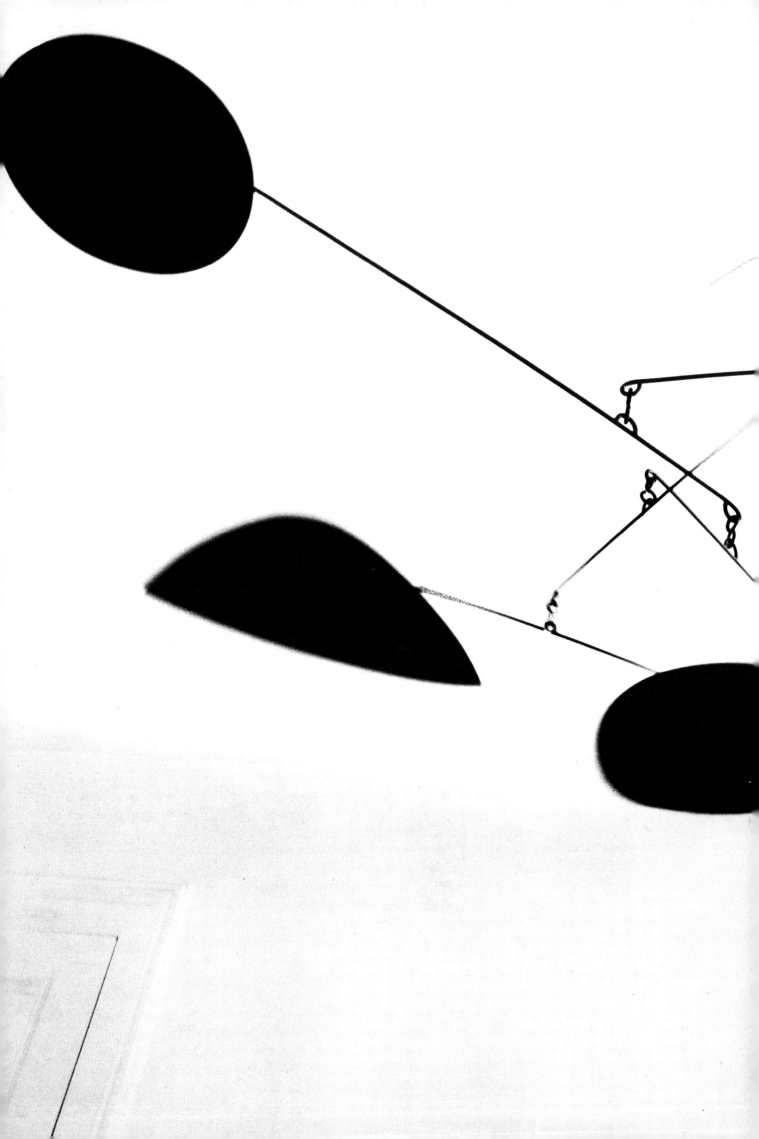

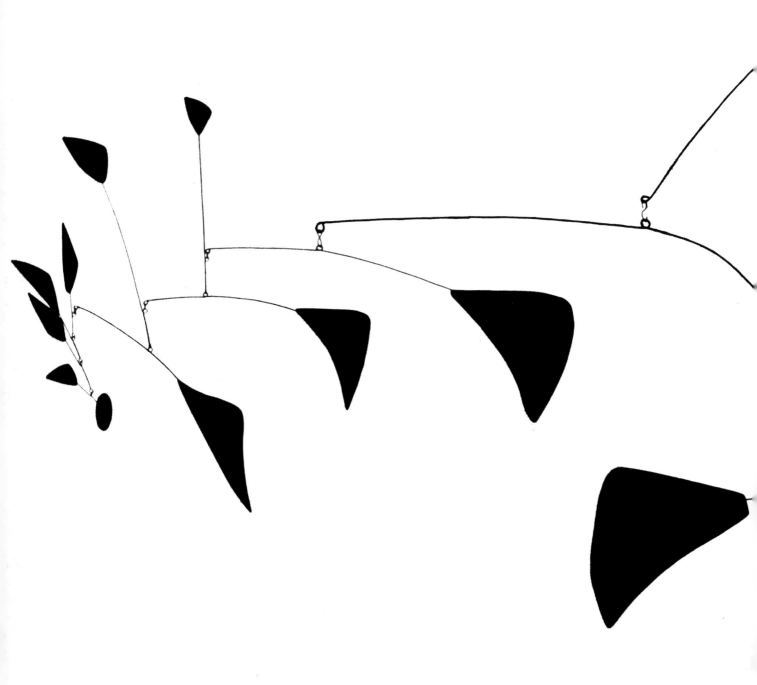

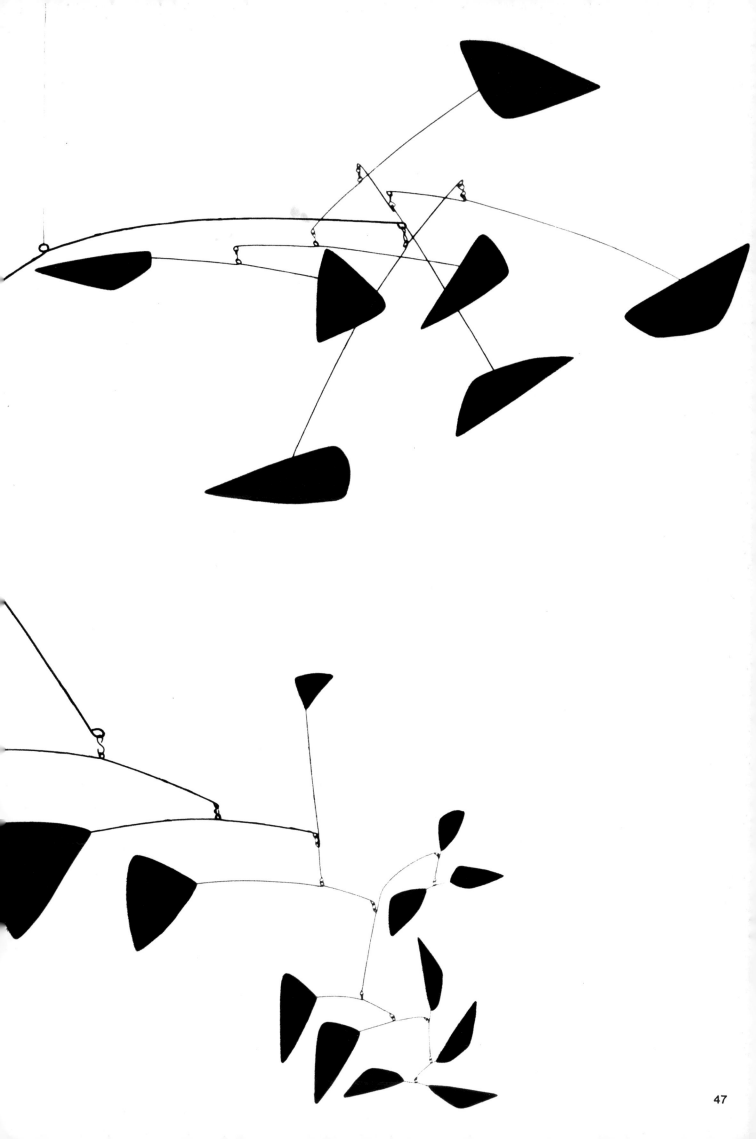

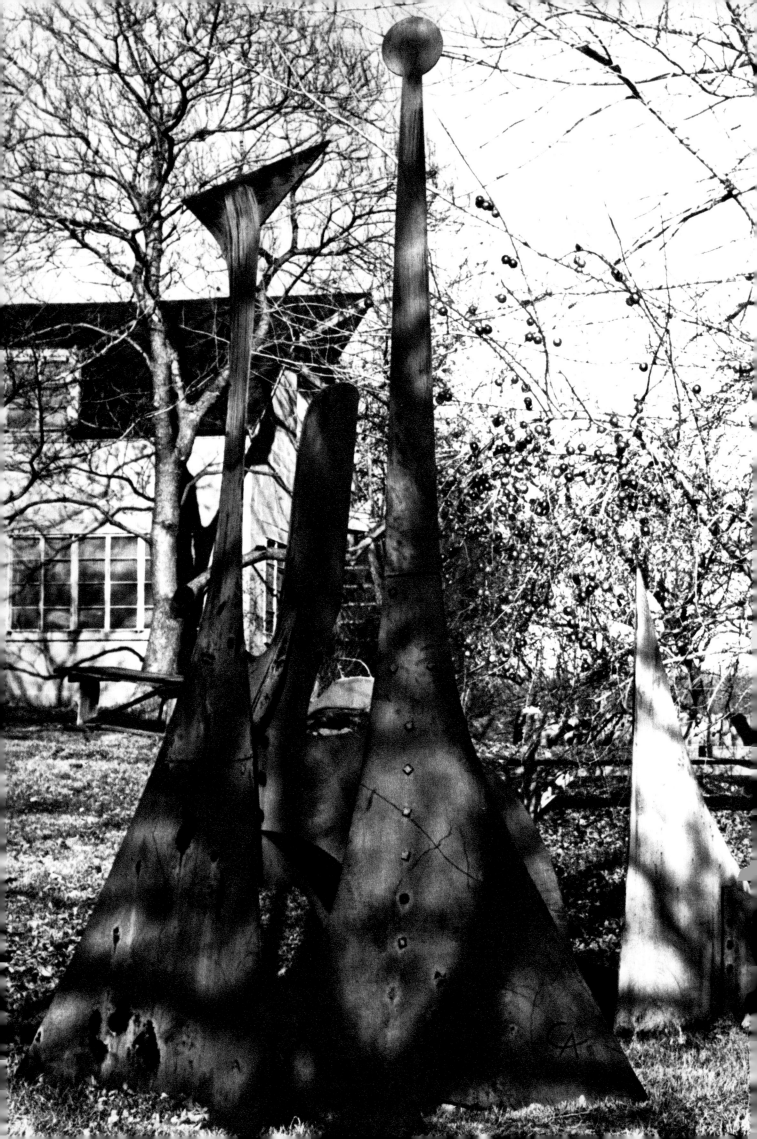

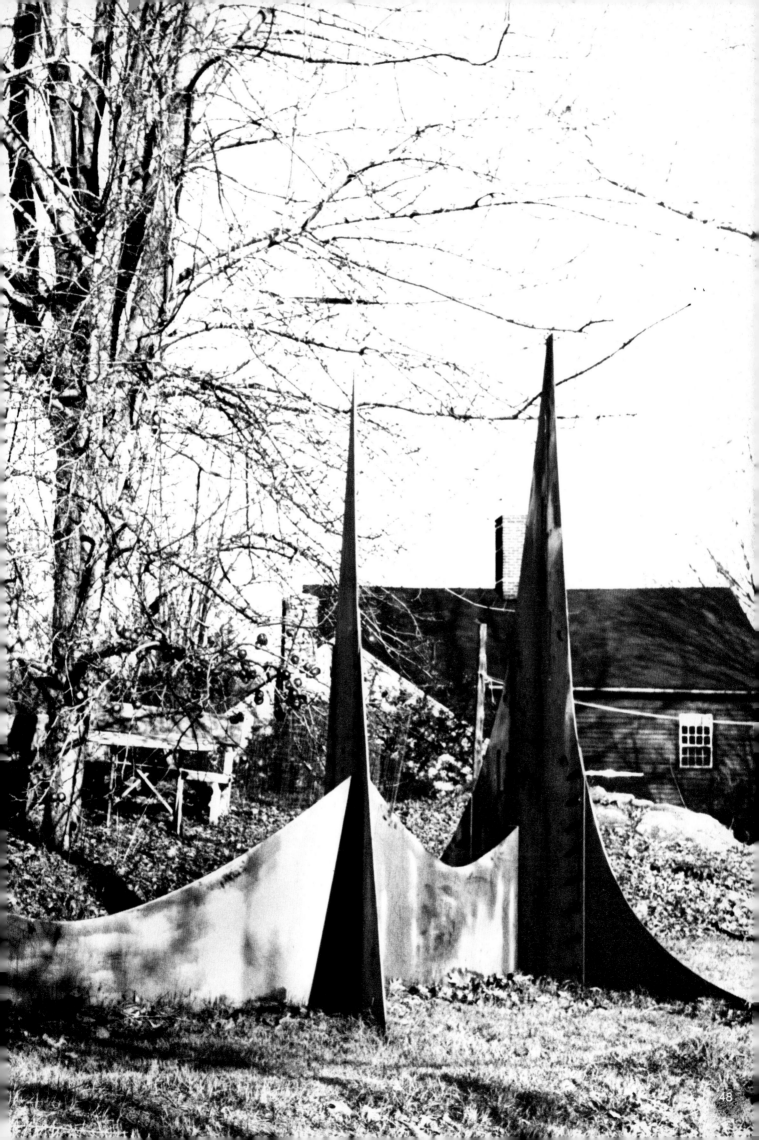

48

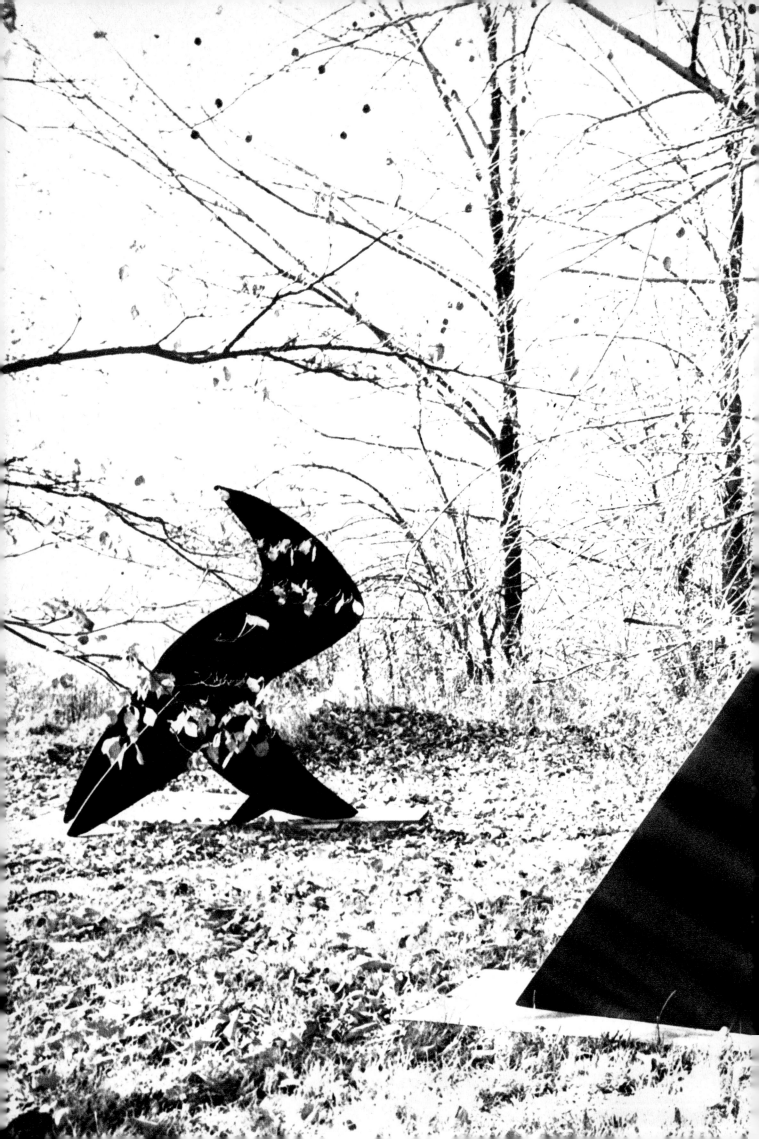

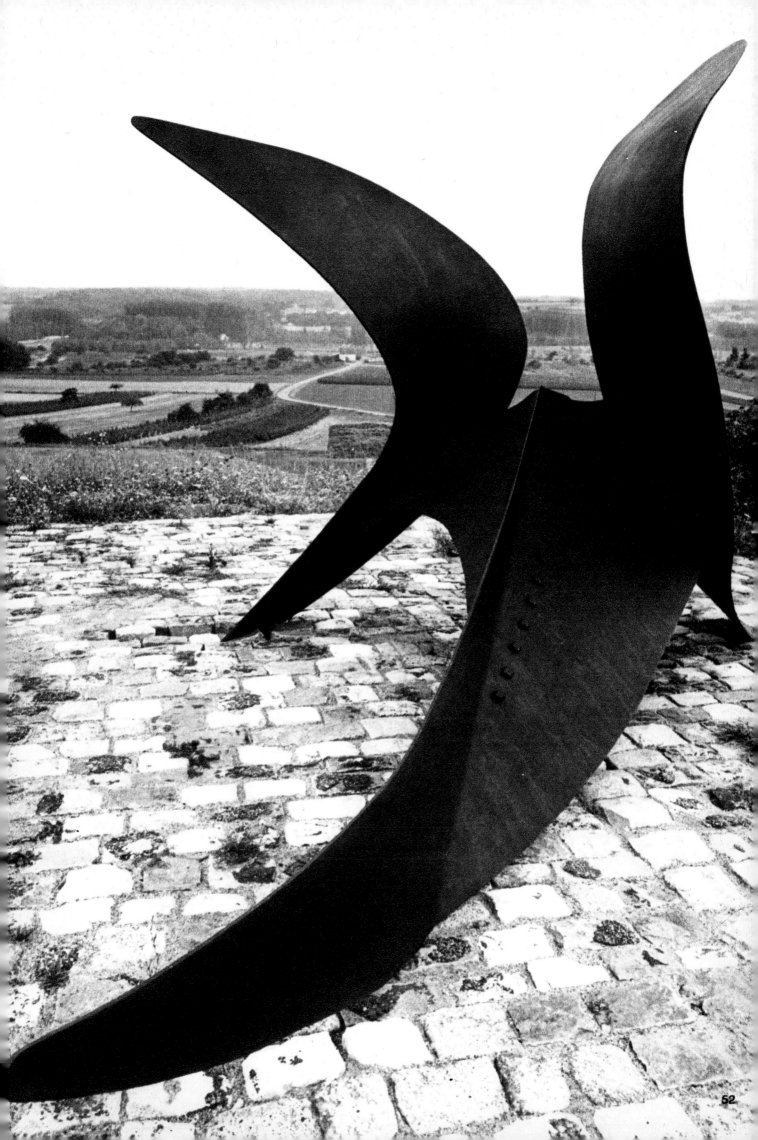

52

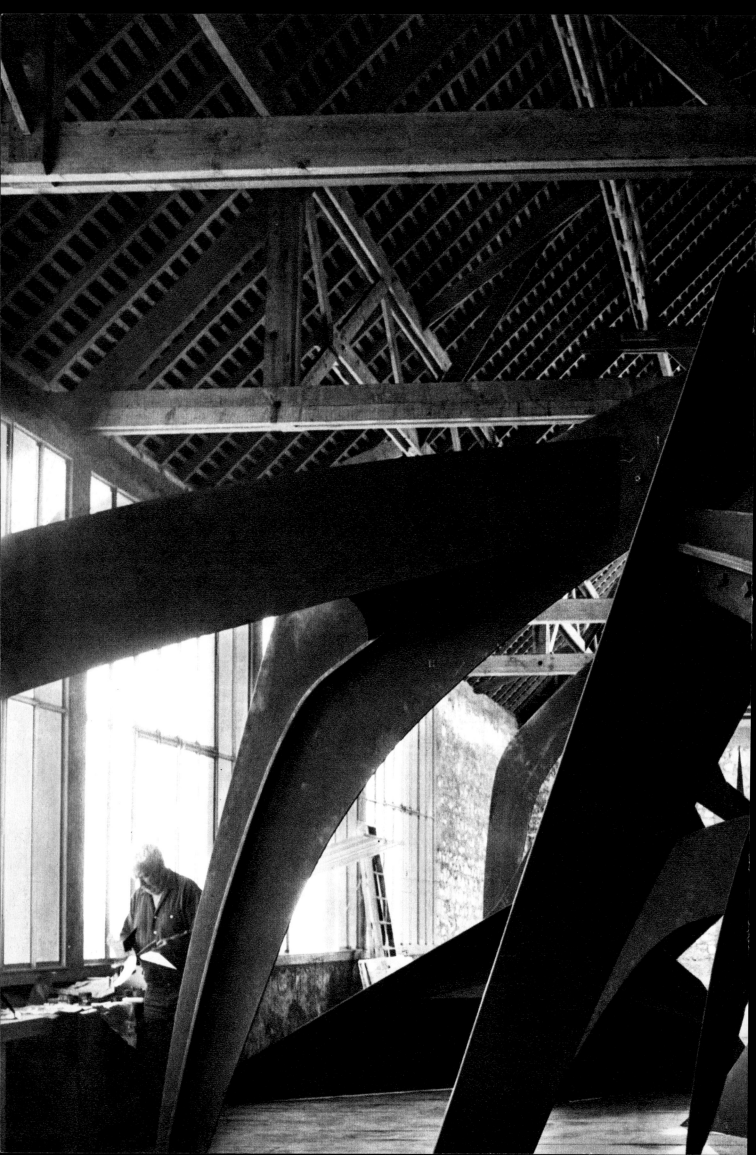

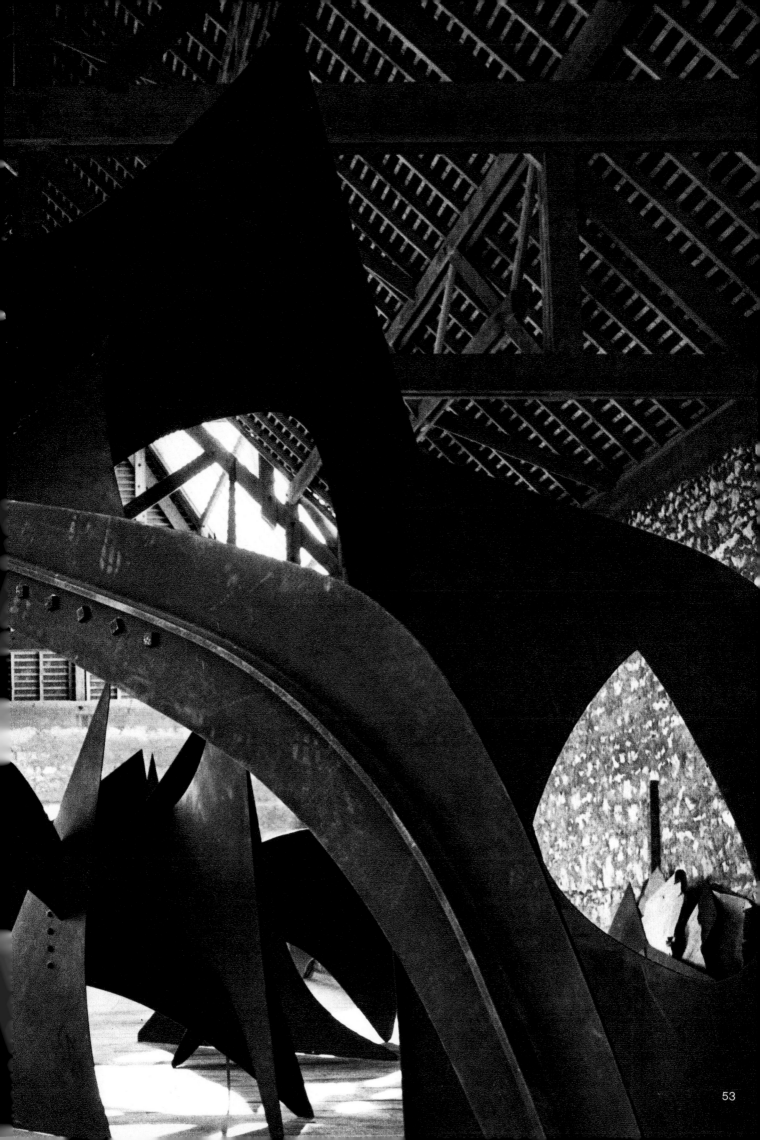

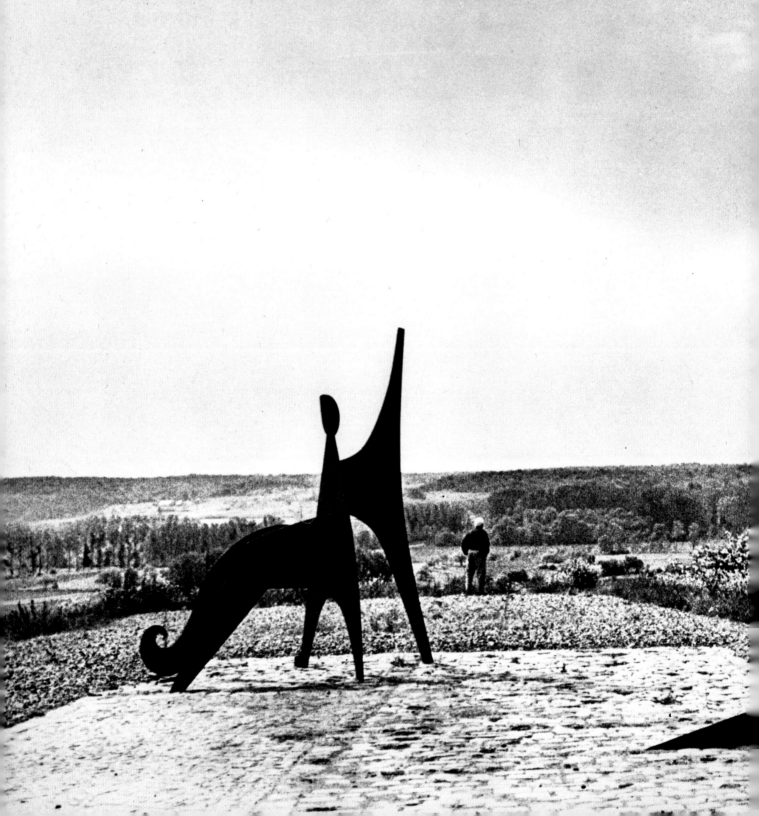

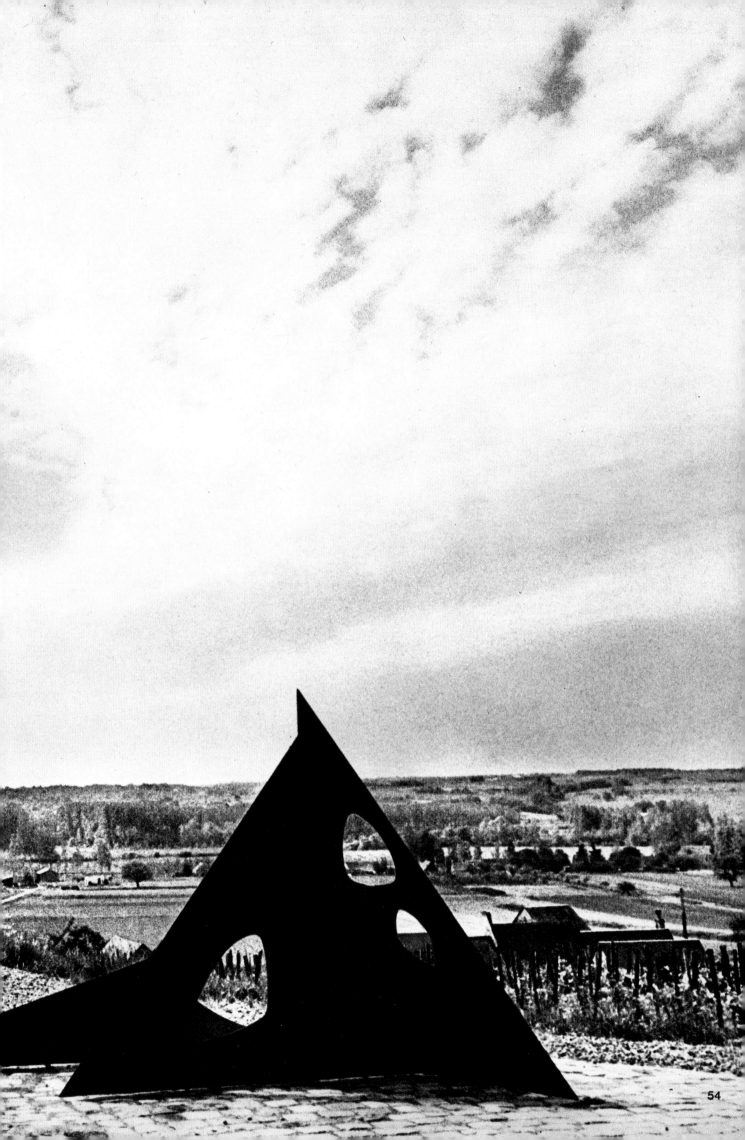

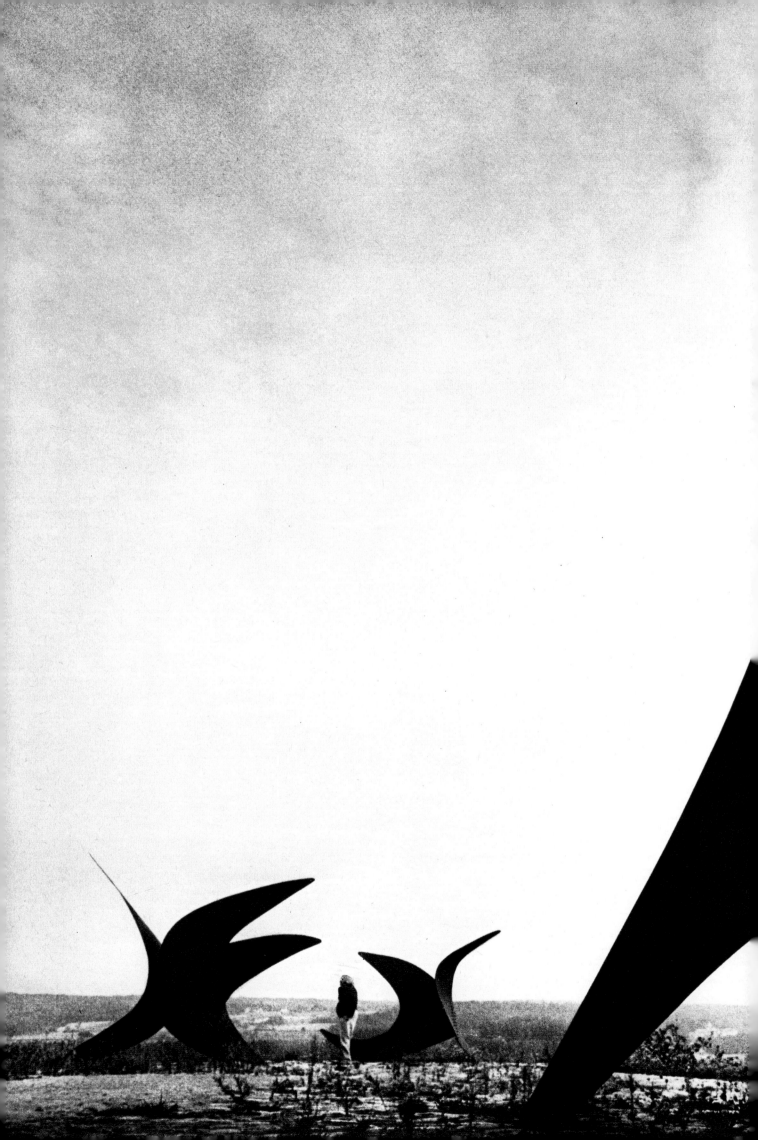

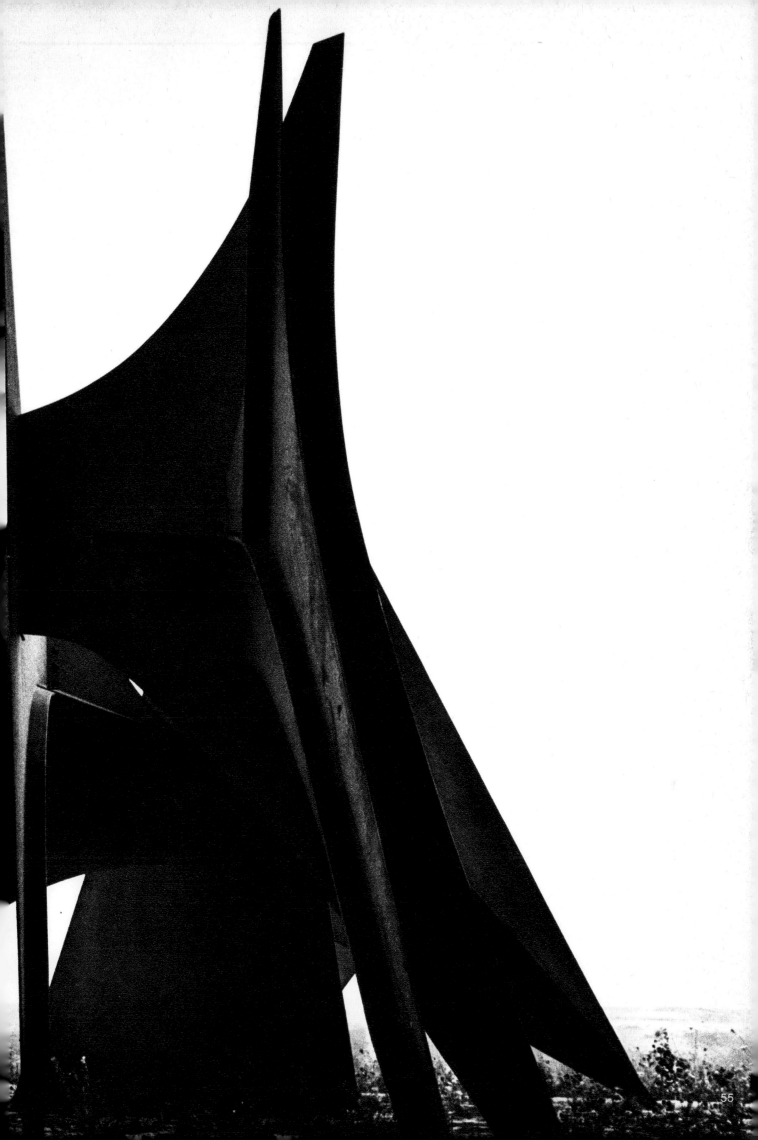

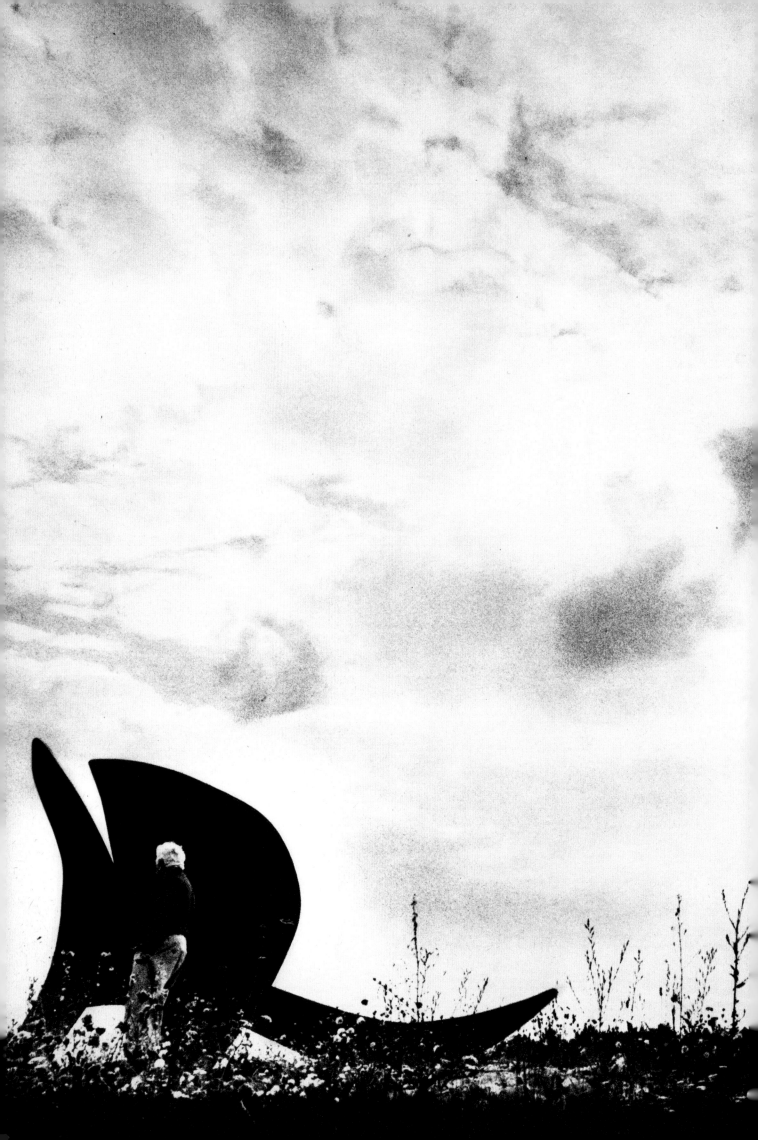

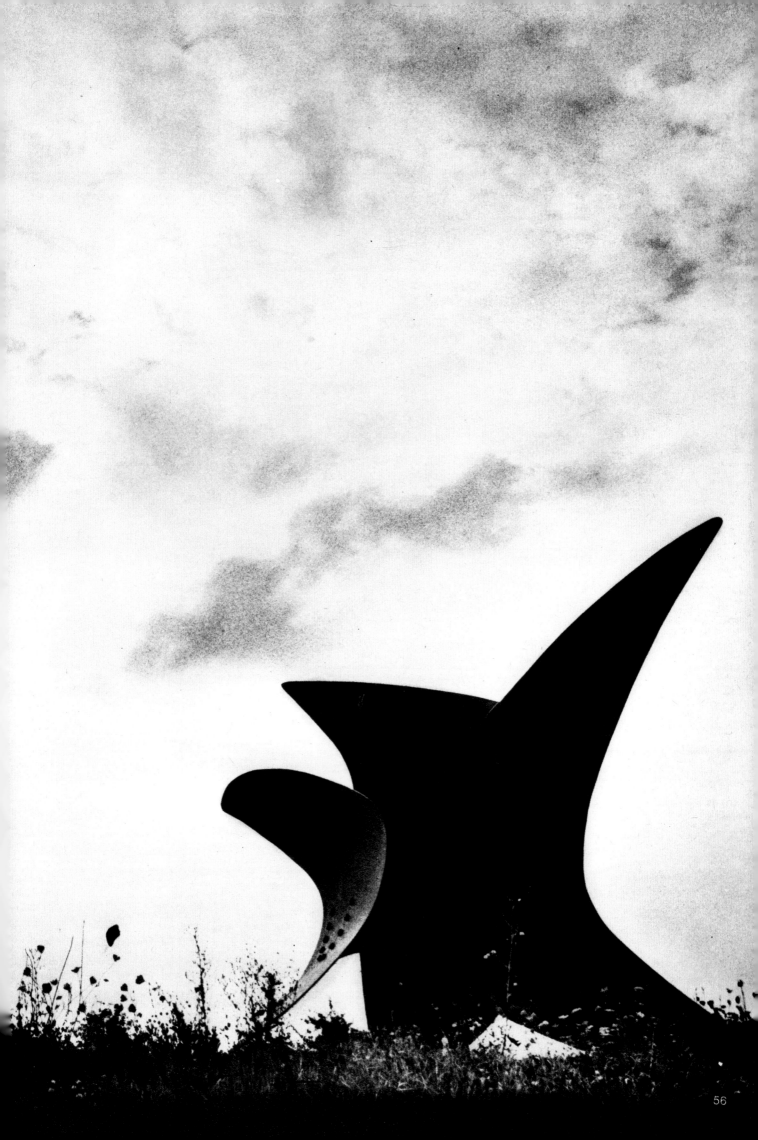

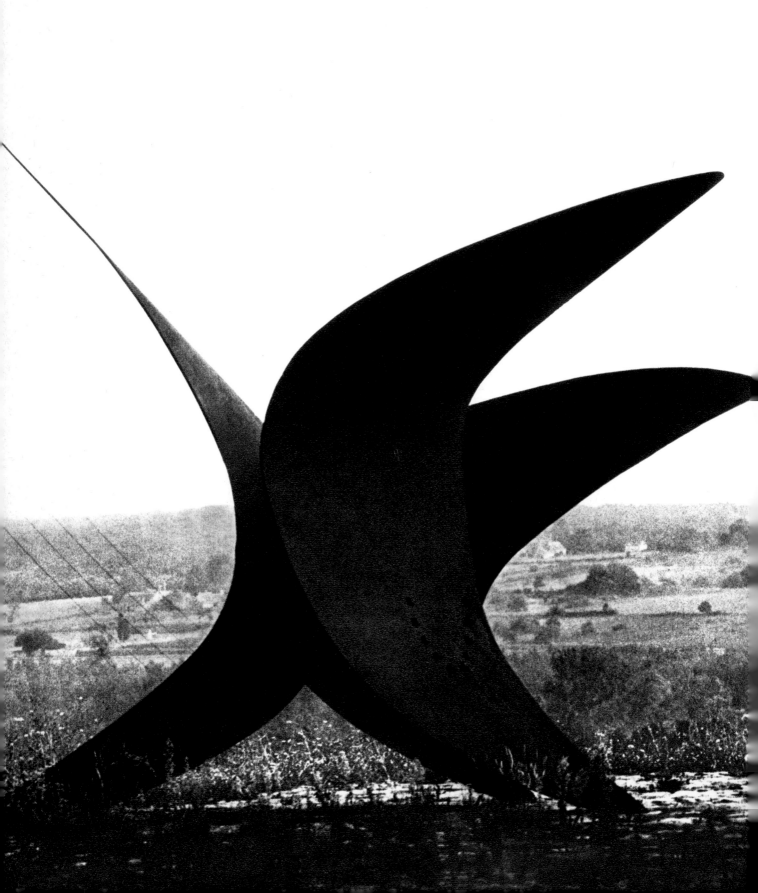

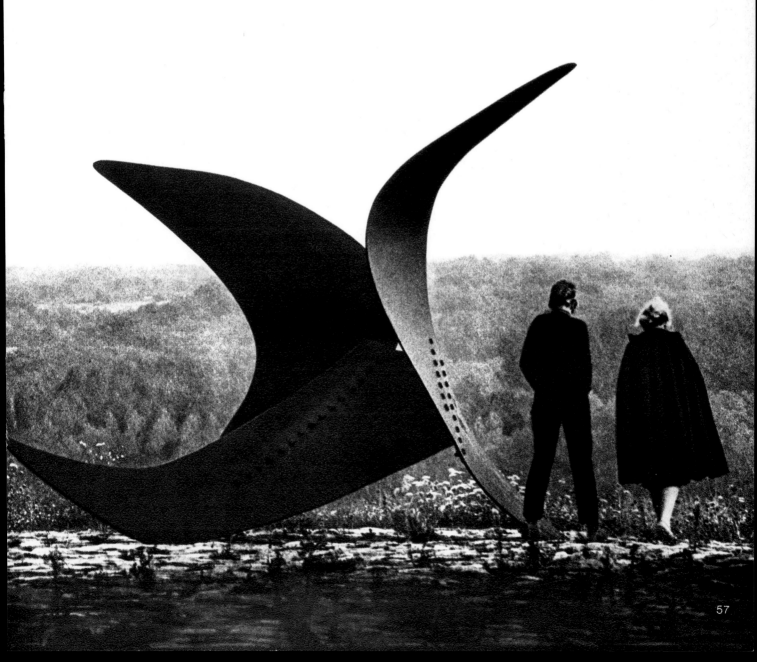

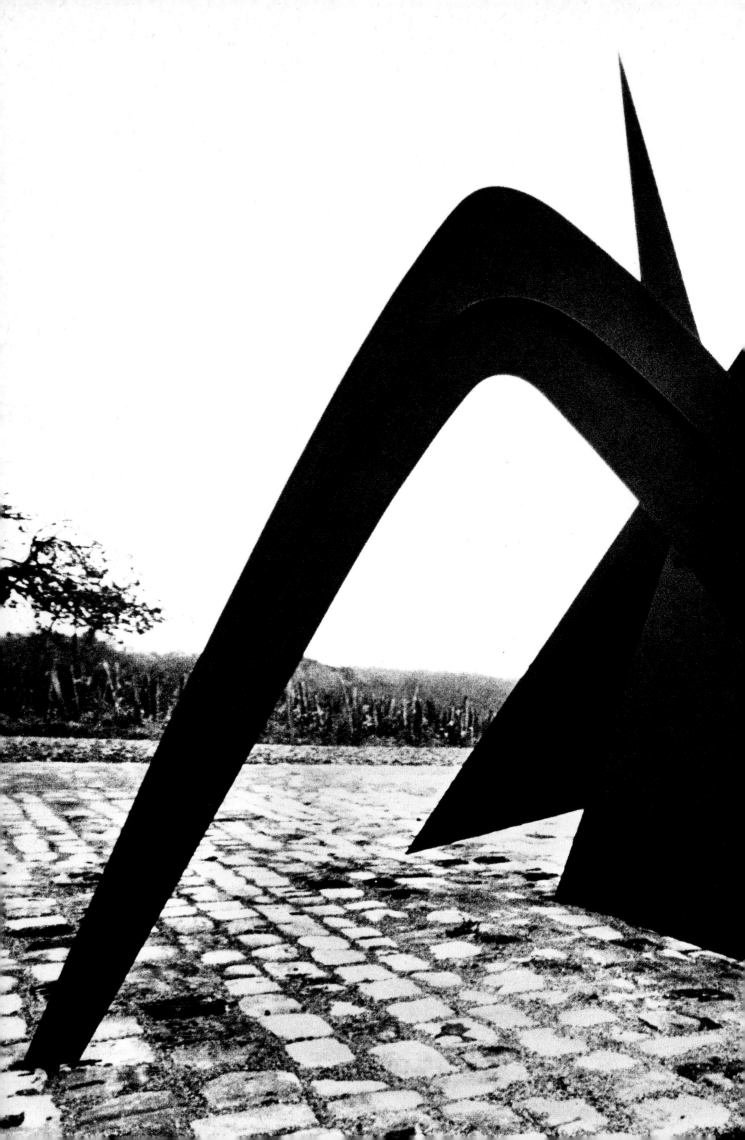

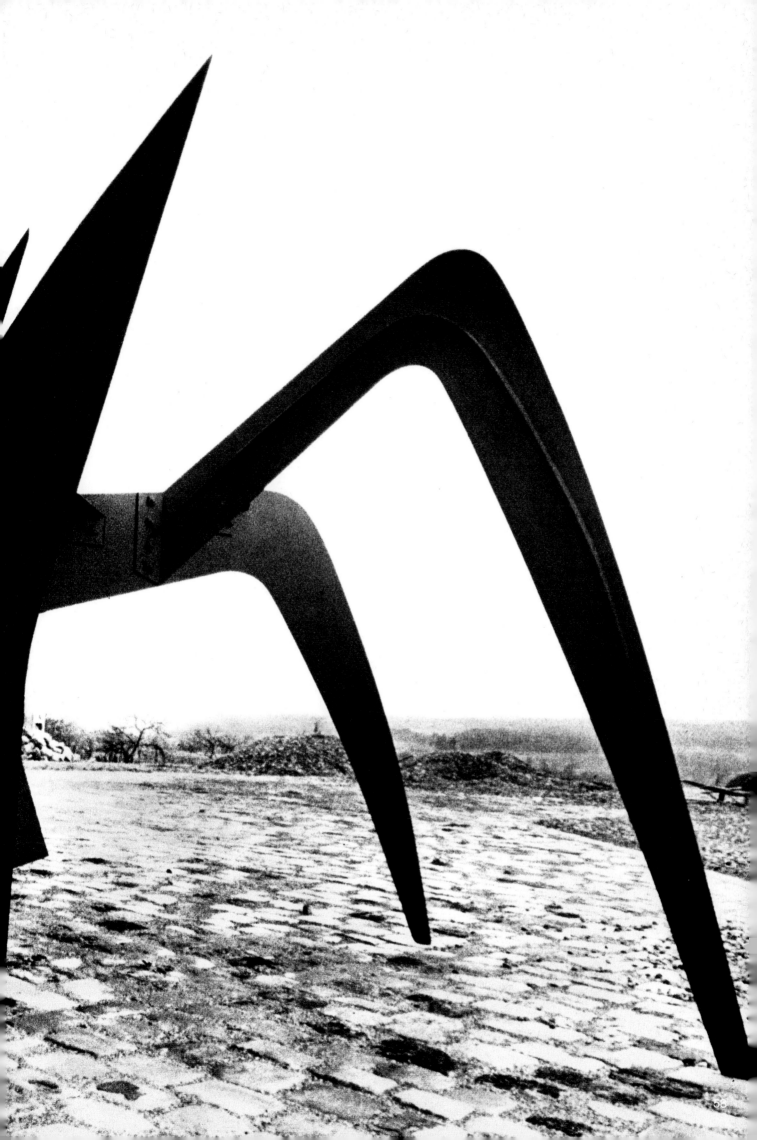

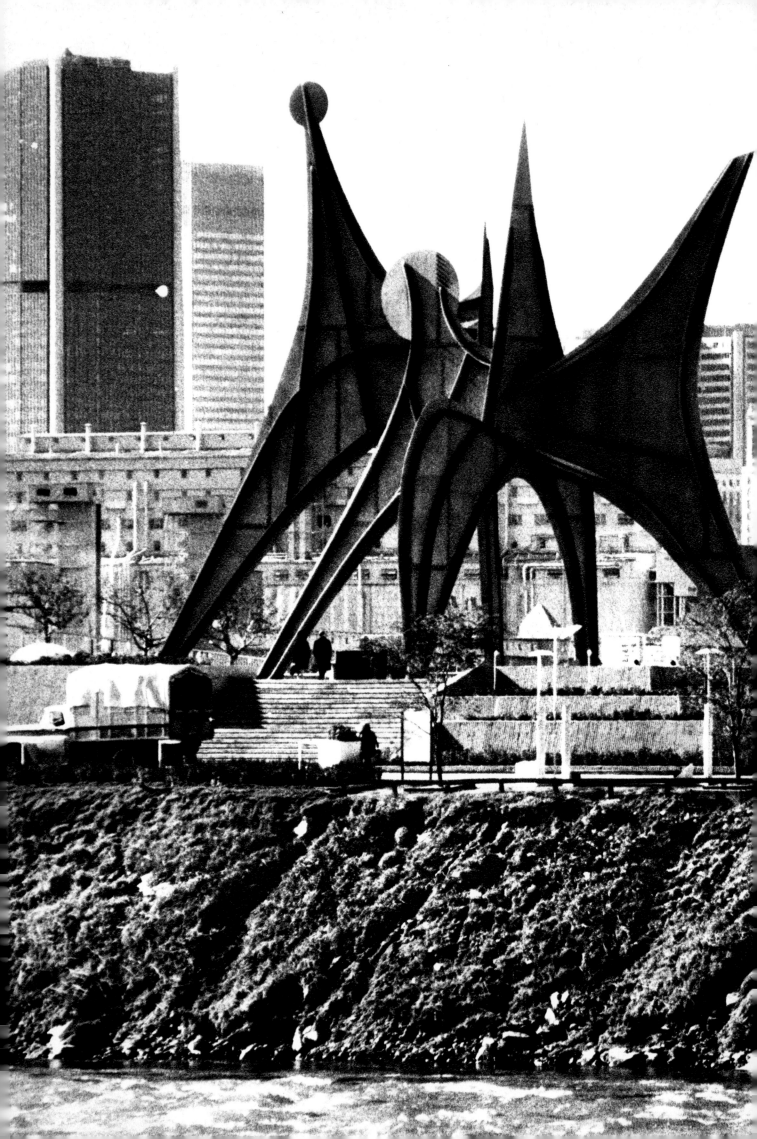

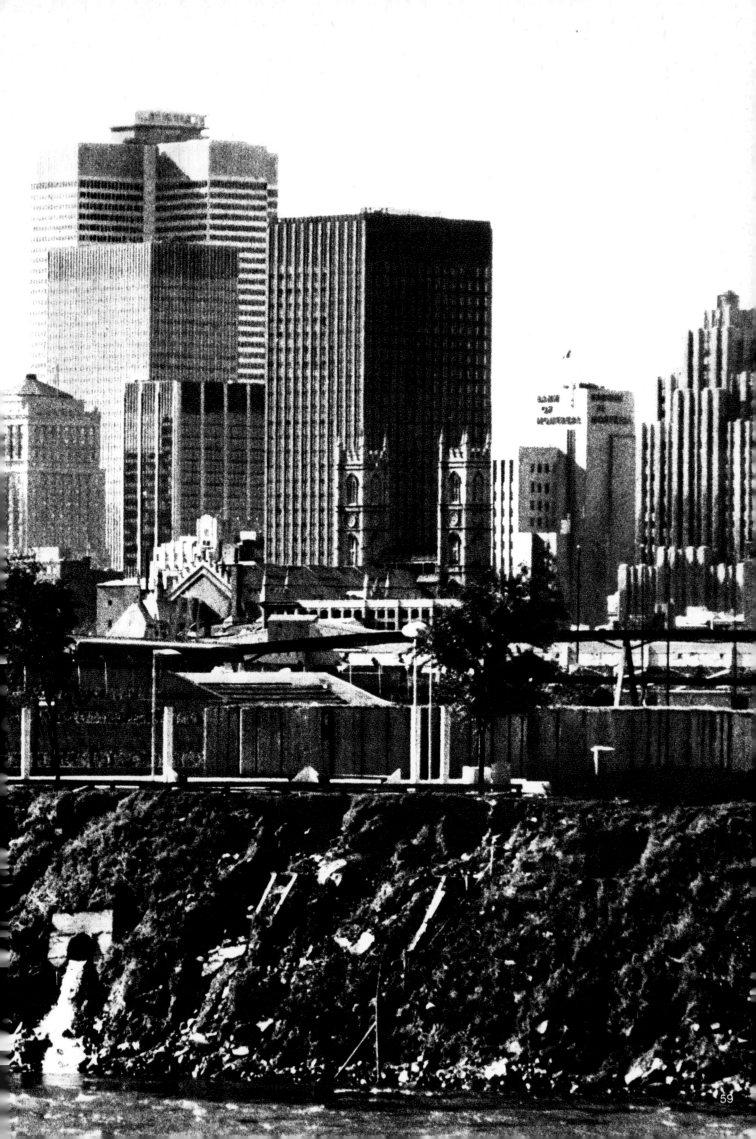

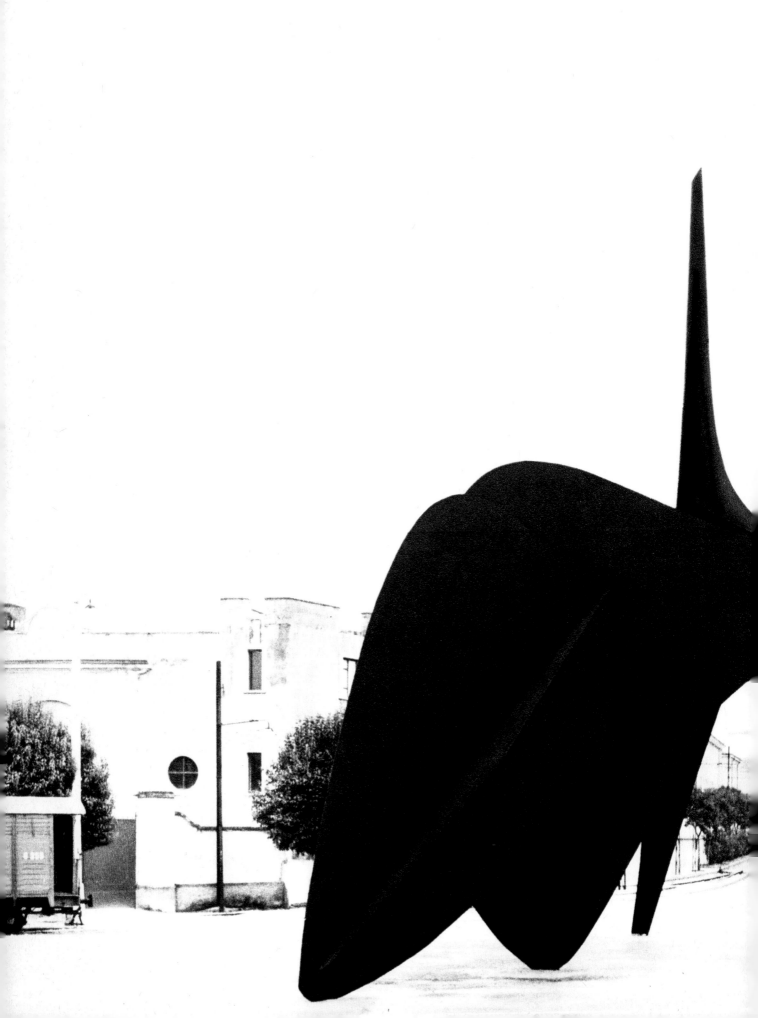

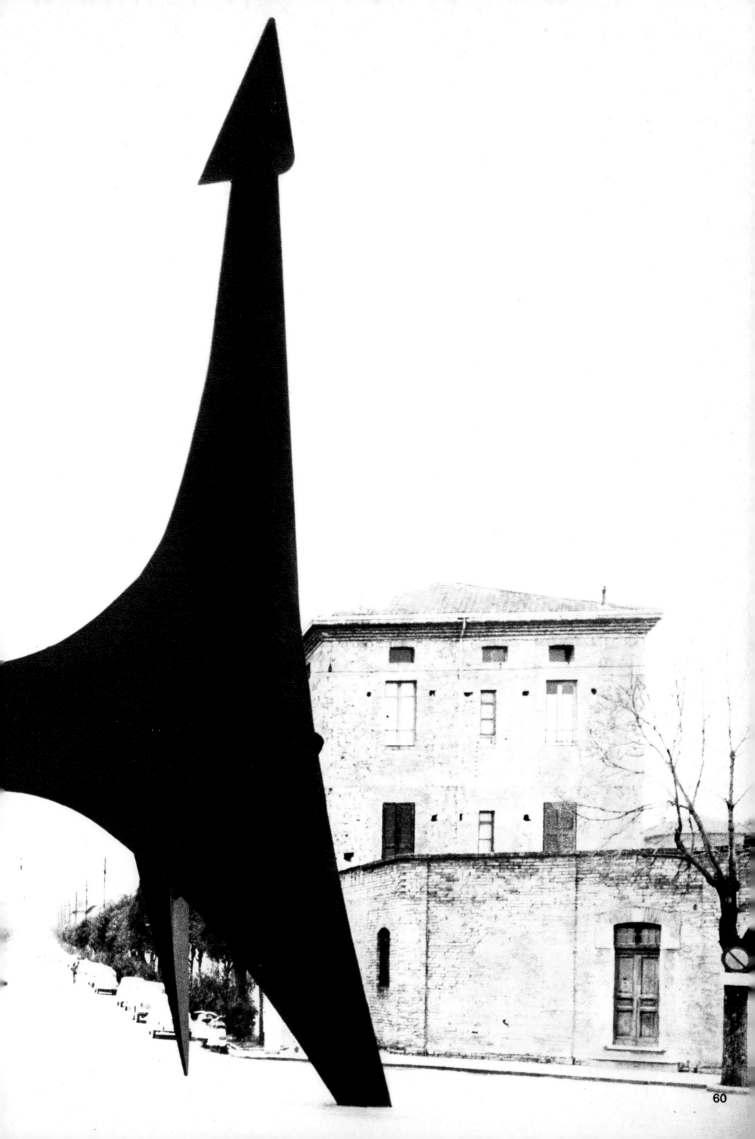

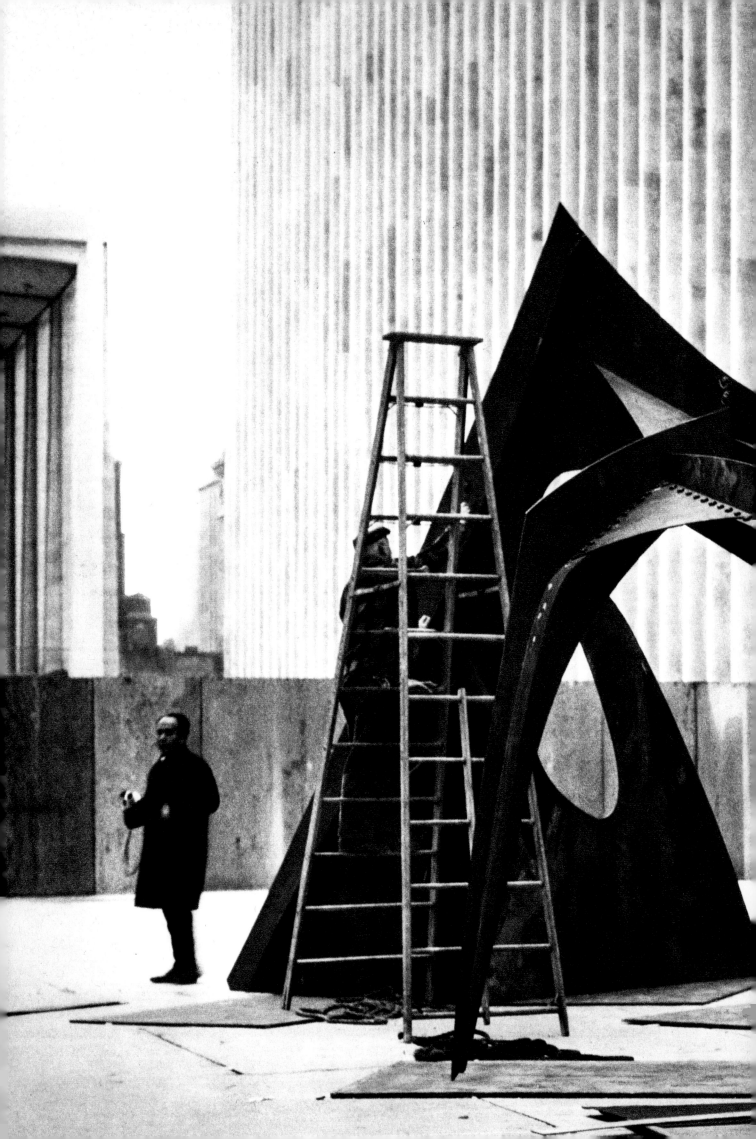

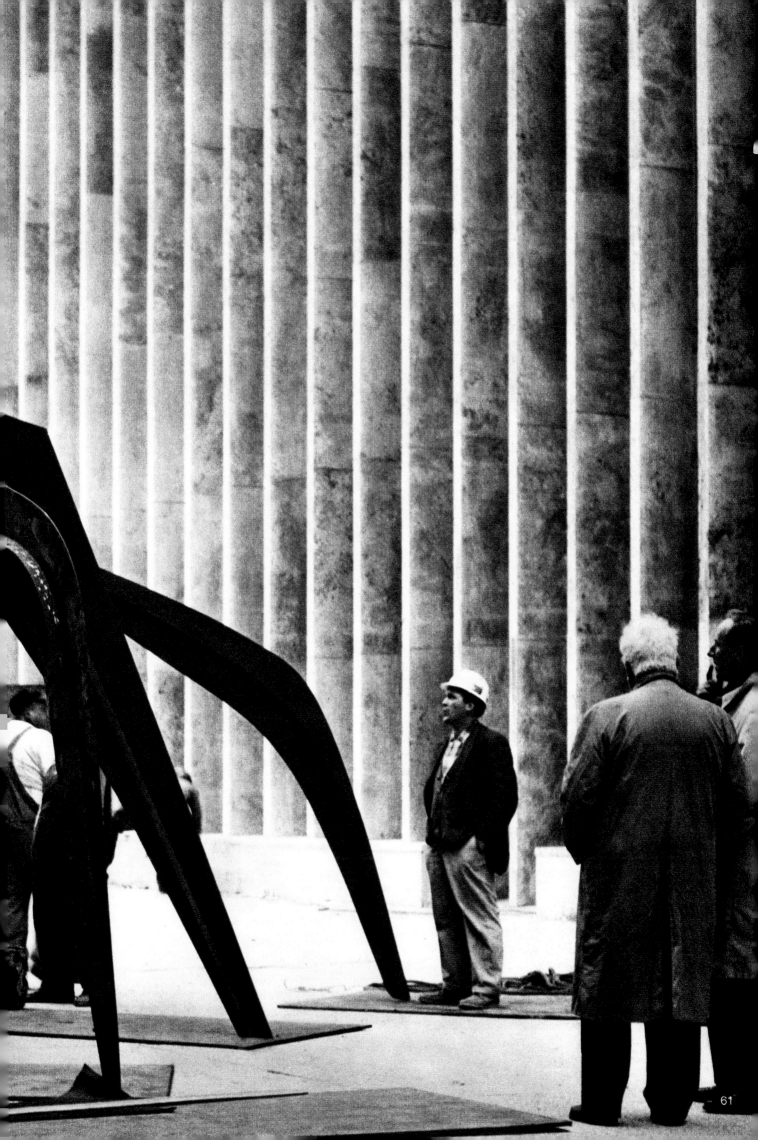

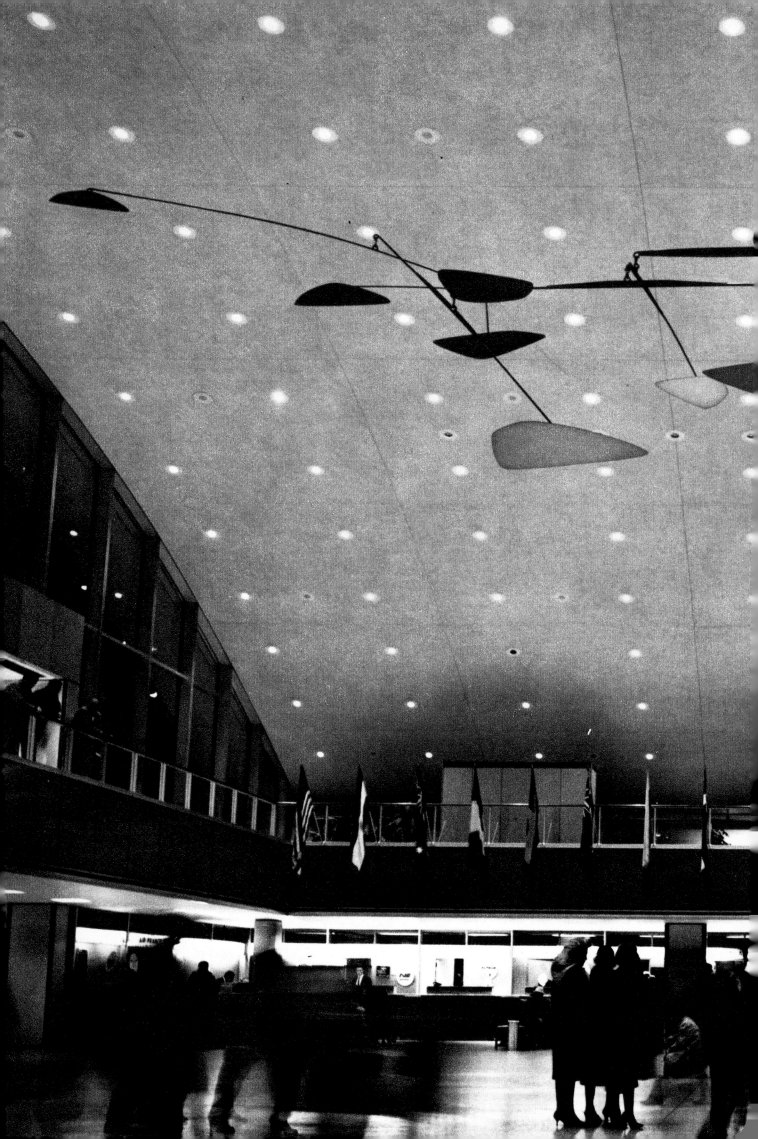

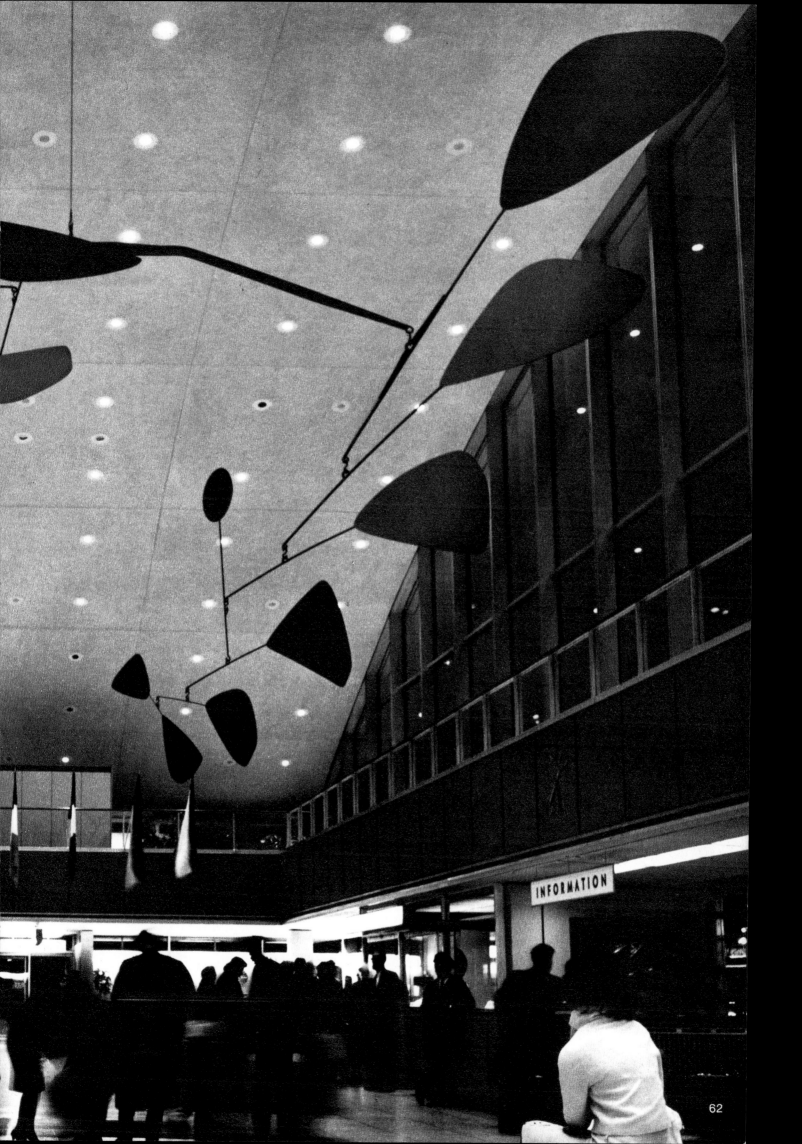

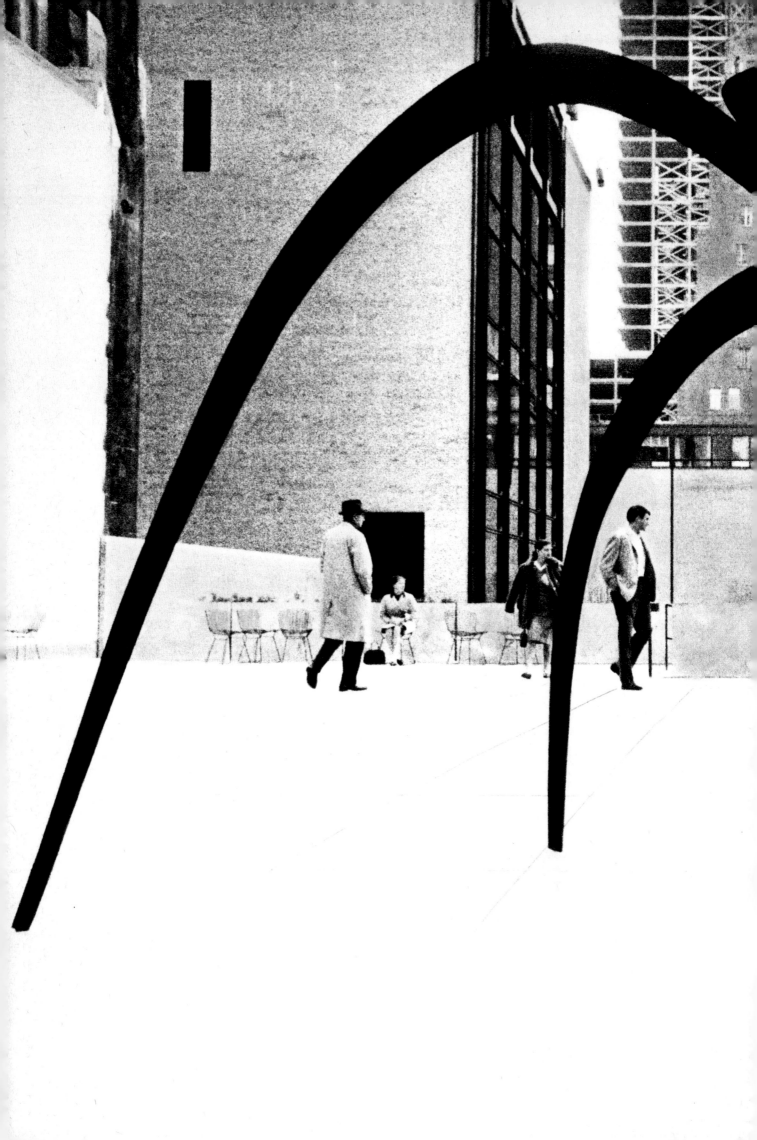

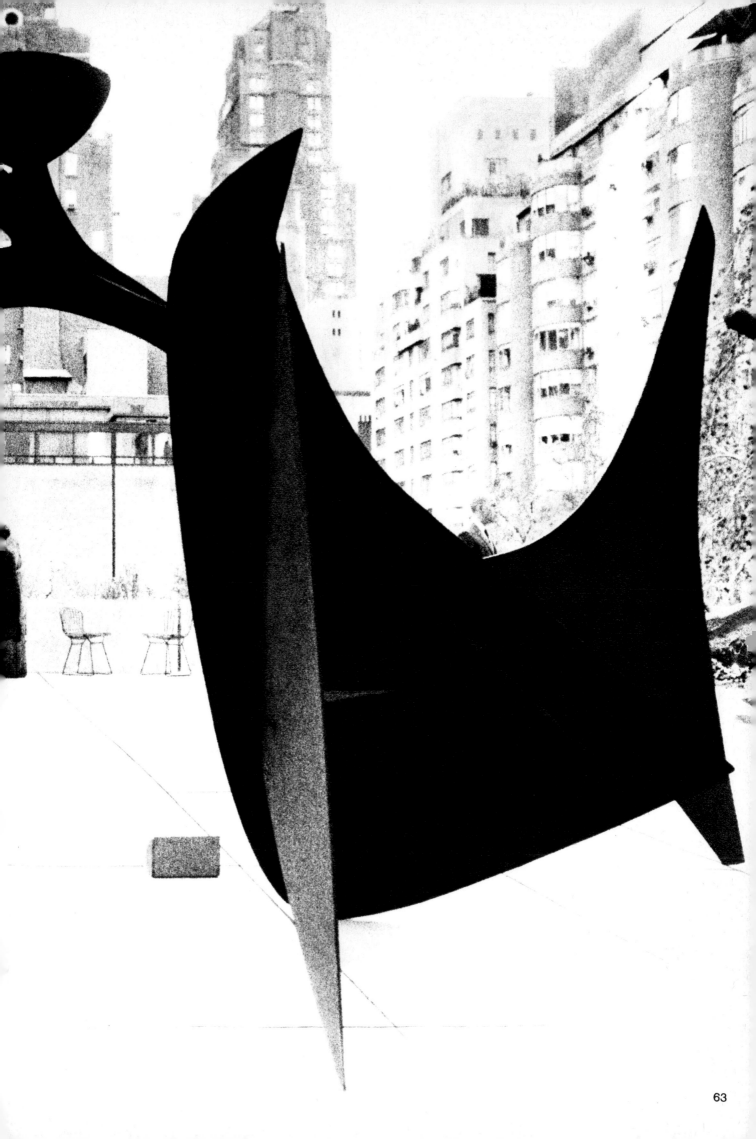

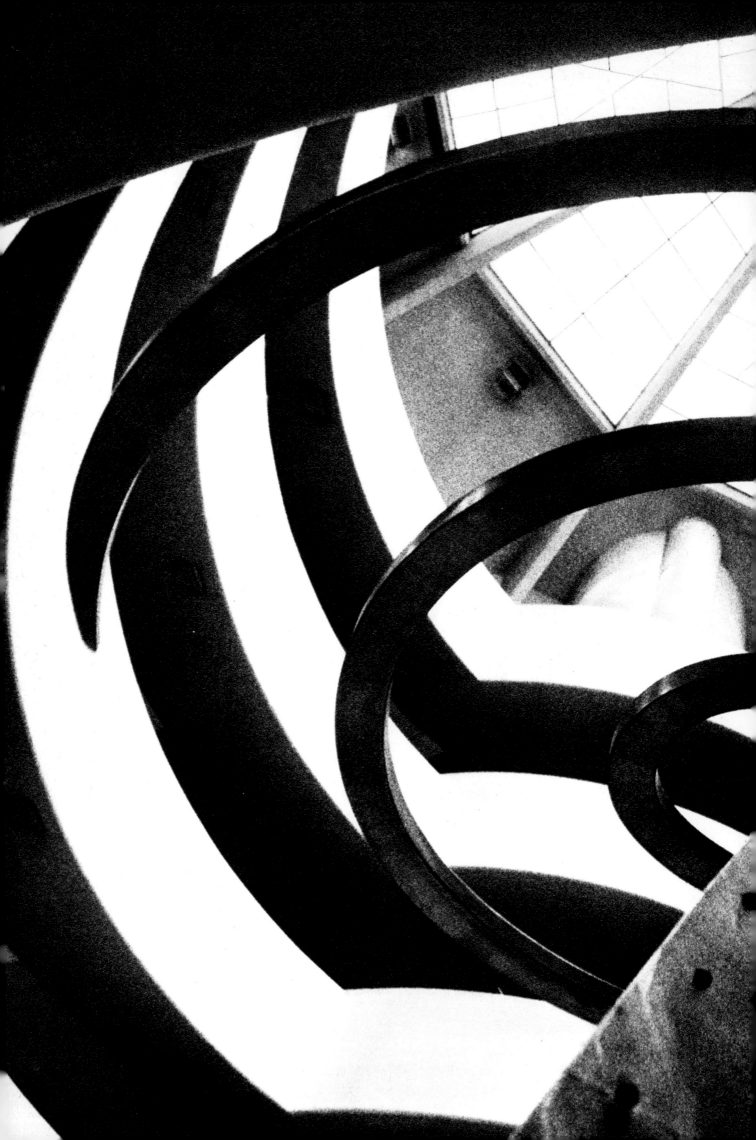

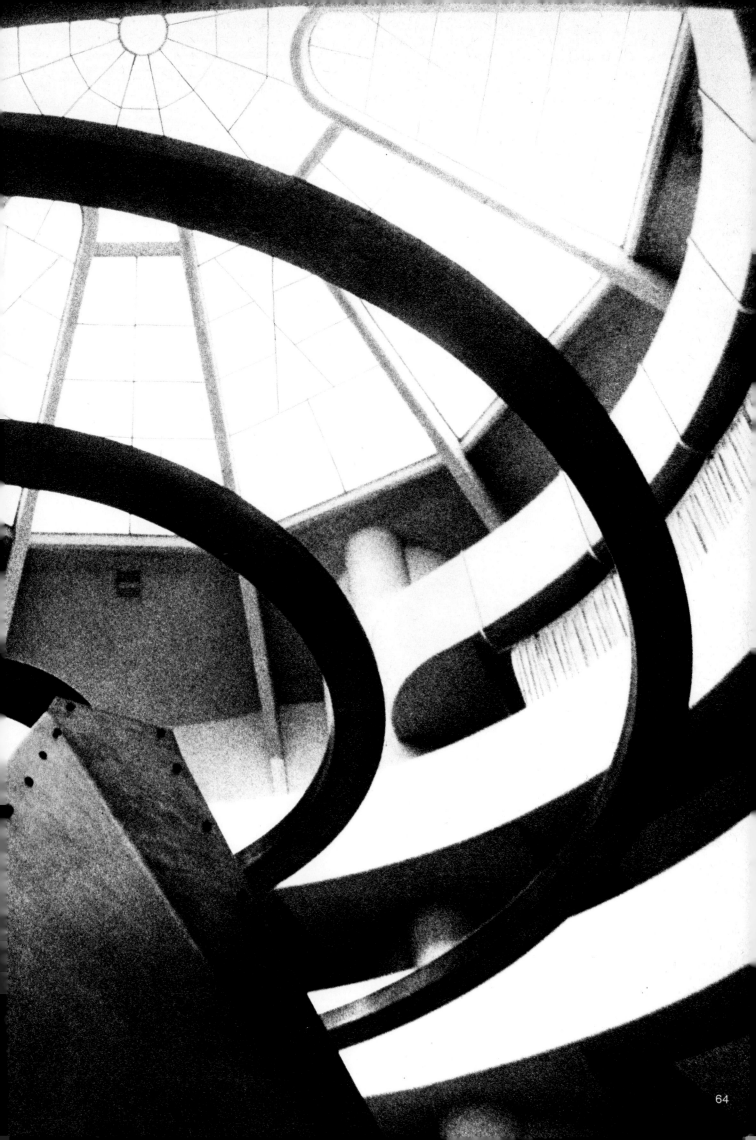

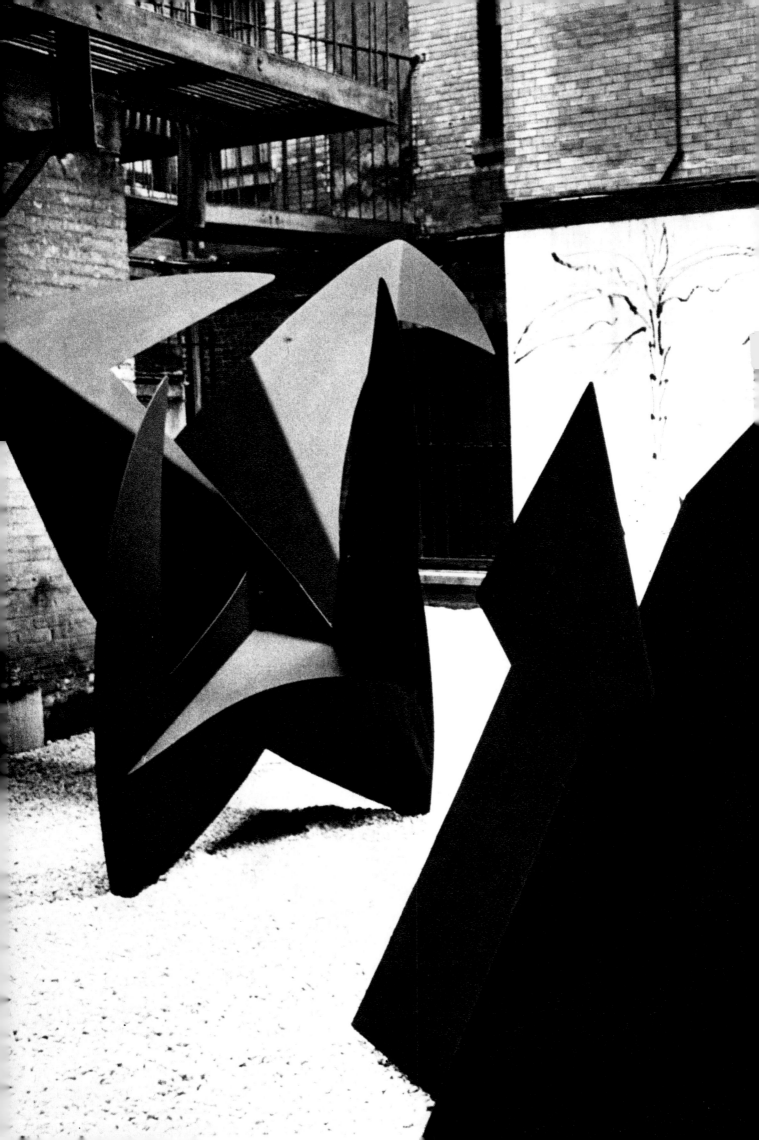

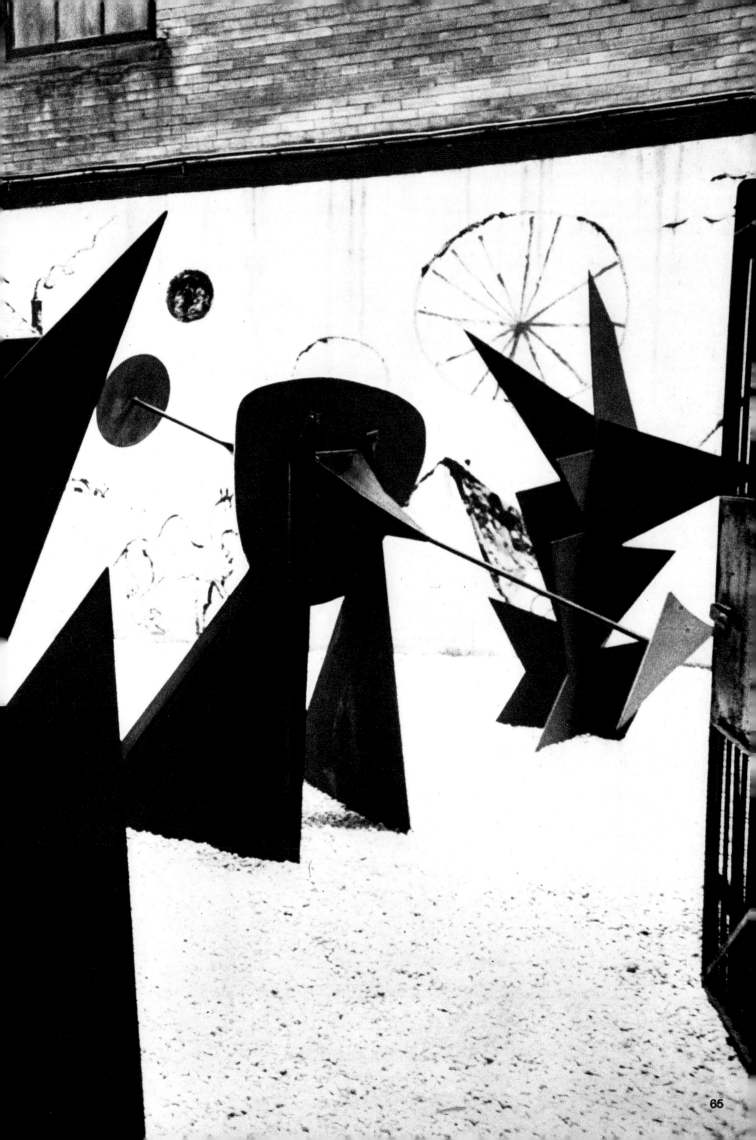

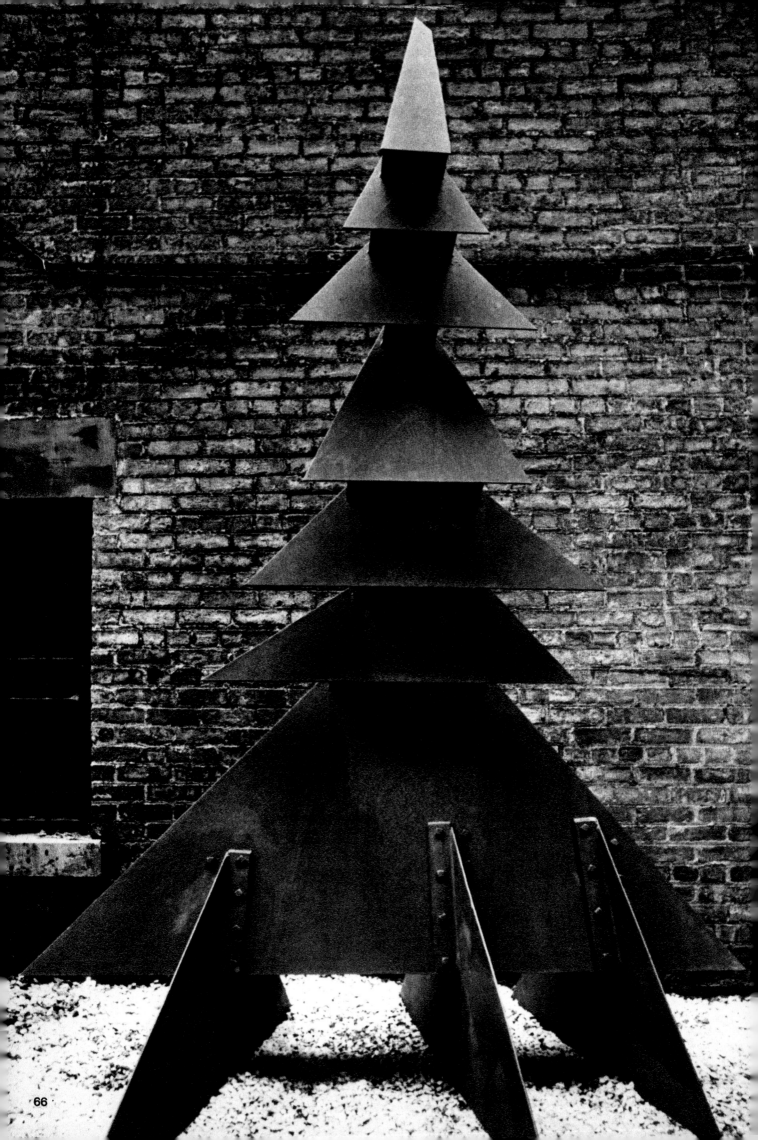

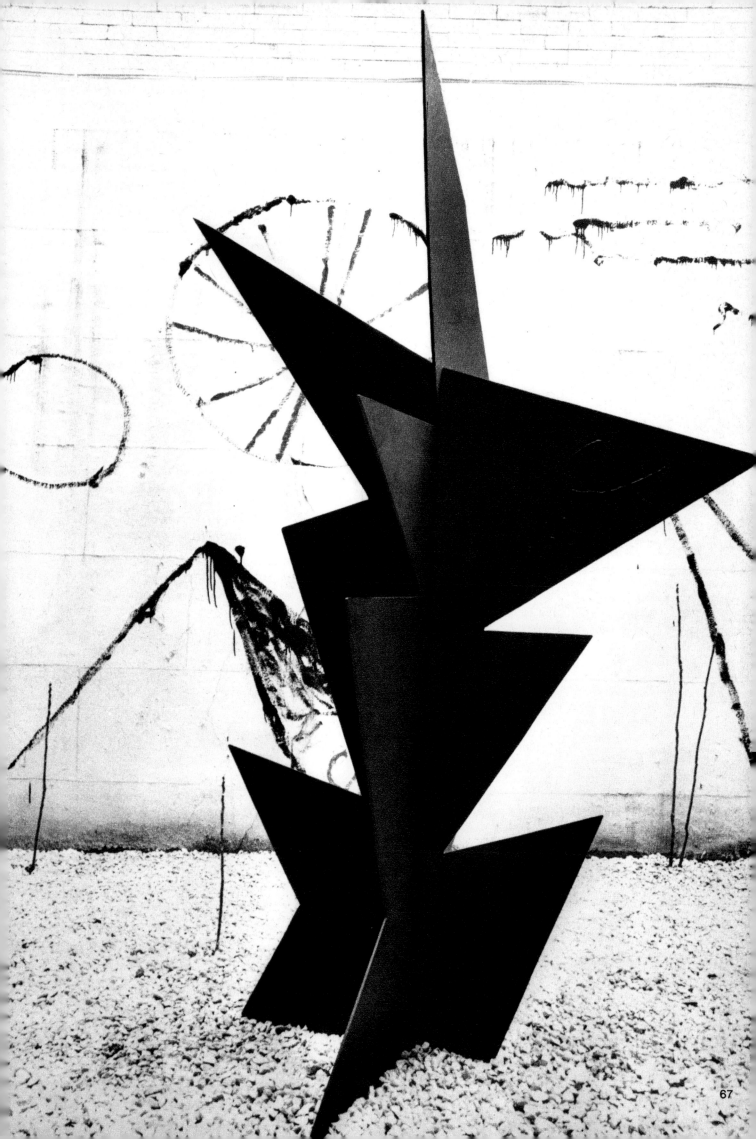

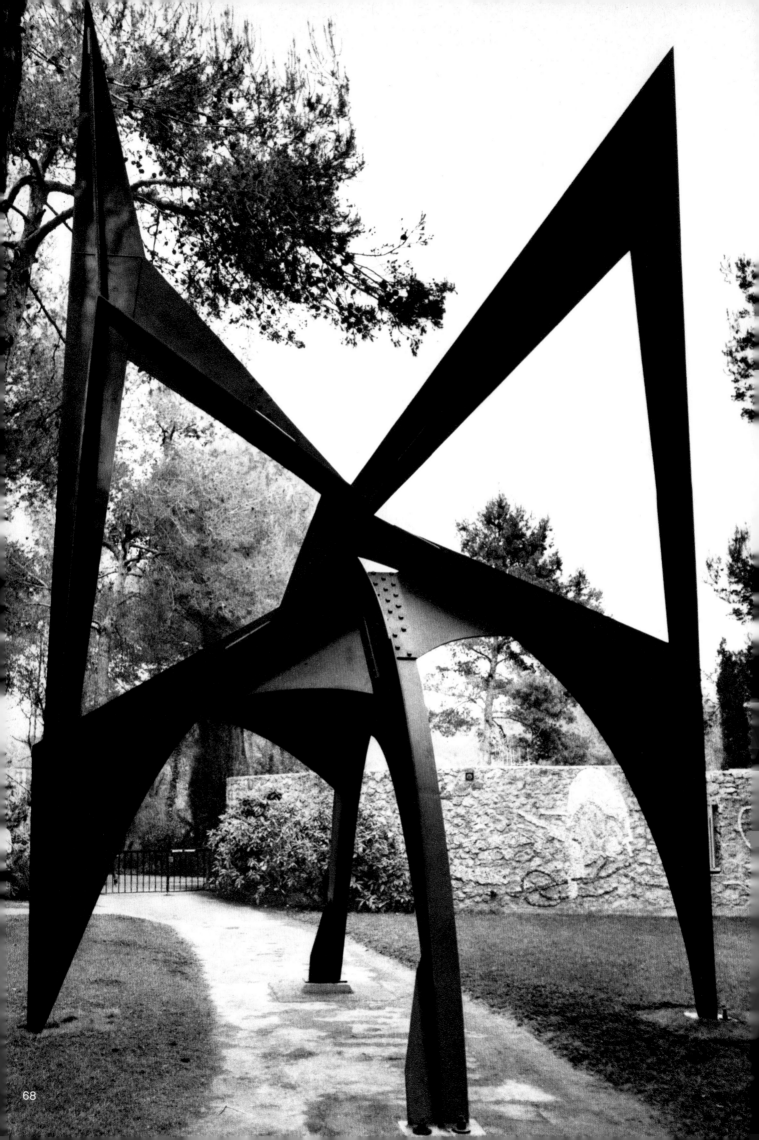

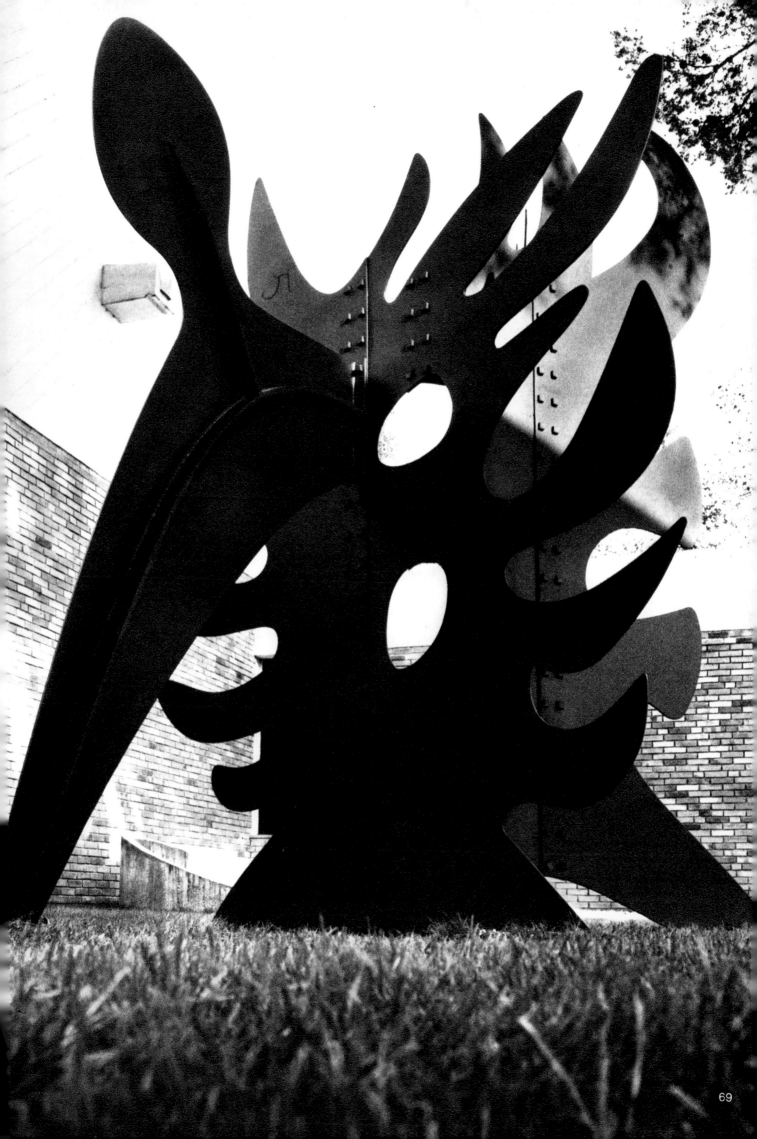

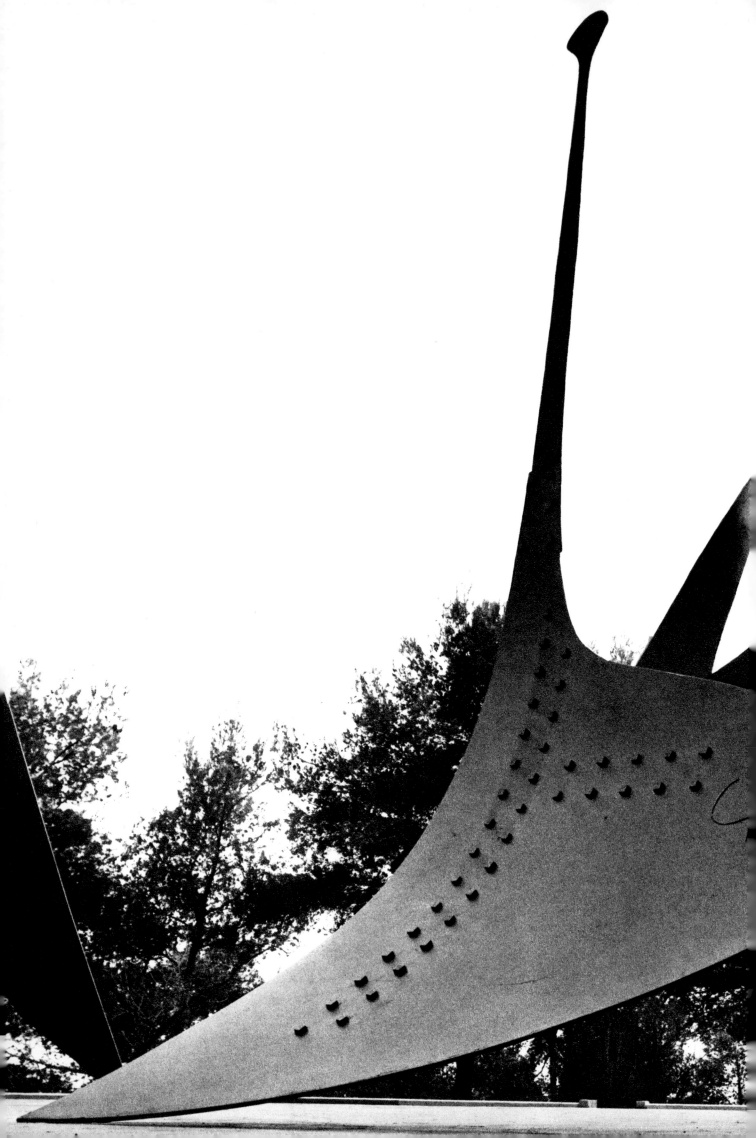

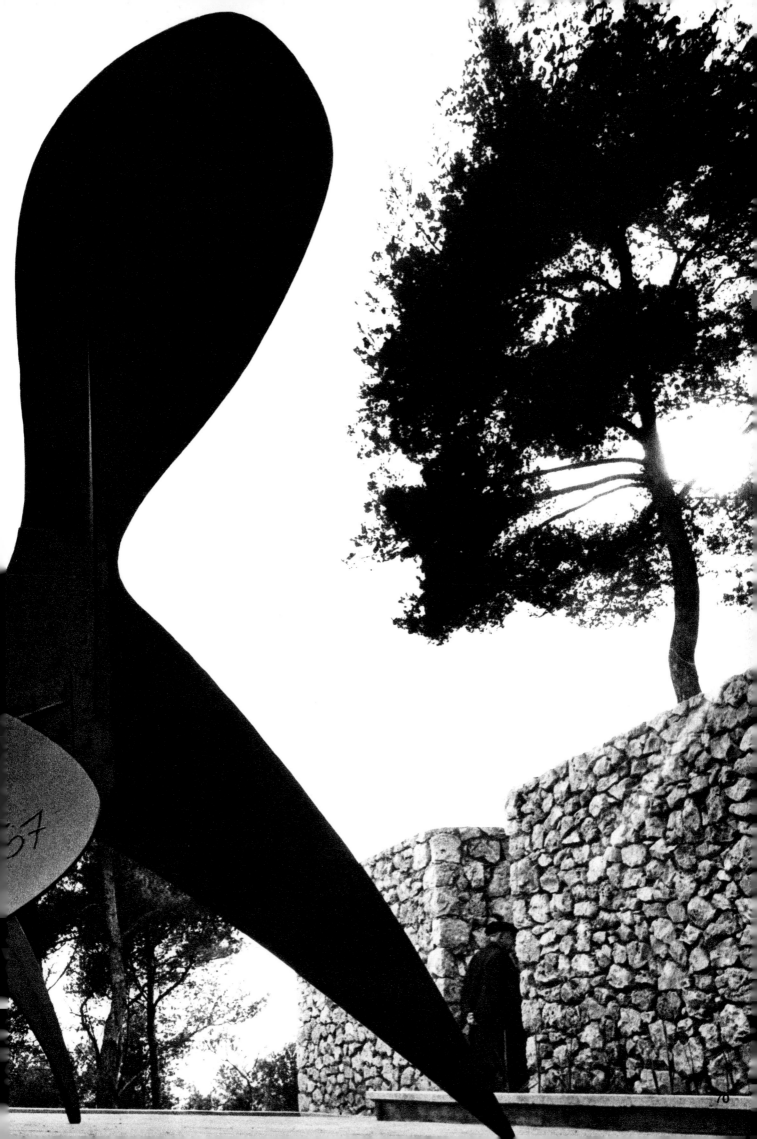

_calder_

75

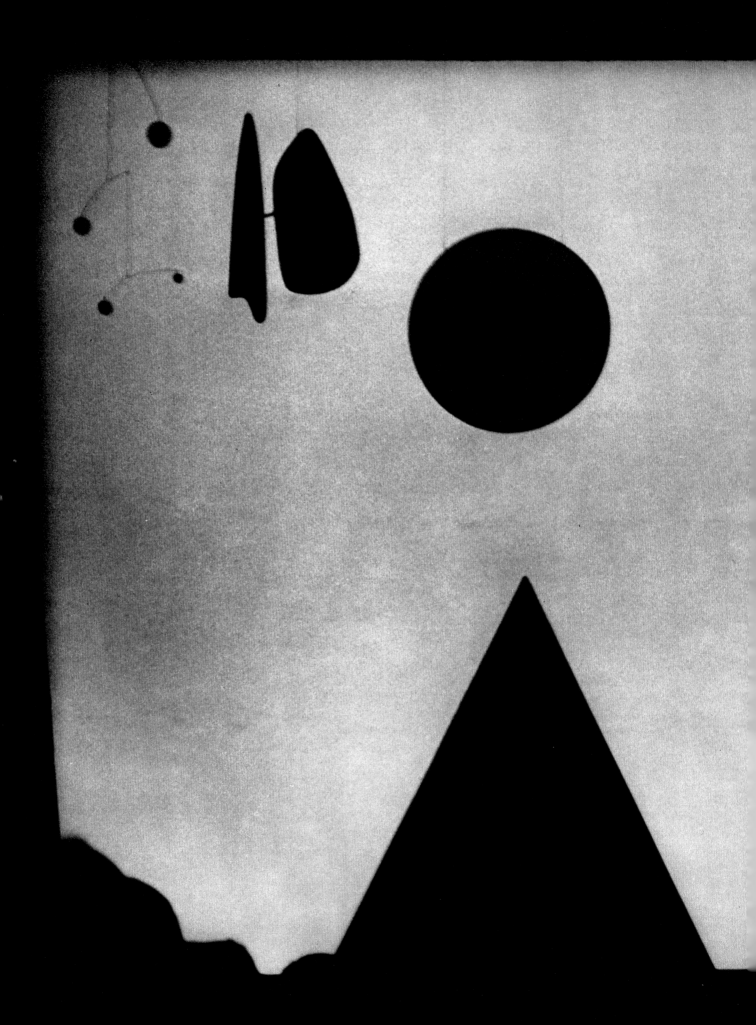

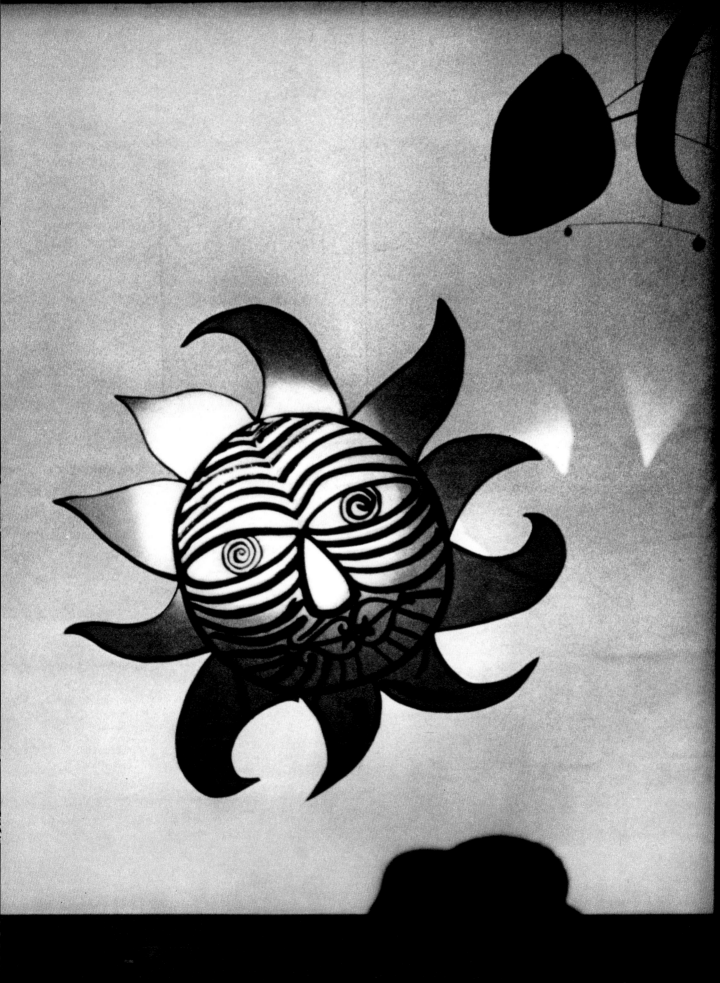

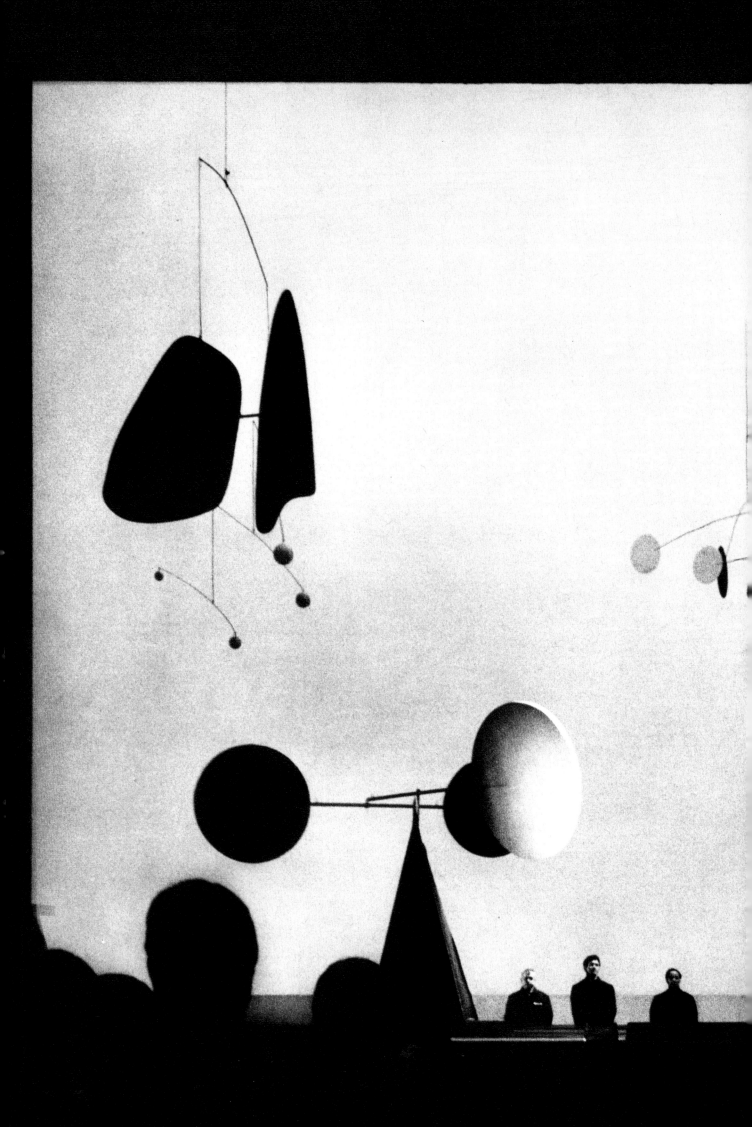

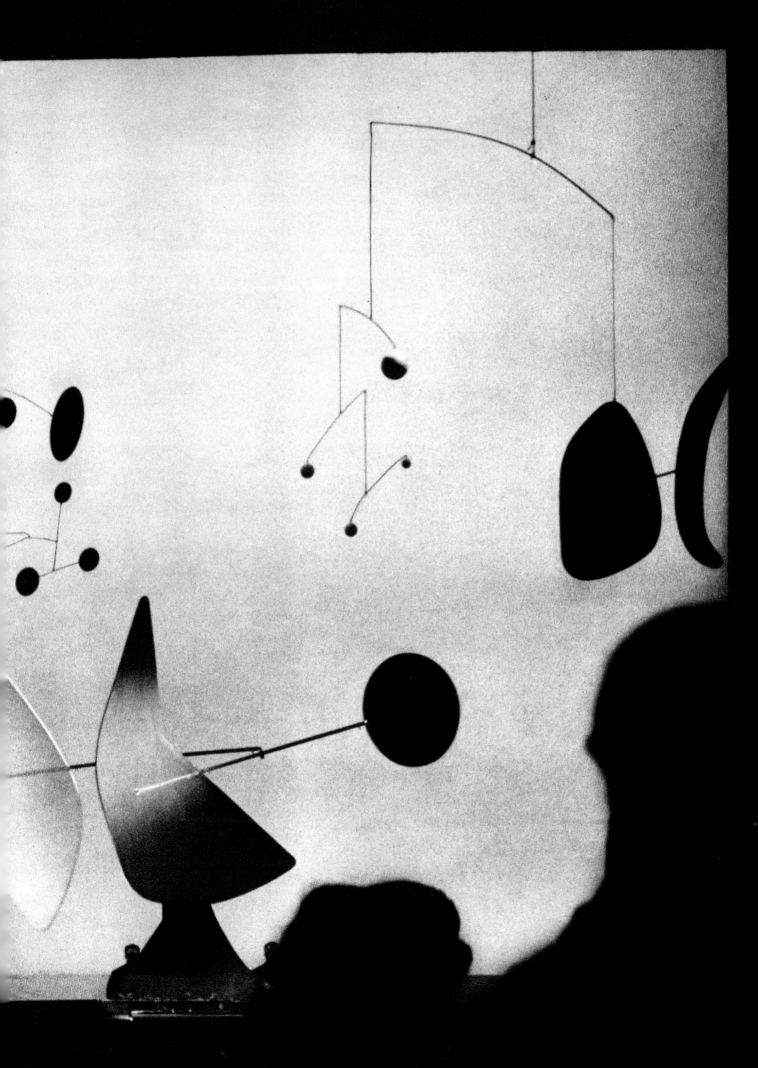

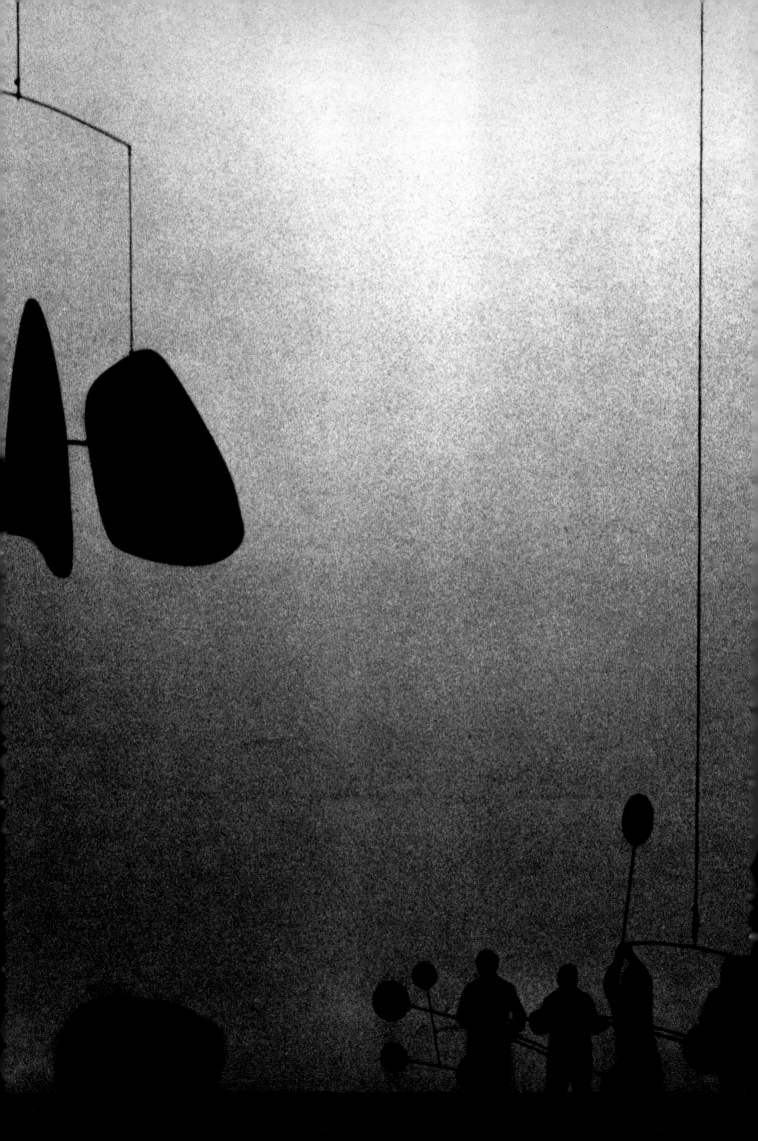

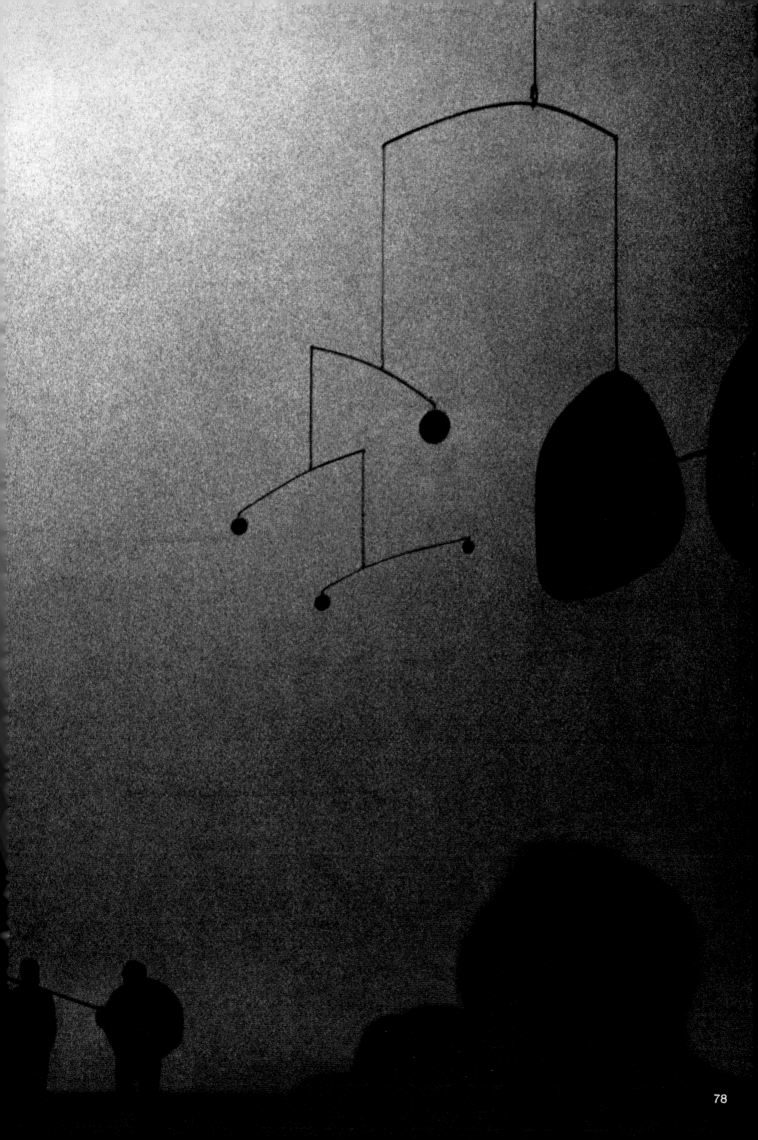

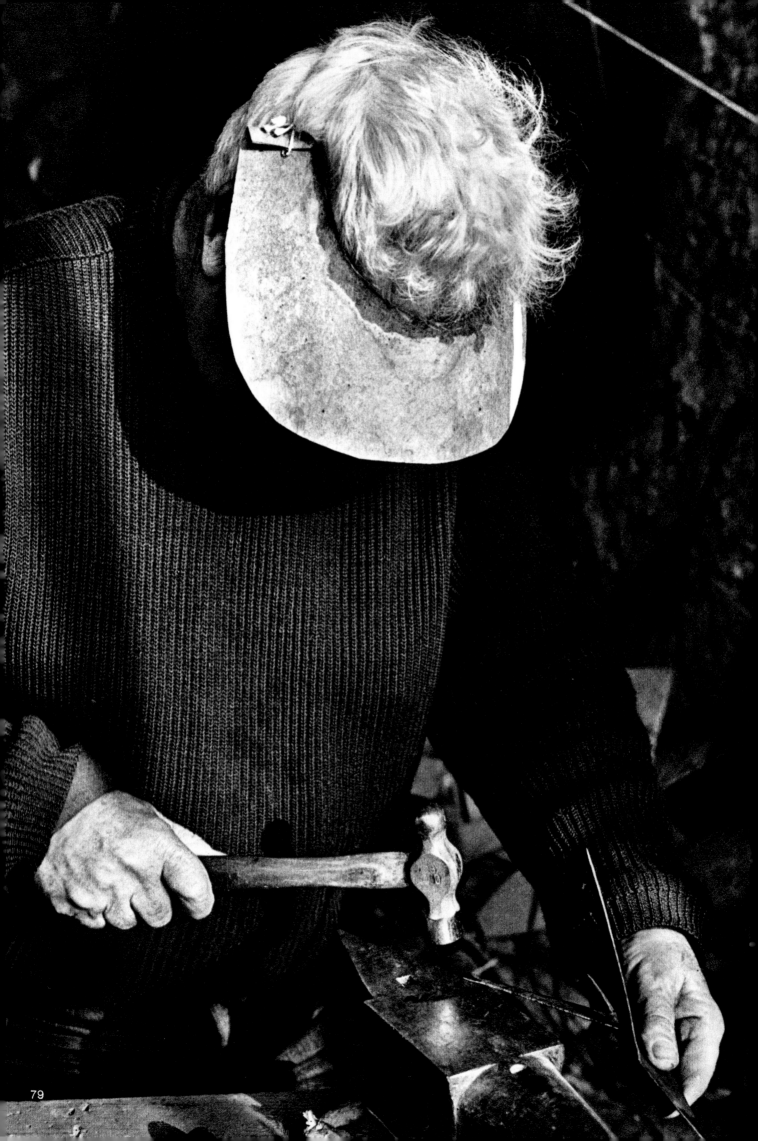

# LIST OF PLATES

201

18 *Universe*, 1931
Abstract construction
3′ 0″ high
A.C.: 'The *Universes* were in my 1931 show at the Galerie Percier and were the indirect result of my visit to Mondrian's studio in the Fall of 1930. They weren't intended to move, although they were so light in construction that they might have swayed a little in the breeze. Although I was affected by Mondrian's rectangular paintings, I couldn't do anything similar. After seeing him, I tried to paint for a couple of weeks, but then I came back to construction in wire. The circular forms, particularly interacting, seem to me to have some kind of cosmic or universal feeling. Hence the general title *Universe*. What I would like to have done would have been to suspend a sphere without any means of support, but I couldn't do it.'

19 *A Universe*, 1934
Motorized mobile: iron pipe, wire, wood, string
3′ 4½″ high
Coll: Museum of Modern Art, New York. Gift of Abby Aldrich Rockefeller

20 Wood mobile, 1935
3′ 3⅓″ × 1′ 11¼″ × 7⅜″
Private collection, New York

21 *Gibraltar*, 1936
Lignum vitae, 2′ 4½″ × 1′ 3⅛″ × 7″; walnut 3′ 1″ × 2′ 0⅜″ × 1′ 0⅛″; steel rods 4′ 3⅞″ × 2′ 0¼″ × 22⅜″
Coll: Museum of Modern Art, New York. Gift of the artist, 1966

22 Mechanical Object, 1941
Wood, wire and motor
1′ 7⅔″ × 1′ 7⅔″ × 1′ 4½″

23 *Totem Post*, 1940s
Wood abstract construction

24 *Constellation*, 1943
Wood and metal wires
2′ 0″ × 2′ 4⅓″ × 1′ 8⅝″
Coll: Musée National d'Art Moderne, Paris
A.C.: 'There wasn't much metal around during the war years, so I tried my hand at wood carving in the so-called constellations. I have always liked wood carving, but these were now completely abstract shapes. The shapes, as well as titles, came from Miró, who has been a friend of mine since 1929, but they had for me a specific relationship to the *Universes* I had done in the early 1930s. They had a suggestion of some kind of cosmic nuclear gases—which I won't try to explain. I was interested in the extremely delicate, open composition. I experimented once with plexiglas to see what effects I could get, and even won a competition. But I didn't like the stuff and so I gave it up. I think it stinks.'

25 *Nymph*, 1928
Wood sculpture
2′ 8⅔″ high

26 *Caryatids*, 1933
Wood sculpture
3′ 3⅓″ × 9″

27 *Halterophile*, 1944
Bronze
8″ high
Coll: Fondation Maeght, St Paul de Vence

28 *Acrobats*, 1944
Bronze
1′ 8½″
Coll: Fondation Maeght, St Paul de Vence

29 *The Dancer*, 1944
Bronze
2′ 3″ high
Coll: Fondation Maeght, St Paul de Vence
A.C.: 'The acrobats and dancers were done in bronze mainly in 1944. In some of them I experimented with figures balanced on a point which could rotate, or things like the lady sliding along the loose wire. I had tried out these balancing solid objects as early as 1933 in a piece called *Shark and Whale* (34) and I made them more or less abstract in works like *Double helix* (32) and the *Snake on the Arch* (30) although there was usually some reference to a natural object. When I made *Double helix* I did not know that it was going to become the basis of all genetics.'

30 *Snake on the Arch*, 1944
Bronze
2′ 10⅝″ high
Private collection, New York

31 *Starfish*, 1944
Bronze
2′ 0¾″ high
Coll: Fondation Maeght, St Paul de Vence

32 *Double helix*, 1944
Bronze
2′ 9″ high
Coll: Galerie Maeght, Paris

33 *Apple monster*, 1938
Wood
5′ 7″ high

34 *Shark and Whale*, c. 1933
Wood
2′ 8″ × 3′ 7½″

35 *Morning Cobweb*, 1945
Stabile (model)
2′ 11¾″ high
See plate 69

36 *Portrait of a young man*, 1945
Stabile
2′ 11¼″ high
Private collection, U.S.A.
A.C.: 'One of the earlier stabiles done in 1945. I just cut out the legs and then the upper part became a face and I thought he looked pretty snotty. Hence the title. Brancusi also did a *Portrait of a Young Man* but it has no relationship to this one and I don't think I had heard of it when I made this.'

37 *Little ball with counterweight*, 1930
Mobile
5′ 2¼″ × 1′ 0¼″ × 1′ 0¼″
Private collection, Chicago

38 *Un Mobile au plomb*, 1931
3′ 5″ × 3′ 4″
Private collection, Barcelona

39 Mobile, c. 1935
2′ 1″ × 1′ 11″
Coll: Solomon R. Guggenheim Museum, New York

40 Mobile, 1936
8⅛″ high
Coll: Solomon R. Guggenheim Museum, New York. Mary Reynolds Collection, gift of her brother.

41 *Small frame*, 1937
Metal
11⅝″ × 1′ 7⅔″

42 *Rusty Bottle*, c. 1936
Hanging mobile, metal
8′ 0″ high
Coll: Perls Galleries, New York

43 *Small Spider*, *c.* 1940
Standing mobile, metal
4' 7" × 4' 2"
Coll: Mr and Mrs Klaus G. Perls

44 *Escutcheon I*, 1952
Metal
2' 7" × 3' 2" × 2' 1"
Private collection, New York

45 *Pomegranate*, 1949
Mobile
5' 5⅔" × 5' 5"
Coll: The Whitney Museum of American Art, New York

46 *Red Sun, Black Clouds*, 1963
Hanging mobile
2' 9" × 10' 10"
Private collection, London

47 *Sumac*, 1961
Mobile
4' 1¾" × 7' 10"
Private collection, Washington, D.C.

48 *'Funghi Neri'*, 1960
Stabile
9' 3"
Coll: Perls Galleries, New York

*Discontinuous*, 1962
Stabile
9' 6"
Coll: Perls Galleries, New York

49 *'S'*
Stabile

*Bomb*, 1964
Stabile

50 *Bomb*, *'Funghi Neri'*, *Mobile*, *Southern Cross* (1963, standing mobile, 17' 6" × 24' 0"), *Prickly Pear* (1964, stabile, 10' 0", Coll: Perls Galleries, New York), *Octopus* (1944, stabile, 10' 0", Coll: Perls Galleries, New York), *Discontinuous*.

51 *Tamanoir* ('Anteater'), 1963
Stabile
Now in Amsterdam
A.C.: 'I particularly like that picture. It looks like an old engraving. The title of this again was just some vague association. After I had finished it and walked around it, it began to look like an anteater. On this business of titles, sometimes it's the whole thing that suggests a title to me, sometimes it's just a detail.'

52 *Falcon*, 1963
At Saché
A.C.: 'The *Falcon*, seen from another point of view, becomes a kind of dragon, although I had no such idea.'

53 *Guichet* (ticket window), 1965 (in the big studio at Saché)
14' × 21'
Now at Lincoln Center (see plate 61)

54 *Sabot* (wooden shoe), 1963
Stabile
10'

*Dent de Sagesse* (wisdom tooth), 1964
Stabile
6' 8" × 15' 0"

55 *Trois Ailes* (Three wings); *Falcon*; *Triangles and Arches*, all 1963
At Saché

56 *Falcon*; *Trois Ailes*
At Saché

57 *Trois Ailes*; *Falcon*
At Saché

58 *Bucephalus*, 1963
Stabile
9′ 2⅝″
Now in San José, California

59 *Man*, 1967
Stainless steel
70′ high
Montreal
A.C.: '*Man* was the biggest stabile I have made before the one in Mexico City done for the Olympics. This is about 70 feet high, made out of stainless steel. In the beginning I called it *Three Disks*, but when I got over to Canada, they wanted to call it *Man* as a sort of theme for the exposition. I built a three-foot high model out of aluminum and then turned it over to the iron workers in Tours to enlarge. I brought some of them with me to Canada and we assembled it on the spot. When we first talked about a sculpture twenty meters tall—that's about 64 feet—they asked me to stretch it to 67 feet because it was 1967. But I told them that was like giving me the commission because I was 67 years old. I happened to be 67 then.'

60 *Teodelapio*, 1962
Stabile
Spoleto

61 *Guichet*
Lincoln Center, New York, installed 1965. Gift of Howard Lipman

62 Mobile, 1957
Kennedy Airport, New York

63 *Black Widow*, 1959
Stabile
7′ 7⅞″ × 14′ 3″
Coll: Museum of Modern Art, New York. Mrs Simon Guggenheim Fund.

64 *Spiral*, 1966. ('No! to Frank Lloyd Wright')
National Collection of Fine Arts, Smithsonian Institution, Washington, D.C.
A.C.: 'This was a recent return to the earlier machine mobiles. The brass spiral at the top rotates and rocks slowly, powered by a motor inside the red base. This was in the last big sculpture show at the Guggenheim Museum. Despite Mulas' photographs mixing it up with Frank Lloyd Wright's architecture, the piece was not inspired by the Guggenheim. I made a small version of this earlier and gave it to Jean Davidson for his birthday. Later, I enlarged it.'

65 Exhibition at Perls Galleries, New York

66 *Pagoda*, 1963
Stabile
Perls Galleries, New York
Calder speaks of this as 'a primitive totem'.

67 *Hard to Swallow*, 1966
Stabile
7′ 7″ × 3′ 9″ × 5′ 2″
Coll: Perls Galleries, New York

68 *Morning Cobweb*, 1969
Stabile
25′ 5″ high
Made for a retrospective show at the Fondation Maeght, St Paul de Vence.

69 *Les Arêtes de Poissons*, 1966
Stabile
11′ 3½″ × 13′ 1½″ × 8′ 2½″
Coll: Galerie Maeght, Paris

70 *Cactus provisoire*
Stabile
9′ 10″ × 16′ 4⅞″

71–72 Drawings, 1931–32
A.C.: 'These are some drawings I made right after I visited Mondrian's studio. They are among the first abstract things that I did and they led to the wire universes and possibly, later, to some of those bronze sculptures I did in the 1940s like the *Snake on the Arch*.'

73 Gouache, 1968
Private collection, Paris

74 Gouache, 1967

75 Black head, 1962
Tapestry
3′ 5½″ × 2′ 5¼″
Made for Louisa Calder

76–78 Performance of *Work in Progress*, 1968
A mobile ballet with electronic music by Niccolo Castiglioni, Aldo Clementi and Bruno Moderna; directed by Giovanni Carandente. Given at the Opera House, Rome.

79 Calder at work

# SELECTED BIBLIOGRAPHY

ILLUSTRATED BY THE ARTIST

*Animal Sketching.* Pelham, New York, Bridgman Publishers, Inc., 1926.

*Fables of Aesop.* Paris, Harrison of Paris, 1931.

*Three Young Rats and Other Rhymes.* Edited with an introduction by James Johnson Sweeney. New York, Curt Valentin, 1944.

Coleridge, Samuel Taylor. *The Rime of the Ancient Mariner.* With an essay by Robert Penn Warren. New York, Reynal and Hitchcock, 1946.

La Fontaine, Jean de. *Selected Fables.* Translated by Eunice Clark. New York, Quadrangle Press, 1948.

*A Bestiary.* Edited by Richard Wilbur. New York, Pantheon Books, 1955.

"Alexander Calder's Circus." *Art in America* 52 no. 5 October 1964. Facsimile lithographed portfolio.

Elleouet, Yves. *La Proue de la Table.* Paris, Soleil Noir, 1967. Seven etchings by Calder.

STATEMENTS BY THE ARTIST

*Abstraction-Création, Art Non Figuratif.* 1 : 6 1932. Partial translation in *Art of This Century*, Ed. Peggy Guggenheim, New York, 1942.

Berkshire Museum, Pittsfield, Mass. *Modern Painting and Sculpture.* August, 1933. E.C.

Evans, Myfanwy, ed. *The Painter's Object.* London, Gerald Howe, 1937.

"Mercury Fountain." *Technology Review* 40 : 202 March 1938.

"Mercury Fountain." *Stevens Indicator* 55 no. 3 : 2–3, 7 May 1938.

Addison Gallery of American Art, Andover, Mass. *Mobiles by Calder.* June, 1943. E.C.

"The Ides of Art—14 sculptors write." *The Tiger's Eye* no. 4 : 74 June 1948.

Katzenbach and Warren, New York. *Calder, Matisse, Matta, Miro: Mural Scrolls.* Introduction by James Thrall Soby. New York, Katzenbach and Warren, 1949.

"What Abstract Art Means to Me." *Museum of Modern Art Bulletin*, New York 18 no. 3 : 8, Spring 1951.

Alvard, Julien and Gindertael, R. V., eds. *Témoignages pour l'art abstrait 1952.* Paris, Editions "Art d'aujourd'hui," 1952. Translated reprint of "What Abstract Art Means to Me."

Rodman, Selden. *Conversations with Artists.* New York, Devin-Adair, 1957.

Staempfli, George W. "Interview with Calder." *Quadrum* no. 6 1959.

Kuh, Katharine. *The Artist's Voice: Talks with Seventeen Artists.* New York, Harper and Row, 1962.

BOOKS

Hildebrandt, Hans. *Die Kunst des 19 und 20 Jahrhunderts.* Wildpark-Potsdam, Akademische Verlagsgesellschaft Athenaion, 1924 (postscript 1931).

Jakovsky, Anatole. *Six essais: Arp, Calder, Hélion, Miro, Pevsner, Seligmann*. Paris, Chez Jacques Povolozky, 1933.

Grigson, Geoffrey, ed. *The Arts Today*. London, John Lane, 1935.

Barr, Alfred H. *Cubism and Abstract Art*. New York, Museum of Modern Art, 1936. E.C.

Seuphor, Michel. *Douce province, roman*. Lausanne, Jean Marguerat, 1941.

Sweeney, James J. *Alexander Calder*. New York, Museum of Modern Art, 1943. E.C. Revised edition 1951.

Loeb, Pierre. *Voyages à travers la peinture*. Bordas, 1945. "Lettre à Calder."

Valentiner, W. *Origins of Modern Sculpture*. New York, Wittenborn, 1946.

Giedion, Sigfried. *Mechanization takes command*. New York, Oxford University, 1948. "The Hammock and Alexander Calder," also published in *Interiors* 106 no. 10:100–4 May 1947.

Goitein, Lionel. *Art and the Unconscious*. New York, United Book Guild, 1948.

Schnier, Jacques. *Sculpture in Modern America*. Berkeley and Los Angeles, University of California Press, 1948.

Soby, James Thrall. *Contemporary Painters*. New York, Museum of Modern Art, 1948. "Three Humorists: Klee, Miró, Calder."

Yale University Art Gallery. *Collection of the Société Anonyme: Museum of Modern Art, 1920*. New Haven, Connecticut, 1950. With statement by Marcel Duchamp.

Ritchie, Andrew. *Sculpture of the Twentieth Century*. New York, Museum of Modern Art, 1952. E.C.

Heron, Patrick. *The Changing Forms of Art*. London, Routledge and Kegan Paul, 1955.

Ragon, Michel. *L'aventure de l'art abstrait*. Paris, Laffont, 1956.

Buffet-Picabia, Gabrielle. *Aires abstraites*. Geneva, Pierre Cailler, 1957. Reprint of "Sandy Calder, forgeron lunaire." *Cahiers d'Art* 20–21:324–33 1946.

Gómez Sicre, José. *Four Artists of the Americas*. Washington, D.C., Pan American Union, 1957.

Duchamp, Marcel. *Marchand du Sel*. Paris, 1958. Reprint of statement on Calder which appeared in *Collection of the Société Anonyme*, 1950.

Seuphor, Michel. *La Sculpture de ce Siècle*. Neuchatel, Editions du Griffon, 1959.

Giedion-Welcker, Carola. *Contemporary Sculpture*. New York, Wittenborn, 1960.

Trier, Edward. *Form and Space*. New York and London, 1961.

Arnason, H. H. *Modern Sculpture from the Joseph H. Hirshhorn Collection*. The Solomon R. Guggenheim Museum, New York, 1962. E.C.

Todd, Ruthven. *Garland for the Winter Solstice*. Selected Poems. Boston, Toronto, Little Brown, 1962.

Sartre, Jean Paul. *Essays in Aesthetics*. New York, Philosophical Library, *c*. 1963. Reprint of essay from Carré catalogue, 1946.

Butor, Michel. *Cycle*. sur neuf gouaches a la hune. Paris, La Hune, 1962.

Kuh, Katharine. *Break-Up, The Case of Modern Art*. Greenwich, Conn., N.Y. Graphic Society, 1965.

*Current Biography*. New York, H. W. Wilson Co., Vol. 27, no. 7, July, 1966.

Arnason, H. H. (with Pedro Guerrero). *Calder*. New York, Van Nostrand, 1966.

Calder, Alexander. *An Autobiography with Pictures*. New York, Pantheon, 1966.

Rickey, George. *Constructivism*. New York, Braziller, 1967.

Werner, Bruno. "Porträts, Skulpturen, Drahtplastiken." *Deutsche Allgemeine Zeitung* April 12, 1929.

Szittya, Emil. "Alexander Calder." *Kunstblatt* 13:185–6 June 1929.

Westheim, Paul. "Legenden aus dem Künstlerleben." *Kunstblatt* 15:246–8 1931.

Gasch, Sebastià. "El escultor americano Calder". *AC* no. 7:43 1932.

Recht, Paul. "Les sculptures mouvants." *Mouvement* no. 1:49 June 1933.

Jakovsky, Anatole. "Alexander Calder." *Cahiers d'Art* 3 no. 5–6:244–6 1933.

Sweeney, James Johnson. "Alexander Calder." *Axis*, no. 3, July 1935, pp. 19-21.

Benson, E. M. "Seven sculptors." *American Magazine of Art* 28:468–9 Aug. 1935.

Tracy, Charles. HO to AA, a stage playlet in two scenes. *transition* no. 27:134–40 1937.

"Stabiles and Mobiles." *Time*. New York, March 1, 1937, pp. 46–7.

Sweeney, James Johnson. "L'Art contemporain aux Etats-Unis." *Cahiers d'Art* 13 no. 1–2:45–68 1938.

Sweeney, James Johnson. "Alexander Calder: Movement as a Plastic Element." *Architectural Forum* 70:144–9 Feb. 1939.

Lane, James. "Alexander Calder as Jewelry Designer. *Art News* 39:10–11 Dec. 1 1940.

Hellman, Geoffrey T. "Everything is Mobile." *New Yorker* Oct. 4, 1941.

Coan, Ellen Stone. "The Mobiles of Alexander Calder." *Vassar Journal of Undergraduate Studies*, Poughkeepsie, New York 15:1–19 May 1942.

Morris, George L. K. "Relations of Painting and Sculpture." *Partisan Review* 1 no. 1:63–71 Jan.–Feb. 1943.

Sweeney, James Johnson. "El Humor de Alexander Calder, Le Imprime Gracia y Fantasia a su Arte." *Norte* 4 no. 3 January 1944.

Sweeney, James Johnson. "The Position of Alexander Calder." *Magazine of Art* 37:180–3 May 1944.

Buffet-Picabia, Gabrielle. "Sandy Calder, forgeron lunaire." *Cahiers d'Art* 20-21:324–33 1946.

Mounin, Georges. "L'Object de Calder." *Cahiers d'Art* 20–21:334–5 1946.

Sartre, Jean-Paul. "Des mobiles." *Style en France* no. 5:7–11 April 15 1947, from Carré catalogue 1946.

Schneider-Lengyel, I. "Alexander Calder, der Ingenieur-Bildhauer." *Prisma*, Munich 1 no. 6:14–15 April 1947.

Veronesi, Giulia. "Braque, Picasso, Calder." *Emporium* 106 no. 635–6:121–23 Nov.–Dec. 1947.

Sartre, Jean-Paul. "Existentialist on Mobilist: Calder's newest works judged by France's newest philosopher." *Art News* 46 no. 10:22–3, 55–6 Dec. 1947, from Carré catalogue 1946.

Sartre, Jean-Paul. "Calder." *Art Présent*, Paris no. 3:45 1947.

Janis, Harriet. "Mobiles." *Arts & Architecture* 65 no. 2:26–8, 56–9 Feb. 1948.

Todd, Ruthven. "An Illuminated Poem: Alexander Calder." *Here and Now*, Toronto 1 no. 2:69 May 1948.

Masson, André. "L'Atelier de Calder." *Cahiers d'Art* 24 no. 2:274–5 1949.

Soby, James Thrall. "Calder, Matisse, Miro, Matta." *Arts & Architecture* 66 no. 4:26–8 April 1949.

Drexler, Arthur. "Calder." *Interiors* 109 no. 5:80–87 Dec. 1949.

Clapp, Talcott. "Calder." *Art d'Aujourd'hui* no. 11–12:2–11 June 1950. With "Notes sur Calder" by Léon Degand, p. 12.

Sartre, Jean-Paul. "Die Mobile Calder." *Das Kunstwerk* 8/9:76–80 1950, from Carré catalogue 1946.

"Calder." *Derrière Le Miroir*. no. 31:1–8 July 1950. Includes: "Les Mobiles d'Alexander Calder" by James Johnson Sweeney, "Calder le constructeur" by Henri Laugier, "Ces Météores Tombés du Ciel" by Henri Hoppenot, and "Calder" by Fernand Léger.

Sylvester, David. "Mobiles and Stabiles by Alexander Calder." *Art News & Review*, 2 no. 26 Jan. 27, 1951.

Schiller, Ronald. "Calder." *Portfolio, the Annual of the Graphic Arts*, Cincinnati, The Zebra Press, New York, Duell, Sloane and Pearce, 1951.

Degand, Léon. "A. Calder." *Art d'Aujourd'hui* 3 no. 1:5 Dec. 1951.

Mellquist, Jerome. "Alexander Calder et Hans Fischer: hommes d'un langage nouveau." *Arts Plastiques*, Brussels 5 no. 6:427–34 June 1952.

Courthion, Pierre. "Calder et la poésie de l'espace." *XX Siècle* Series II no. 3 June 1952.

Seiberling, Dorothy. "Calder, his Gyrating Mobile Art Wins International Fame and Prizes." *Life*, New York 33:83–8, 90 August 25, 1952.

Newton, Eric. "Critico Analiza a Alexander Calder." *Noticas de Arte*, Havana 1 no. 10:3, 11 Aug.–Sept. 1953.

Schmidt, Georg. "Alexander Calder's 'Mobiles'." *Du*, Zurich 13:60–61 Dec. 1953.

Joppolo, Benjamino. "Deux Sculpteurs." *XX Siècle* no. 4:68–70 Jan. 1954.

Bruguière, P. G. "L'objet-mobile de Calder." *Cahiers d'Art* 29 no. 2:221–228 1954.

"Calder." *Derrière Le Miroir*. nos. 69–70 Oct.–Nov. 1954. Includes: "Poème offert à Alexander Calder et à Louisa" by Henri Pichette; "Calder" by Frank Elgar.

Banham, Rayner. "Eppur si muove." *Art*, London 1 no. 7:4 Feb. 17, 1955.

Alloway, Lawrence. "Amos 'N'Remus." *Art News and Review*, London 7 no. 2:5 Feb. 19, 1955.

Jouffroy, Alain. "Portrait d'un artiste: Calder." *Arts Spectacles* no. 568 May 16–22 1956.

Schlösser, Manfred. "Fernand Léger und Alexander Calder Ausstellung in der Basler Kunsthalle." *Baukunst und Werkform*, Nürnberg 10 no. 9:549–51 1957.

"Calder." *Arts, Lettres, Spectacles* no. 687 Sept. 7–16 1958, unsigned interview.

"Calder." *Derrière Le Miroir*. no. 113, 1959. Includes: "Stabiles" by Georges Salles; "Le luron aux protège-genoux" by Jean Davidson.

Restany, Pierre. "L'Autre Calder." *Art International*, Zurich 3 nos. 5–6:46–7 1959.

Grenier, Jean. "Calder." *XX Siècle* April 15 1959.

Taillandier, Yvon. "Calder: personne ne pense à moi quand on a un cheval à faire." *XX Siècle* March 15 1959.

Gasser, Helmi. "Alexander Calder." *Werk*, Zurich 46 no. 12:444–450 Dec. 1959.

Hellman, Geoffrey. "Calder Revisited." *New Yorker* Oct. 22, 1960.

Davidson, Jean. "Four Calders." *Art in America* 50:68–72 Winter 1962.

Guéguen, Pierre. "Alexandre Calder et la sculpture éolienne." *XX Siècle* 24 no. 19 June 1962.

Rickey, George. "Calder in London." *Arts* 36 no. 10:22–27 Sept. 1962.

Terrière, Henri. "Rennes: Calder aventurier de l'espace." *Arts, Lettres, Spectacles* no. 898 Jan. 9–15 1963.

Chabrun, Jean-François. "En pleine Touraine Calder batit son Musée de Titan." *Paris Match* no. 725 March 2, 1963.

Sweeney, James Johnson. "Alexander Calder: Work and Play." *Art in America* 51 no. 4:93–9 Aug. 1963.

Rickey, George. "The Morphology of Movement." *College Art Journal* 22 no. 4 Summer 1963. Reprinted in *The Nature and Art of Motion*. Ed. Gyorgy Kepes, New York, 1965.

"Calder." *Derrière Le Miroir*. no. 141 Nov. 1963. Includes: "L'ombre de l'avenir" by James Jones; "Qu'est-ce qu'un Calder?" by Michel Ragon.

Courthion, Pierre. "Des Mobiles aux Stabiles Calder est passé du ciel à la terre." *Arts, Lettres, Spectacles, Musique* no. 938 Nov. 27–Dec. 3 1963.

Joffroy, Pierre. "Calder." *Paris Match* no. 764 Nov. 30, 1963.

Jones, James. "Letter Home." *Esquire* 61 no. 3:28, 30, 34 March, 1964.

Gindertael, R. V. "Stabiles monumentaux d'Alexander Calder." *XX Siècle* no. 26: sup. 417 May 1964.

"Le case di Calder: come vive un artista in America e in Europa." *Panorama*, Milan 2 no. 21:88–101 June 1964.

Gray, Cleve. "Calder's Circus." *Art in America* 52 no. 5:23–48 Oct. 1964.

Guppy, Nicholas. "Alexander Calder." *Atlantic Monthly* pp. 53–60 Dec. 1964.

Lemon, Richard. "The Soaring Art of Alexander Calder." *Saturday Evening Post* Feb. 27, 1965.

Getlein, Frank. "Calder the Pioneer." *The New Republic* March 27, 1965.

Rose, Barbara. "Joy, Excitement Keynote Calder's Work." *Canadian Art* 22:30–3 May 1965.

Restany, Pierre. "La Grande Mostra di Calder a Parigi." *Domus* no. 431:28a Oct. 1965.

Anderson, Wayne. "Calder at the Guggenheim." *Art Forum* III no. 6 1965.

Smith, Brydon. "Art in Motion." *Canadian Art* 23:66 Jan. 1966.

"Calder." *Derrière Le Miroir*. no. 156 Feb. 1966. Includes: "Oiseleur du fer" by Jacques Prévert; "Alexander Calder" by Meyer Schapiro; "Les gouaches de Calder" by Nicholas Guppy; "De l'Art Students League aux Totems" extracted from Calder's autobiography.

Frigerio, S. "Calder." *Aujourd'hui* 9:79 Feb. 1966.

Ragon, Michel. "Les premiers Calder." *XX Siècle* no. 26:sup. 34–36 May 1966.

Irwin, David. "Motion and the Sorcerer's Apprentice." *Apollo* no. 84:58 July 1966.

Rickey, George. "Origins of Kinetic Art." *Studio International* 173:67 Feb. 1967.

Russell, John. "Calder, in Saché . . ." *Vogue* July 1967.

Meisenheimer, Wolfgang. "Wurzeln der dynamischen Plastik." *Kunstwerk XXI* no. 5–6 Feb.–March 1968.

"Calder." *Derrière Le Miroir*. no. 173 Oct. 1968. Includes: "Un géant enfant" by Giovanni Carandente; "Note sur les flèches" by Jacques Dupin.

Osborn, Robert. "Calder's International Monuments." *Art In America* 57 no. 2:32– March–April 1969.

Galerie Billiet, Paris, Jan. 25–Feb. 7, 1929; preface by Pascin.

Galerie Percier, Paris. *Alexander Calder*, April 27–May 9, 1931; foreword by Fernand Léger.

Julian Levy Gallery, New York. *Calder Mobiles*, May 12–June 11, 1932; with note by Fernand Léger. (Exhibition catalogues appearing in other categories are noted as E.C.)

Pierre Matisse Gallery, New York, April 6–28, 1934. *Calder Mobiles*, foreword by J. J. Sweeney.

Renaissance Society of The University of Chicago, Jan. 14–31, 1935. *Calder Mobiles*, foreword by J. J. Sweeney.

Arts Club, Chicago. *Mobiles by Alexander Calder*, Feb. 1–26, 1935; preface by J. J. Sweeney.

Museum of Modern Art, New York, *Fantastic Art, Dada, Surrealism*, 1936; Ed. by Alfred H. Barr, Jr.

George Walter Vincent Museum, Springfield, Mass. *Calder Mobiles*, Nov. 8–27, 1938; preface by J. J. Sweeney.

San Francisco Golden Gate International Exposition, 1939–40; comment by J. J. Sweeney.

Design Project, Los Angeles. Calder exhibition, Sept. 27–Oct. 27, 1941; preface by René Lefevbre-Foinet.

The Cincinnati Modern Art Society, Cincinnati. *Paintings by Paul Klee and Mobiles and Stabiles by Alexander Calder*, April 7–May 3, 1942.

Addison Gallery of American Art, Andover, Mass. *Maud and Patrick Morgan and Alexander Calder*. June 5–July 6, 1943.

Galerie Louis Carré, Paris. *Alexander Calder; Mobiles, Stabiles, Constellations*, Oct. 25–Nov. 16. 1946; essay by Jean-Paul Sartre.

Kunsthalle, Bern. *Calder, Léger, Bodmer, Leuppi*, May 4–26, 1947; introduction by Arnold Rüdlinger.

Stedelijk Museum, Amsterdam. *Alexander Calder, Fernand Léger*, July–Aug. 1947.

Buchholz Gallery, New York. *Alexander Calder*, Dec. 9–27, 1947; with reprint of text by Jean-Paul Sartre.

Ministério da Educacao e Saude, Rio de Janeiro. *Alexander Calder*, Sept. 1948; with reprint of text by Jean-Paul Sartre, essay by H. E. Mindlin, and statements by Breton, Cunard, and Sweeney.

California Palace of the Legion of Honor, San Francisco, Oct. 2–Nov. 21, 1948; with introduction by Jermayne MacAgy.

Buchholz Gallery, New York. *Calder*, Nov. 30–Dec. 17, 1949; with poem by André Masson.

Galerie Blanche, Stockholm. *Alexander Calder: Mobiles et Stabiles*, Dec. 1950; with foreword by Eric Grate.

Lefevre Gallery, London. *Calder, Jan.* 1951; foreword by J. J. Sweeney.

Art Club, Internationaler unabhängiger Künstlerverband Oesterreichs. Neue Galerie, Wien., U.S. Information Center, Wien, and Museum of Modern Art, New York. *Calder*, 10V–15VI, 1951; with statement by Léger.

Contemporary Arts Museum, Houston. *Calder-Miró*, Oct.–Nov. 1951; with introduction by Mary Gershmowitz.

Curt Valentin Gallery, New York. *Alexander Calder: Gongs and Towers*, Jan. 15–Feb. 10, 1952; with reprints of texts by Sweeney & Léger.

XXVI Biennale di Venezia, Venice, 1952; with introduction by J. J. Sweeney Wadsworth Atheneum, Hartford, Conn. *Alexander Calder's Mobiles—Naum Gabo's Kinetic Constructions*, Oct.–Nov. 1953.

Hannover Gesellschaft, Hannover. *Alexander Calder: Stabiles, Mobiles, Gouachen*, March 18–May 2, 1954. Introduction by Alfred Hentzen; reprint of Sartre.

Galerie Rudolf Hoffman, Hamburg. *Calder*, 1954; with introduction by C. A. Isermeyer.

Museo de Bellas Artes, Caracas. *Calder*, Sept. 11–Oct. 25, 1955; with introduction by Alijo Carpentier and reprints of statements by Calder, Sartre and Léger.

Galleria del Naviglio, Milan, April 7–17, 1956; announcement of exhibition with brief article by Giulio Carlo Argan.

World House Galleries, New York. *4 Masters Exhibition: Rodin, Brancusi, Gauguin, Calder,* March–April, 1957; with statement by Calder.

Kunsthalle, Basel. *Calder*, 1957; introduction by Arnold Rüdlinger.

Whitney Museum, New York. *18 Living American Artists*, March 5–April 12, 1959; includes reprint of Calder's statement "What Abstract Art Means to Me."

Museu de Arte Moderno do Rio de Janeiro. *Alexander Calder, Escultura—Guache*, Sept. 23–Oct. 25, 1959; with reprint of statement by Léger.

Stedelijk Museum, Amsterdam. *Alexander Calder*, 1959; includes essays by Georges Salles and Willem Sandberg.

Palais des Beaux-Arts, Brussels. *Calder*, April 3–May 1, 1960; with text by Georges Salles.

Kunstgewerbemuseum, Zurich. *Kinetische Kunst, Alexander Calder, Mobiles und Stabiles aus den letzten Jahren*, May–June, 1960; introduction by Hans Fischli and Willi Rotzler.

The Arts Council of Great Britain, London. *Alexander Calder*, July 4–Aug. 12, 1962; introduction by J. J. Sweeney.

Galerie D'Art Moderne, Basel. *31 Gestalter einer totalen visuellen Synthese*, 1962; introduction by C. Belloli.

Galerie Alex Vömel, Düsseldorf. *Gouachen von Calder*, May–June, 1963; with note by Alfred Hentzen.

Galleria del Naviglio, Milan. *Alexander Calder: Gouaches 1963–64*, May 25–June 5, 1964; announcement of exhibition with note by Fernand Léger.

Documenta III Kassel. *Malerei und Skulptur*, June 27–Oct, 1964, vol. 1, p. 214–5.

The Museum of Fine Arts, Houston. *Alexander Calder*, Nov. 24–Dec. 13, 1964; introduction by J. J. Sweeney.

The Solomon R. Guggenheim Museum, New York. *Alexander Calder*, Nov. 5–Jan. 31, 1965; introduction by Thomas M. Messer.

Musée National d'Art Moderne, Paris. *Calder*, July–Oct. 1965.

Galerie Krugier & Cie, Geneva, June, 1966; *Calder*, with introduction by Giovanni Carandente.

The Phillips Collection, Washington, D.C. *Recent Stabiles*, April 8–May 30, 1967; with text by M. Phillips.

Arco D'Alibert, Studio Art, Rome, April 21–May 28, 1967; introduction by Carandente.

Akademie der Künste, Berlin, May–July, 1967; introduction by Hans Scharoun, poem by Willem Sandberg, essay by Stephan Waetzoldt, reprint of Sartre's "Die Mobiles von Calder," excerpt from Calder's autobiography on "Erinnerungen an Berlin 1929," and reprint of Bruno Werner's review of 1929.

Dayton's Gallery 12, Minneapolis, April 17–May 11, 1968.

Gimpel Fils, London. *Alexander Calder, Standing Mobiles 1968*, Feb.–March, 1969.

Museum of Modern Art, New York. *A Salute to Alexander Calder*, 1969; Introductory essay by Bernice Rose.

Fondation Maeght, Saint-Paul, France, *Calder*, April 2–May 31, 1969; with texts by James Johnson Sweeney, Michel Butor, Jean Davidson, Giovanni Carandente, Pol Bury, Jean-Paul Sartre, Fernand Léger, Gabrielle Buffet-Picabia, Francis Miroglio.

# INDEX

*All works listed, whether by title (in italic) or category, are by Calder unless otherwise indicated. Figures in italic refer to illustrations.*

215

216

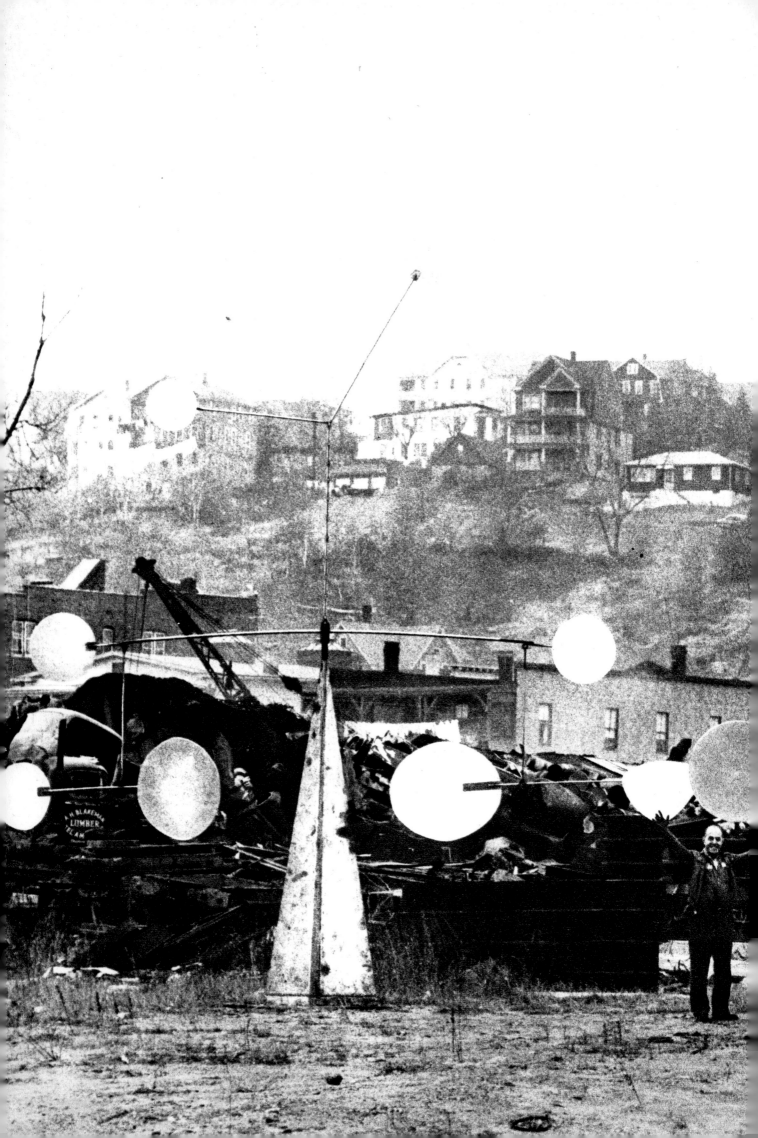